5,000 YEARS OF CHINESE JADE

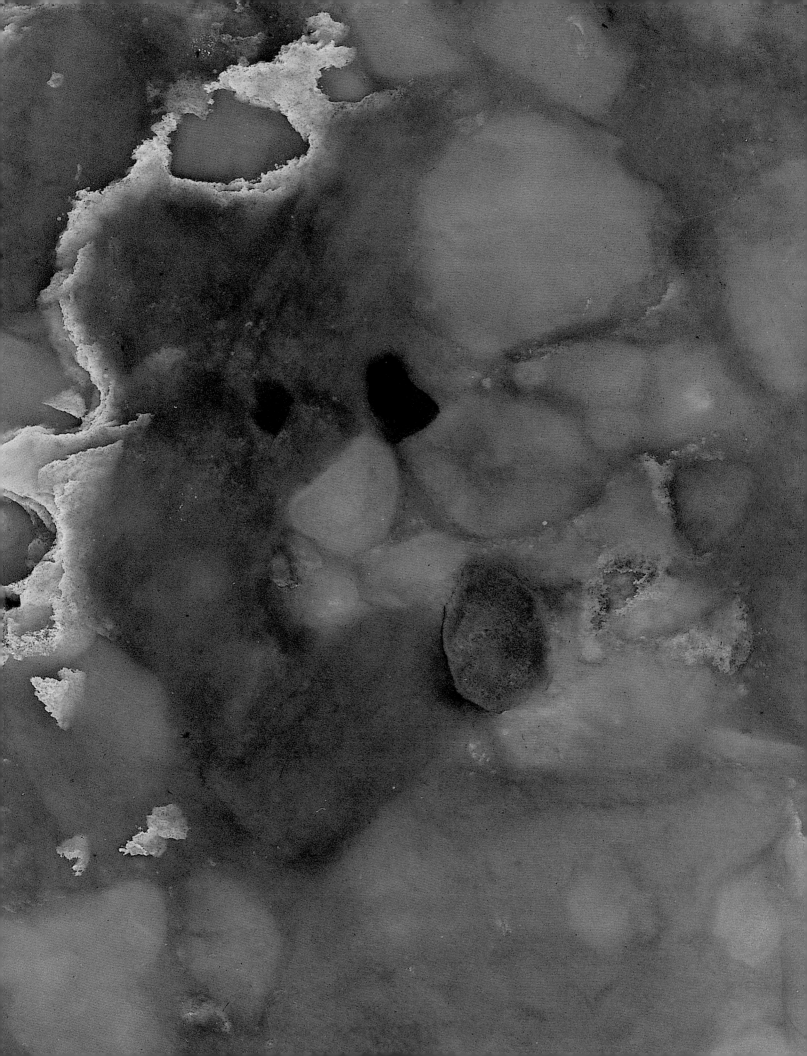

5,000 YEARS OF
CHINESE JADE

FEATURING SELECTIONS FROM THE
NATIONAL MUSEUM OF HISTORY, TAIWAN
AND THE ARTHUR M. SACKLER GALLERY,
SMITHSONIAN INSTITUTION

JOHN JOHNSTON AND CHAN LAI PIK, PhD

WITH AN ESSAY BY LIN SHWU SHIN

San Antonio
Museum of Art

This book is published in conjunction with the exhibition
5,000 *Years of Chinese Jade*, presented at San Antonio Museum of Art
from October 1, 2011 to February 19, 2012

Photographs appearing on pages
6, 34, 45, 76, 90, 91, 92, 97, 99—101, 103, 106–110, 116, 117–122, and 126
are by Steven Tucker.

A catalogue record is available from the Library of Congress

ISBN: 978-0-615-47180-8

Published by
San Antonio Museum of Art
www.samuseum.org

Distributed by
University of Washington Press
www.washington.edu/uwpress

Produced by
Marquand Books, Inc., Seattle
www.marquand.com

Designed by John Hubbard
Typeset in Electra LT Standard by Susan Kelly
Color Management by iocolor, Seattle
Printed and bound in China by C&C Offset Printing Co., Ltd.

The primary lender to this exhibition:

National Museum of History

The organizers of this exhibition are grateful for financial support for the catalog and exhibition
from the following government agencies:

Council for Cultural Affairs, Taiwan
Taipei Cultural Center of TECO in New York

Texas
Commission
on the Arts

CITY OF SAN ANTONIO
OFFICE OF CULTURAL AFFAIRS

CONTENTS

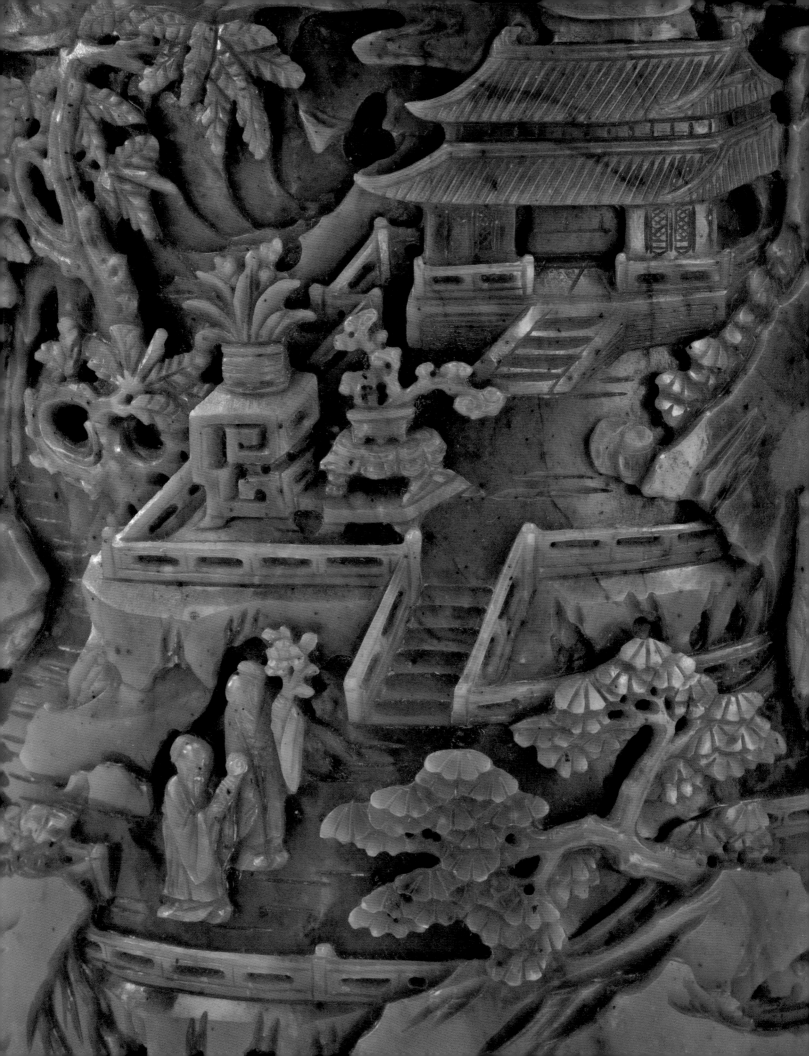

CHRONOLOGY

Neolithic period	ca. 6000–ca. 1700 BC

NORTHEASTERN CHINA

Xinglongwa	ca. 6100–ca. 5300 BC
Hongshan	ca. 4500–ca. 3000 BC

NORTH-CENTRAL CHINA

Feilegang	ca. 5900–ca. 5500 BC
Central Yangshao	ca. 4900–ca. 2900 BC
Gansu Yangshao	ca. 3100–ca. 1500 BC
Taosi	ca. 2400–ca. 1900 BC
Qijia	ca. 2200–ca. 1800 BC

EASTERN CHINA

Dawenkou	ca. 4200–ca. 2500 BC
Longshan	ca. 2600–ca. 2200 BC

SOUTHEASTERN CHINA

Hemudu	ca. 5000–ca. 3000 BC
Majiabang	ca. 5000–ca. 3900 BC
Songze	ca. 3900–ca. 3300 BC
Liangzhu	ca. 3300–ca. 2100 BC

SOUTH-CENTRAL CHINA

Lingjiatan	ca. 3600–ca. 3300 BC
Qujialing	ca. 3300–ca. 2600 BC
Shijiahe	ca. 2600–ca. 1900 BC

SOUTHERN CHINA

Shixia	ca. 3000–ca. 2000 BC

Erlitou period	ca. 1850–ca. 1560 BC
Shang dynasty	ca. 1600–1046 BC
Erligang phase	ca. 1600–ca. 1400 BC
Anyang phase	ca. 1400–1046 BC
Zhou dynasty	1046–221 BC
Western Zhou dynasty	1046–771 BC
Eastern Zhou dynasty	770–221 BC
Spring and Autumn period	770–476 BC
Warring States period	475–221 BC
Qin dynasty	221–206 BC
Han dynasty	206 BC–220 AD
Western Han dynasty	206 BC–9 AD
Xin period	9–25
Eastern Han dynasty	25–220
Three Kingdoms period	220–265
Jin dynasty	265–420
Western Jin dynasty	265–316
Eastern Jin dynasty	317–420
Southern Dynasties	420–589
Northern Dynasties	386–581
Sui dynasty	581–618
Tang dynasty	618–907
Five Dynasties	907–960
Song dynasty	960–1279
Northern Song dynasty	960–1127
Southern Song dynasty	1127–1279
Liao dynasty	916–1125
Jin dynasty	1115–1234
Yuan dynasty	1271–1368
Ming dynasty	1368–1644
Qing dynasty	1644–1911
Shunzhi period	1644–1661
Kangxi period	1662–1722
Yongzheng period	1723–1735
Qianlong period	1735–1796
Jiaqing period	1796–1820
Daoguang period	1821–1850
Xianfeng period	1851–1861
Tongzhi period	1862–1874
Guangxu period	1875–1908
Xuantong period	1909–1911

FOREWORD AND ACKNOWLEDGMENTS

For thousands of years, jade has been highly esteemed by societies all over the world. Its intrinsic qualities of color, texture, and hardness, together with its rarity, affix near magical powers to jade and have inspired cultures throughout Asia, the Americas, and Oceania to collect jade and use the stone as a symbol of power and wealth and as a means to communicate with the gods. Jade occupies a unique and elevated position in Chinese art and culture. This precious material links thousands of years of Chinese history. Jade is an enduring symbol of Chinese culture, and objects in jade are among the most treasured of Chinese works of art.

The San Antonio Museum of Art is honored to organize a major exhibition exploring the history of jade in Chinese art and for the opportunity to share it with visitors and citizens of our city. The Museum is honored to host this exhibition on the centennial anniverary of the Republic of China. SAMA is home to one of the finest Asian art collections in the United States. The Museum's Lenora and Walter F. Brown Asian Art Wing, inaugurated in 2005, contains highly prized collections of Chinese ceramics, Japanese lacquer and paintings, and other important works of art from all over Asia. This exhibition of rare jades is an important complement to our permanent collection of Asian art.

An international exhibition of this importance would not be possible without the generosity of both lenders and donors. The National Museum of History, Taiwan (NMH) is the primary lender to the exhibition. SAMA has established a strong working relationship with NMH and we hope this project will serve as a model of cooperative international cultural relations. Director Chang Yui-Tan and his dedicated staff in Taipei have graciously hosted SAMA staff and provided them essential assistance. Mrs. Han Hui-Chuan, Section Chief of the Public Affairs Office, has capably handled key administrative matters, and Mr. Kuo Yu-Lin, Curator, has provided many valuable and useful insights on Chinese jade. Ms. Lin Shwu Shin, Curator Emeritus of Jade, graciously contributed an important essay to the catalog.

We are also grateful for the lender participation of another prestigious national museum—the Arthur M. Sackler Gallery of the Smithsonian Institution. Along with the Freer Gallery of Art, the Arthur M. Sackler Gallery serves as America's National Museum of Asian Art. The Sackler is internationally famous for jades of exceptionally fine quality. We thank Julian Raby, PhD, Director of the Arthur M. Sackler Gallery and Freer Gallery of Art, for his encouragement of this project and J. Keith Wilson, PhD, Associate Director and Curator of Ancient Chinese Art, for his valuable assistance with this exhibition. The George Walter Vincent Smith Museum of the Springfield (Mass.) Museums generously lent six large and important examples of 18th century Chinese jade to the exhibition. Director Heather R. Haskell and Curator of Art Julia Courtney have been most helpful with this important loan and we extend thanks to them. And last but not least among the lenders, we thank the owners of A Private American Collection who have generously and anonymously lent the exhibition a dozen jades of extraordinary quality and rarity, including Imperial pieces.

The Museum is grateful for generous financial support of this major exhibition from the Helen and Everett H. Jones Exhibition Endowment, Lenora and Walter F. Brown, the Mays Family Foundation, the City of San Antonio Office of Cultural Affairs, the Texas Commission on the Arts, Rose Marie and John L. Hendry III, the Daniel J. Sullivan Family Charitable Foundation, the Council for Cultural Affairs, Taiwan and the Taipei Cultural Center of TECO in New York. This exhibition is supported by an indemnity from the Federal Council on the Arts and the Humanities.

The Board of Trustees and members of the San Antonio Museum of Art keep our institution thriving, and we are very grateful for their continuing support. SAMA's exceptional and thoroughly professional staff worked hard on every aspect of this exhibition. Special thanks go to SAMA Registrar Karen Baker, Erin Keelin, Curatorial Assistant for Asian Art, Tim Foerster, Head of Exhibitions, and Head Preparator Tyler Lewis. Others who contributed valuable knowledge and assistance were Anthony Carter, James Godfrey, Stephen Tucker, and Thomas Klobe. Chan Lai Pik, PhD, of the Chinese University of Hong Kong, co-authored the catalog and assisted in the selection of jade objects. Dr. Chan is a specialist in Chinese jade and her knowledge and guidance were crucial to the development and realization of the project.

Finally, and most importantly, John Johnston, the Coates-Cowden-Brown Curator of Asian Art at SAMA, conceived of the exhibition and skillfully shepherded it through to inauguration. John's keen knowledge and understanding of Asian art, coupled with a deep appreciation of Chinese aesthetics, contributed enormously to the success of this project. SAMA is indeed fortunate to have him at the helm of our Asian Art Department.

Marion Oettinger, Jr., PhD
The Kelso Director
San Antonio Museum of Art

FOREWORD

Throughout the course of human history, few precious stones have borne as much cultural significance as jade. As early as the 16th century B.C.E., Chinese jade workers of the Shang dynasty were crafting exquisite jade art objects, and over the following millennia jade craft developed into one of Chinese culture's most distinctive art forms. The Chinese language itself has been shaped by jade; in today's speech countless idioms and expressions allude to it, invoking its purity and brilliance to describe good human qualities and natural beauty.

The opening of the San Antonio Museum of Art's 2011 exhibition 5,000 *Years of Chinese Jade Featuring Selections from the National Museum of History, Taiwan and the Arthur M. Sackler Gallery, Smithsonian Institution* coincides with the hundred-year anniversary of the founding of the Republic of China, lending this event special significance. We extend our sincerest thanks to San Antonio Museum of Art for their efforts in putting together this exhibition. This beautiful catalog is a testament to their dedication and care.

5,000 *Years of Chinese Jade* features 89 jade pieces dating from throughout China's history, beginning in the Neolithic and ending in the Qing dynasty. In addition to items from the Arthur M. Sackler Gallery of the Smithsonian Institution, SAMA, Springfield Museums, and an American Private Collection, the exhibition includes 45 pieces of classic jade art from the National Museum of History, Taiwan. SAMA staff made the long journey to Taiwan to see the pieces *in situ* and select items for the exhibition, and the National Museum reciprocated generously, releasing the pieces without a fee. It is our hope that through this exhibition viewers will understand jade artwork not just as the material vestige of an ancient culture, but as a symbol of human civilization's pursuit of beauty, invested with fresh significance in this new era of Sino-Western cultural exchange.

It would have astonished the makers of these pieces to see their artwork transcend space and time, appearing in the West in this globalized age. But I believe it would please them. Chinese jade work, with its history as a symbol of human refinement, is deserving of such transcendence: to radiate its unchanging beauty, purity, and brilliance far beyond the borders of China.

Once again, our deepest gratitude to SAMA for their tireless efforts in bringing this ancient art form, and the culture it symbolizes, to a wider world.

Emile Chih-Jen Sheng
Minister, Council for Cultural Affairs,
Republic of China (Taiwan)

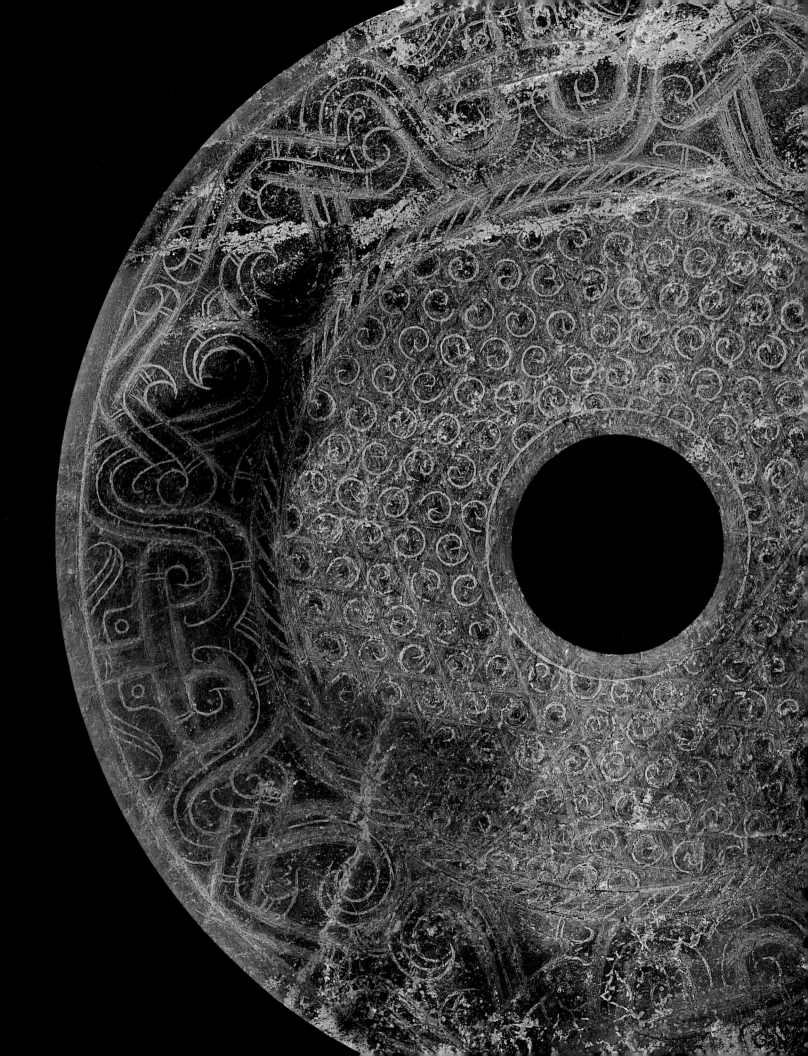

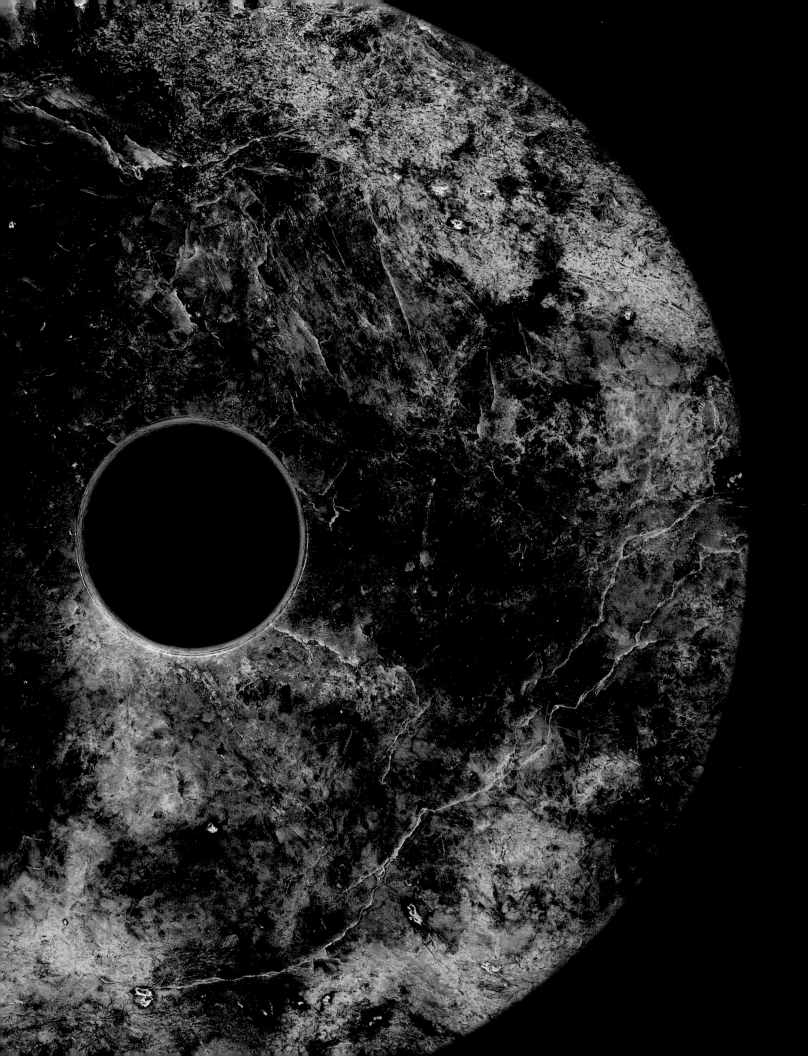

FOREWORD

This year is the centennial anniversary of the founding of the Republic of China. To commemorate this significant occasion, the National Museum of History, Taiwan is honored to collaborate with the San Antonio Museum of Art to organize the exhibition 5,000 *Years of Chinese Jade Featuring Selections from the National Museum of History, Taiwan and the Arthur M. Sackler Gallery, Smithsonian Institution*. This exhibition is a magnificent achievement in international cultural exchange and is a wonderful way of celebrating The Year of Taiwan in San Antonio, Texas. We are grateful to the Trustees and staff of the San Antonio Museum of Art for their hard work and support of this beautiful jade exhibition.

The National Museum of History holds 1,700 pieces of Chinese jade, classified in two categories: ancient and traditional jade and modern jade. A team of international specialists involved with this project selected forty-five exquisite works of ancient and traditional jade ranging from the Neolithic era to the Qing dynasty for display in the exhibition and catalog. With their unique characteristics, these rare jades demonstrate the evolution of style, design, and function through the ages. Among the exhibits are highly valuable jade ornaments such as *huang* (arc-shaped pendants) and *jue* (earrings) for which we have archaeological records. These objects were excavated in 1936 from the Jia and Yi Tombs (burials of Wei nobles dating to the Spring and Autumn period, 770–476 BC) in Hui County, Henan province.

Aside from the intrinsically decorative quality of jade, it is the exquisite carving that places ancient Chinese jade among the most brilliant treasures of the past. In Chinese thinking, jade not only symbolizes nobility, beauty and eternity, but also embodies the humanism of Chinese culture. It was early in its 8,000 year development that jade began to be used in daily Chinese life. The variety of jade styles and broad distribution shows that jade played a significant role in the history of Chinese culture.

Form, color, and carving are among the many aesthetic aspects of jade that inspire people to indulge in jade appreciation, and it is as a result of those aspects that a culture of jade admiration was created in China. Throughout the long history of jade's evolution, it has been widely used for ceremonial, ornamental, and commercial purposes. Above all, jade was also held by traditional Confucianists to be a symbol of virtue. Even to this day, jade is deeply admired in Chinese culture.

Chang Yui-Tan, PhD
Director
National Museum of History, Taiwan

AN OVERVIEW OF
5,000 YEARS OF CHINESE JADE

John Johnston

No material binds together the vast span of Chinese history, or is as closely identified with Chinese identity, as jade. The broadest definition of jade in China includes a wide variety of stones and minerals valued for their color and luster such as agate, turquoise, and marble. During the overwhelming majority of Chinese history, jade, or "*yu*" in Mandarin Chinese, referred primarily to the mineral nephrite. Only over the last 300 years has carved jade in China come to include jadeite (*feicui*). The brilliant greens found in jadeite are responsible for the general Western perception of the color of jade. As this exhibition makes evident, jade occurs in a wide range of colors including auburn and russet tones, white jade, light green and pale celadon jade, "spinach" jade, and black jade.

The term "jade" in English is derived from Spanish and refers to the perceived healing capacity of the stone. "*Piedra de la ijada*," or "stone of the flank," is the likely source for *l'ejade*, which became "jade." The mineral was thought to have curative powers when placed on the abdomen, though the source of this belief is unclear. In 1863 French mineralogist Alexis Damour defined jade in the West as two distinct minerals—nephrite and jadeite. The term nephrite is derived from the Greek word "nephros" meaning "kidney," again related to the healing quality of jade.

Though nephrite and jadeite are both metamorphic rocks containing silicates, their mineralogical structure varies greatly. Nephrite and jadeite are exceptionally durable mineral types, rating 6 to 6.5 and 6 to 7 respectively on the Mohs hardness scale.[1] Owing to the durability of jade, objects could be used and collected for centuries. The presence of a Shang dynasty jade bird in a tomb dating to the Spring and Autumn period, for example, suggests the item was kept above ground for several hundred years (catalog number 20). Jade items were also repaired and reused over lengthy periods of time.[2] For example, a fragment from a comb-shaped mask (catalog number 1) bears two holes on the inner edge, likely a repair allowing for reattachment to the larger original object.

Sources for early Neolithic jade in China are now thought to have been largely exhausted within present day Eastern and Southern China.[3] For much of China's history, jade was largely sourced from neighboring areas in the Northwest, specifically jade from *Hetian* and other sources in present-day Xinjiang. Indeed the distinctive material quarried from various areas lends the name to well known jade types, such as the white and pale celadon *hetian* jade and the spinach-green Manasi jade (catalog numbers 68 and 81), named for jade sources in Xinjiang. The majority of jadeite, or *feicui*, was sourced in present-day Burma and imported into China beginning in the eighteenth century, and on a large scale beginning in the late 19th century. Jade can also be described by color, such as the sought-after "mutton fat" jades (*yang zhi yu*) also sourced in *hetian*.

Early jades are subjected to burial for thousands of years. During this long burial the jade is altered due to environmental conditions including contact with other minerals. Areas of discoloration may indicate penetration of the stone by minerals. The variegated colors present in the two large Liangzhu culture *bi* discs from the National Museum of History (catalog numbers 4 and 5) both show areas of light discoloration formed by contact with minerals. Bodily fluids can also alter the surface of jades, such as areas of white discoloration present on a large *ge* blade (catalog number 15).[4] A small marble jar from the Arthur M. Sackler Gallery shows an unusual area of bronze accretion on the upper shoulder, the result of direct contact with a bronze object during burial (catalog number 22).

The "skin" of jade objects is particularly valued by collectors. The skin of jade refers to areas of discoloration on the surface of the stone caused naturally by environmental conditions, though often enhanced artificially in contemporary examples. As nephrite contains a great deal of iron, for example, a brown discoloration on the skin may be caused by natural weathering.[5] Artists incorporate the skin into the design of the carved object. An excellent example of incorporating the russet skin of nephrite jade into a carved design is evident in the *Bird Holding a Fruiting Branch* bearing a Qianlong mark (catalog number 85). An earlier example, the outstanding figure of a *Hound* from the Five Dynasties period to the Northern Song dynasty (ca. 10th to 11th century), is also

cleverly designed to employ dark areas on the nephrite into the design (catalog number 51).

Describing jade-working as carving is misleading as the very hard material must be ground by abrasives, an incredibly labor intensive and time consuming endeavor. Among the hardest stones worked by human hands, nephrite and jadeite objects may require months or even years to be carved. Treadle saws, cylindrical drills for boring, flat saws, and string saws are the common pre-modern tools for jade working. The modern electric saw fashioned with a steel or diamond blade is used in contemporary jade workshops. Recent research by Dr. Peter Lu indicates that technology for working jade was more advanced in pre-Han China than previously thought.[6]

The word for jade appeared in Chinese at the dawn of the written language in the early Shang dynasty. Numerous volumes, indeed entire libraries, have been devoted to the subject. As China rapidly develops, more scientifically excavated sites come to light, greatly increasing our knowledge of Chinese jade and permitting the establishment of a reliable stylistic chronology. 5,000 *Years of Chinese Jade* provides a concise visual survey of the major time periods and important themes in Chinese jade. The exhibition and catalog present five major thematic groups: ritual objects and weapons, figural jades (both animal and human), adornments, vessels, and scholars' objects.

The earliest epoch of jade carving in China, the Neolithic period, is characterized by jade used for ritual purposes. In 1936 archaeologists first discovered the Liangzhu culture near a village named Liangzhu near Hangzhou in Zhejiang province. The Liangzhu culture was one of many contemporaneous Neolithic cultures in present-day China, though the Liangzhu people were the most advanced at using stone tools and weapons and produced the iconic *bi* discs, *cong* tubes, and *yue* axe heads typically found on or near the corpse in burial.[7] The presence of jade in burials suggests a protective function for the objects in funerary rituals. Discs with a central aperture are known as *bi* and tubes with perforated layers cut into the corners are known as *cong*. *Bi* discs, with their strong circular form, span the length of Chinese art history. Neolithic discs in China's south and east were revived in the Warring States period and Western Han dynasty (see essay by Chan Lai Pik). At least by the Zhou dynasty *bi* discs were associated with Heaven and the *cong* tubes with Earth, as mentioned in early written sources such as the *Li ji*, though the meaning of the shapes in the Neolithic period remains a matter of speculation. Like jade itself, the *bi* disc, and to a lesser extent the *cong*, have come to represent ancient China. An early example of a *bi* disc used as adornment is a small *bi* set into a garment clasp from the Han dynasty (catalog number 38). The strong geometric *bi* and *cong* forms appear frequently in contemporary jewelry and decorative art.

Weapons composed of jade were largely used as ceremonial rather than utilitarian objects. Despite the durability of jade, the material fractures easily owing to molecular structure and is not suitable for use as a commonplace tool. The *zhang* blade, variously translated as halberd, dagger-axe, or simply blade, is an early jade shape with remarkably wide geographic distribution in China from the late Neolithic period to the emergence of the Shang dynasty. The ceremonial role of the *zhang* is indicated in drawings illustrating the blades held in an upright fashion with concave blade pointing upwards. The example from the San Antonio Museum of Art, formerly in the private collection of Arthur M. Sackler and on loan to the Metropolitan Museum of Art for many years, is a fine example of a *zhang* in highly polished blackish-green nephrite (catalog number 10). Two *yue* axe heads composed of exceptionally beautiful jade (catalog numbers 6 and 9) also have a ceremonial rather than utilitarian function and were likely produced as grave goods.

Jade has been used for luxurious adornment throughout China's long history. In the Neolithic Liangzhu culture, for example, adornments include jade beads, pendants, and bracelets.[8] The use of jade as adornment in Neolithic and early China may relate to protective or healing qualities associated with the material. A beautifully carved pair of barrel shaped earrings (catalog number 32, one of Taiwan's Important National

Treasures) excavated from the Jia tomb in Huixian, Henan province, is carved overall with an interlocking stylized pattern based on dragon imagery. Hair accessories in jade are a subject unto themselves. The jade hairpin is an elegant form particularly popular in the Ming dynasty. The most prized hairpins of the Ming were carved by Lu Zhigang, the carver of a small waterpot in this exhibition (catalog number 63). The jade hairpin with openwork carved terminal featuring a phoenix also bears beautifully carved botanical imagery along the stem (catalog number 60). An archaistic hair cover (catalog number 61) composed of evenly toned dark green nephrite is a Ming revival of a popular Song style. The archaistic revival of hair covers worn by men during the Ming is evident in elite burials.[9]

Vessels appear early, though rarely, in Chinese carved jade. A Shang vessel from the Sackler Gallery composed of marble is representative of stone vessels carved in miniature (catalog number 22). The thin-walled vessel is evenly carved and symmetrical, with three lugs symbolically providing for a rope for transport. The shape of the marble jar is based on wheel thrown pottery prototypes. Jade vessels are rare in early dynastic and medieval China, with a few notable exceptions of Zhou and Han dynasty jade vessels based on small gold and silver prototypes.[10]

Vessels emerge as a major subject of jade carving in the Ming and Qing dynasties. In keeping with the elite taste of the times, archaistic themes celebrating the ancient roots of Chinese civilization were the frequent inspiration for both form and surface decoration. Archaism as a movement in the visual arts began in the Song dynasty and remained important in the decorative arts of the Ming and Qing dynasties. An exceptionally rare and early example of *fanggu*, or archaism, from the Song dynasty is included in this exhibition (catalog number 54). The archaistic motifs present on two vases from the George Walter Vincent Smith Collection dating to the 18th century bear imaginative visual references to the décor of Shang and Zhou ritual bronzes (catalog numbers 83 and 84). From the Ming and continuing through the Qing, connoisseurship guides with line drawings of often completely imagined forms were the popular inspiration for carved jade vessels. *Guyu tupu* ("Illustrated Guide to Ancient Jades") compiled by Long Dayuan in the late eighteenth century was particularly influential.

The Qianlong period (r. 1735–1796) marks a highpoint in archaistic jade. The Emperor was famously enthralled by jade and his Imperial collection, largely divided today between The Palace Museum, Beijing and the National Palace Museum, Taipei, forms the finest Chinese jade collection in the world. Of special importance in this exhibition are two superior jade objects likely made in Qianlong's Imperial workshops located within the Forbidden City. The *Bird with Fruiting Branch* bears a fine Qianlong reign mark and dates from the period (catalog number 85).[11] The extraordinary surface carving of archaistic and zoomorphic imagery found on the *Rhyton* drinking vessel from the Qianlong period is characteristic of the highest standards for workmanship found in Imperial workshops (catalog number 73). Based on Han dynasty prototypes, such as the jade rhyton from the tomb of the King of Nanyu in Guangzhou, the drinking vessel is composed of fine and well polished *hetian* white jade with russet areas on the skin.[12] A number of other vessels in the exhibition bear archaistic association with Chinese bronzes, such as a small Qing dynasty jade *ding* tripod, a retelling in stone of the most iconic Shang dynasty bronzes shape (catalog number 75).

The scholar's studio of Ming and Qing China was a place of refinement, an atmosphere encouraging purity of thought and upright behavior. With jade's long association with superior qualities and ancient philosophy, jade objects were a natural and prized addition to the scholar's studio. The archaistic jade vessels which celebrate Chinese antiquity were appropriate for a scholar's studio. Objects normally composed of more modest materials, such as bamboo, were copied in jade for the scholar's desk. Examples of jade versions of bamboo articles includes brushpots (catalog number 68) and wrist rests (catalog number 66). A richly carved aromatics container (catalog number 82), also based on bamboo prototypes, appears in jade form. The most popular themes for scholar's objects include Daoist gods and immortals in paradise scenes.

The composition of landscape scenes rendered in jade often reflect landscape painting traditions beginning in the Song dynasty, such as the one-corner composition appearing on both sides of a remarkable jade inkstone (catalog number 65).

Any introduction to the history and appreciation of Chinese jade would be incomplete without mention of the Confucian virtues embodied in the stone. In a conversation between Confucius and a disciple, as captured in the Book of Rites (*Li ji*), Confucius answers why jade is valued: "Anciently, superior men found the likeness of all excellent qualities in jade. Soft, smooth, and glossy, it appeared to them like benevolence; fine, compact, and strong—like intelligence; angular, but not sharp and cutting—like righteousness; hanging down [in beads] as if it would fall onto the ground—like [the humility of] propriety; when struck, yielding a note clear and prolonged, yet terminating abruptly—like music; its flaws not concealing its beauty, nor its beauty its flaws—like loyalty; with an internal radiance issuing from it on every side—like good faith; bright as a brilliant rainbow—like heaven; exquisite and mysterious, appearing in the hills and streams—like the earth; standing out conspicuous in the symbols of rank—like virtue; esteemed by all under the sky—like the path of truth and duty."[13] Indeed Chinese language is filled with aphorisms and ancient sayings extolling the virtues embodied in jade.

The elevated position of jade in Chinese art and culture is rooted in Stone Age practices of using jade in funerary rituals. Over time jade was used for many purposes, though the rarity and brilliance of the mineral, and the enormous labor required to carve it, always lent jade a special status. Jade eventually became a popular medium for the decorative arts, including furnishings for elite homes and the scholar's studio. In every context jade was prized and the mineral became known as an embodiment of admirable qualities. This exhibition and catalog provides an introduction to the enormous beauty, power, and complexity of jade in Chinese art and culture. The continuous appreciation and enjoyment of jade in China, which spans over 5,000 years, provides a tangible link between China's most distant past and the present.

NOTES

1. By comparison, quartz rates seven and diamond ten on the Mohs hardness scale.

2. Rawson, Jessica. "The Reuse of Ancient Jades," in *Chinese Jades: Colloquies on Art and Archaeology in Asia*, No. 18, Rosemary Scott, ed., London: University of London, Percival David Foundation of Chinese Art, School of Oriental and African Studies, 1997, pp. 171–186.

3. Middleton, Andrew, and Ian Freestone. "The Mineralogy and Occurrence of Jade," in *Chinese Jade: From the Neolithic to the Qing*, Jessica Rawson, Chicago: Art Media Resources, 1995, p. 417.

4. See Chan Lai Pik, catalog number 15, in this catalog.

5. Middleton and Freestone.

6. Ibid.

7. Sun, Zhixin. "The Liangzhu Culture," in *The Golden Age of Chinese Archaeology: Celebrated Discoveries from the People's Republic of China*, Xiaoneng Yang, ed., Washington, D.C.: National Gallery of Art, 1999, p. 117.

8. Ibid.

9. Jade carving styles of the Qianlong period also persist into the reign of the Emperor Jiajing (r. 1796–1820), further complicating dating. However, by 1821, the first year of the Daoguang reign, the supply of jade from Xinjiang ceased by Imperial order, though jade continued to be imported to private workshops.

10. Rawson, pp. 386–387.

11. For a similar jade bird with fruiting branch, see Terese Tse Bartholomew entry in Knight, Michael, He Li, and Terese Tse Bartholomew. *Later Chinese Jades: Ming Dynasty to Early Twentieth Century from the Asian Art Museum, San Francisco*, San Francisco: Asian Art Museum, 2007, p. 266.

12. Rawson 1995, p. 70, fig. 61.

13. Legge, James, trans. *Li ji* (Book of Rites), New York: New Hyde Park, 1967.

CIRCULAR JADES:
THE DEVELOPMENT OF JADE *BI* DISCS
IN THE LATE BRONZE AGE

Chan Lai Pik, PhD

Jade, or *yu* in Mandarin Chinese, has been treasured in China for more than 5,000 years.[1] The unique and durable stone has been closely associated with religion and philosophy in China for millennia. Bold geometric shapes, such as rectangular and circular forms, constitute the earliest and most basic shapes appearing in carved Chinese jade. Circular jades are a very popular type, and can be found in discs, rings, bracelets, and other objects. Circular jades are normally created by slicing off four corners of a rectangular jade block, or through the use of rotary tools. The apertures on such discs usually repeat the circular disc shape. The apertures appearing on *bi* discs of the Liangzhu culture (ca. 3300–ca. 2100 BC), for example, are biconical (having been carved from both sides), and are evenly concentric (catalog numbers 4, 5, and 13). The fascination with circular jade objects throughout Chinese history is evident in a number of examples of wide-ranging date included in this exhibition (catalog numbers 3, 4, 5, 12, 13, 14, 17, 18, 27, 40, and 48).

The complex appreciation and understanding of circular jades in China is influenced by various ideologies. Confucius, or Kongzi (ca. 551–ca. 479 BC), promoted moral cultivation through the ritual use of jades, including discs. The prevalence of Daoism and its belief in immortality during the Han dynasty facilitated the use of *bi* discs as a "gate of heaven," serving as a link between earth and heaven.[2] The cosmological significance of *bi* discs was fully established and recorded in the Warring States period and Han dynasty[3] and jade discs enjoyed a revival in the Song, Ming, and Qing dynasties.[4] The enduring circular shape in Chinese visual culture has come to hold special significance as a geometric archetype representing completion, wholeness, and unity.[5]

The names given to various disc or ring forms varies depending on the terminology used during different periods. For instance, the oldest Chinese encyclopedia, *Erya*, from the third century BC states, "When the width of the disc is twice the diameter of the hole in the center, it is named a *bi*; when the width of the ring is half the diameter of the hole, it is named a *yuan*; when the width of the ring is equal to the diameter of the hole, it is named a *huan*."[6] These definitions are based on the proportion of jade disc to circular hole. For our purposes, a small central aperture and large width of circular jade will be called a *bi* disc, while the other discs are referred to as a *huan* ring.[7]

Large nephrite jade discs first appear in China by the fifth millennium in the Neolithic Hongshan culture (ca. 4500–ca. 3000 BC) and were prevalent in the late Neolithic period, such as in the Liangzhu (ca. 3300–ca. 2100 BC) and Qijia (ca. 2200–ca. 1800 BC) cultures. However, for over one thousand years following the Neolithic period, large size *bi* discs (those exceeding 15 centimeters in diameter) were rarely used in burials and the quantity of discs in burials diminished.[8] The use of large *bi* discs was revived in the fifth century BC and the iconic jade discs maintained both ritual and cultural importance throughout the history of Imperial China. Discussion of the presence of this distinctly Chinese jade shape in the second half of the first millennium BC, and the relationship between two types of jade discs of disparate date (such as catalog numbers 4 and 40), follows. This essay focuses on jade *bi* discs in the late Bronze Age, particularly those of the Eastern Zhou dynasty (770–221 BC).

BI DISCS AND THEIR USE IN BURIAL PRACTICES OF THE LATE BRONZE AGE

A large number of *bi* discs with a diameter of 15 centimeters or greater have been recovered from tombs in Eastern China dating to the Warring States period (475–221 BC). These *bi* discs are found in the tombs of high-ranking individuals and can be divided into three types (figure 1). Type I jade *bi* disc is decorated with several symmetrical zoomorphic masks on the inner and outer bands of decoration, with raised-knob patterns appearing between the decorated bands. Type II is decorated with four or five symmetrical zoomorphic masks appearing on an outer band of decoration with raised-knob patterns on the inner band (catalog number 40). Type III is decorated with

FIGURE 1

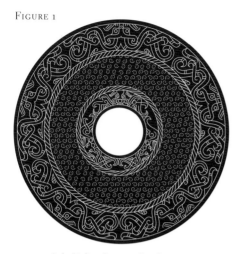

TYPE I: Jade *bi* disc decorated with outer and inner rings of four to five symmetrical zoomorphic masks with an inner ring raised knobs.

TYPE II: Jade *bi* disc decorated with an outer ring of four to five symmetrical zoomorphic masks and an inner ring of raised knobs (see catalog number 38).

TYPE III: Jade *bi* discs decorated overall with systemically organized raised knobs.
Illustrations in figure 1 after Qufu, 1982, p. 132.

orderly arranged raised spirals or knobs and without the distinctive bands of decoration. All disc types were used to cover the entire corpse of tomb occupants in select Warring States period tombs.[9] The practice of placing numerous large jade *bi* discs on the body is rarely found in tombs dating to the Shang (ca. 1600–1046 BC) and Western Zhou (1046–771 BC) dynasties[10] and the Spring and Autumn period (770–476 BC).[11]

Two tombs at the State of Lu in Qufu, Shandong province dating to the 5th century BC (during the early Warring States period) are early examples of the late Bronze Age use of large jade *bi* discs in burial.[12] In tomb number 52, the body is placed on top of a layer of jade *bi* discs (see table 1 for distribution of jade *bi* discs in tomb 52). Another layer of jade *bi* discs was placed directly on top of the body, extending from head to foot. The largest and most elaborate jade *bi* discs, each featuring three rings of decoration, were placed on and under the abdomen. The head was covered with jade *bi* discs featuring two rings of decoration (figure 1, type II), and the legs and feet were covered with jade *bi* discs decorated with only the raised-knob pattern (figure 1, type III). In tomb number 58, the burial practices appear nearly identical to tomb 52, though the upper and lower layers of *bi* discs were mixed together (see table 2 and figure 3 for distribution of jade *bi* discs in tomb 58). The largest and most elaborate *bi* discs, with a diameter ranging 22.2 to 27.7 centimeters and featuring two rings of decoration, were placed on the chest and abdomen. *Bi* discs of descending sizes were placed on the body at locations perhaps deemed of lesser importance, such as the legs (15.2 to 16.0 cm in diameter) and feet (12.1 to 12.6 cm in diameter).

Another late Warring States period burial in Shandong province, the King of Shang's tomb number one at Linzhi, shows the orderly and deliberate placement of jade *bi* discs in relation to the corpse.[13] A total of 13 jade *bi* discs cover the upper body and head of the tomb occupant. The largest and most detailed jade *bi* disc (19.4 cm in diameter) was used to cover the skull. Two small jade *bi* discs were placed under the skull, and two were placed on the side of the head. Eight smaller *bi* discs were placed on the waist and pelvis area.[14] In a 2008 to 2009 excavation, ten jade *bi* discs (14–15.1 cm) were placed on and under the corpse of a late Warring States period noble buried in a small tomb at Xixin in Qingzhou, Shandong province.[15] Two jade discs were placed on the corpse, seven under the waist, and one under the skull. This example indicates that standardized *bi* disc burial, though practiced mainly among high elites, also included people of lower status in the Warring States period in Eastern China.

In addition to the rather uniform burial practices in Shangdong province during the Warring States period, a similar custom of using jade *bi* discs in burial is evident far to the South, near the coastal line in Guangdong province, during the early Western Han dynasty (206 BC–9 AD). In the burial of the King of Nanyue, dating to approximately the 3rd century BC, numerous jade *bi* were placed in the tomb (see table 3 for distribution of jade *bi* discs in this burial).[16] The corpse was not only surrounded by 19 jade *bi* discs extending from head to feet, but the body was entirely enclosed within a jade suit. Three layers of jade *bi* discs were placed in the King of Nanyue's tomb. Six *bi* discs were placed on top of the jade suit near both the abdomen and feet. Inside the jade suit were five beautiful, comparatively large *bi* discs placed under the corpse arranged from head to foot. Above the corpse, still within the suit, two smaller discs covered the ears and ten discs were found on the torso. Moreover, several elaborate and large jade *bi* discs were placed on the coffin (type I, 28.5–30.3 cm in diameter) and inside the coffin near the head (type I, 29.1–33.4 cm in diameter; type II, 25.0–28.5 cm in diameter) and feet (type II, 25.7–28.6 cm in diameter). Interestingly, 139 pottery *bi* discs were arranged in four columns and placed inside the coffin near the feet, perhaps serving as a substitute for precious nephrite *bi* discs. The large quantity of jade *bi* discs placed under, on, or near the corpse suggests a protective funerary function for the discs.

FIGURE 2. Tomb 23 from the Fanshan burial site. Neolithic period, Liangzhu culture (ca. 3300–ca. 2100 BC). Shaded objects composed of nephrite. After *Fanshan*, vol. 1, p. 300, fig. 243.

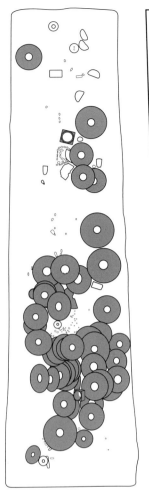

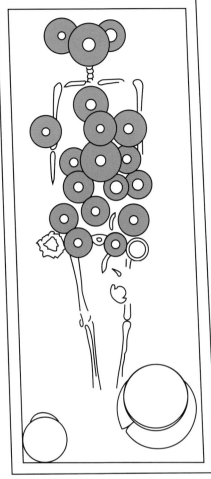

FIGURE 3. Tomb 58 from the State of Lu, Gucheng in Qufu, Shandong province. Early Warring States period (ca. 5th century BC). Shaded objects composed of nephrite. After *Qufu luguo gu cheng*, p. 31, fig. 82.

ORIGINS OF *BI* DISC BURIAL PRACTICES
ON CHINA'S EAST COAST

Surprisingly, the use of *bi* discs in high-ranking burials during the late Bronze Age (ca. 5th–ca. 2nd century BC) in Eastern China bears a close relationship to *bi* disc burial practices of the Liangzhu culture (ca. 3300–ca. 2100 BC) located in the area near the lower Yangzi River in Southeastern China and dating to the late Neolithic period, despite the chronological gap of nearly two millennia. Large nephrite discs with highly polished surfaces and varied colors, mainly of concentric form and undecorated, are characteristic of *bi* discs from this early date (catalog numbers 4 and 5).

Hundreds of jade *bi* discs were excavated from Neolithic Liangzhu burial sites such as those at Fanshan in Zhejiang province, Fuquanshan in Shanghai, and Zhanglingshan and Sidun in Jiangsu province.[17] An example of large quantity jade *bi* disc burial in the Liangzhu culture is tomb 23 at the Fanshan burial site. Fifty-four jade *bi* discs were densely placed on the body within the coffin (figure 2).[18] The two largest jade discs at tomb number three of the Sidun site (with a minimum diameter of 26.2 cm) were placed on the chest of the tomb occupant.[19] More than ten *bi* discs were placed on top of the body and several were placed underneath the body. Jade *cong* tubes surrounded the corpse.

The custom of placing large jade *bi* discs underneath the head of the corpse, such as at tomb one of the King of Shang in Linzhi, Shangdong province, can also be found in Hongshan culture sites in coastal Northeastern China.[20] Two discs of rectangular form with rounded corners were placed underneath the head of the tomb occupant at the Niuheliang burial site of the Hongshan culture (ca. 4500–ca. 3000 BC), along with a cloud-shaped jade pendant (similar to catalog number 1) placed on the chest.[21]

23

Confucian texts and practices were very likely related to the resurgence of large *bi* disc burials during the Warring States period in coastal Eastern China. The earliest example of large jade *bi* discs occurring in a late Bronze Age burial actually occurs in Qufu, Shandong province, the home of Confucius.[22] Numerous references to the ritual use of jade *bi* and *cong* occur in Confucian texts such as *The Rite of Zhou*, a ritual text compiled in the second century BC or earlier. For example, the chapter "*chunguan bazunbo*" in *The Rite of Zhou* claims, "Jade is used to produce six ritual objects for worshipping heaven and earth: Celadon *bi* are used to propitiate heaven, yellow *cong* are used for worshipping the earth."[23] "The motif of jade types *gui, zhang, bi, cong, hu,* and *huang*, with the connection of heaven and earth through *bi* and *cong*, are used in the burial of corpses."[24]

The association of heaven with the round *bi* disc and earth with the rectangular *cong* tube was established by approximately the second century BC and became the dominant interpretation of the two forms. Similarly, texts prescribing the use of jade *bi* discs occur in the late Warring States period and early Han dynasty.[25] The funerary application of jade *bi* discs recorded in texts of the Warring States period and Han dynasty corresponds to the period during which jade *bi* discs were widely distributed in high ranking burials along China's Eastern coastline.

The prehistoric Liangzhu culture obviously left no written records, so people of the Warring States period did not have access to the intended meaning of jade *bi* disc burials predating them by two thousand years. One striking similarity between burial practices on the Eastern coast of China in the Warring States period and the spectacular Neolithic burials of the lower Yangzi River region near Lake Tai is the use of a great quantity of large jade *bi* discs. Perhaps Warring States period knowledge of Liangzhu jades was based on the discovery of Neolithic burials. By coincidence, a middle Warring States tomb buried with typical Eastern Zhou jade *bi* discs was excavated in Fuquanshan in Shanghai, one of the important Liangzhu burial sites in the Lake Tai region. A large type II jade *bi* disc (19.2 cm) decorated with symmetrical zoomorphic masks and a type III small jade disc (5.6 cm) were placed around and flanking the skull, indicating a burial function.[26] It is presumed that the Confucian reinterpretation of the *bi, cong,* and *gui* (ritual tablets) revitalized the use of such objects in burial.

WARRING STATES PERIOD JADE *BI* DISCS IN EASTERN CHINA AND RELATED EXAMPLES

During the Warring States period, the size of jade *bi* discs differed between the larger stylized *bi* discs (approximately 15–30 cm in diameter) excavated in tombs in Eastern China and smaller discs or rings (less than 15 cm in diameter) in contemporaneous tombs located in inland areas. An example of inland disc burial is found at the tomb of the Marquis Yi of Zeng (d. 433 BC) in Hubei province which dates to the mid-fifth century BC (early Warring States period). Of the 67 jade *bi* discs found in the Marquis Yi of Zeng tomb, only three discs are of a large size (exceeding 15 cm in diameter).[27] The numerous small discs or rings were placed on and under the head and torso of the corpse.

The late third century BC (late Warring States period) tombs numbers two and eight at the Yanggong burial site in Changfeng, Anhui province demonstrates a specific *bi* disc burial pattern. Pairs of jade discs were placed next to the head and flanking the knees and under the pelvis, while a small *bi* disc (11.6–14 cm in diameter) was placed on the chest of the occupant of tomb number eight.[28] Of the 50 plus jade objects in the tomb covering the corpse in tomb number two, 36 are jade *bi* discs (11.8–16.5 cm in diameter).[29] The placement of numerous small jade *bi* discs or rings in the tombs cited above indicates a possible connection and extension of similar Neolithic burial practices in the Eastern China. The scarcity of large jade *bi* discs in inland China during the Warring States period, and relationship between jade *bi* disc burial practices in Eastern and inland China, requires further investigation.

CONCLUSION

Rather than adopting the shape and proportions of the larger-hole jade discs found in Northwestern China originating in the Neolithic Taosi (ca. 2400–ca. 1900 BC) and Qijia (ca. 2200–ca. 1800 BC) cultures (which possibly continue in part through the Shang and Western Zhou dynasties),[30] the stylized *bi* discs prevalent in the Warring States period and Western Han dynasty bear similarities in shape, size, and the placement in burial to the Neolithic Liangzhu culture jade *bi* discs of Southeastern China. As with Liangzhu culture burials, archaeological evidence shows that numerous large jade *bi* discs were placed in tombs of the elite in the Warring States period and Western Han dynasty. Warring States *bi* discs differ from Liangzhu examples as they are thinner and decorated with raised knob patterns that evolved from dragon imagery.[31]

In the Neolithic Liangzhu culture, jade *bi* discs were carefully and deliberately placed underneath and/or above the corpse, with the largest and highest quality jade discs usually placed on key areas of the body, such as the chest or abdomen. Similar burial practices appeared along the Eastern coastline in present-day Shangdong and Guangzhou provinces between the 5th and 2nd century BC, and are reminiscent of Neolithic Liangzhu burials in Zhejiang, Shanghai and Hangzhou.[32] This specific regional distribution suggests that the transmission of *bi* discs and related ritual practices occurred along the East Coast of China during the Age of Confucius (fifth to second century BC), and are linked to the Stone Age practices of the Liangzhu culture.

NOTES

1. Possibly the earliest excavated carved jade dates to approximately 5500 BC and was excavated from a burial site of the Hinlongwa culture (ca. 6100–5300 BC) in Liaoning province (Hinglongwa 1994, 1997).

2. On a bronze *bi* disc decorated on the coffin excavated from Wushan, Sichuan province, the two Chinese characters *tianmen* (meaning "heaven gate") were written on the gate directly above the motif of jade *bi* disc (Zhao Dianzeng 1990). Uses of "heaven gate" can be found in painted form, in jade carvings, and in other *bi* discs decorated on coffins of Chu tombs in the Warring States period and many tombs in the Han dynasty (Wu 1997, p. 24, fig. 15, 16).

3. For a discussion on mandates for the use of jade in specific rituals and jade's connection to cosmology, please see *Zhuangzi zhu* 1987 (reprinted), p. 160 and *Zhouli Zhushu* 1987 (reprinted), p. 377.

4. This article does not address the archaistic discs made in the Song, Ming and Qing dynasties.

5. Lu 2000, pp. 1550–1.

6. *Erya yishu* 1983 (reprinted), vol. 2, p. 704.

7. Rawson 1995, p. 130.

8. For discussion of the lower frequency of jade *bi* discs in burials during the intervening period of Shang and Western Zhou dynasties and early Eastern Zhou dynasty (Spring and Autumn period), see also footnote number 10 and 11.

9. The stylized *bi* discs excavated from high ranking tombs in the Warring States period in Eastern China and in the Han dynasty are categorized by and based on the methodology used in the archaeological report *Qufu luguo gucheng* (Qufu 1982, p. 130, 132).

10. For example, in 900 low ranking tombs in the West of Yinxu, only four jade discs were excavated. Only 16 jade discs were excavated among 775 pieces of jade in Lady Fu Hao's tomb, with the largest measuring 12.8 centimeters in diameter (Fuhao 1980, p. 118). Circular jades in the Western Zhou dynasty tend to be under 15 centimeters and have large apertures. Discs in this period did not play a dominant role among different types of jades used in burials, and are mainly found in small numbers in high ranking tombs. For example, while six jade discs and rings (10.1–12.8 cm) were found in tomb 2001 of the State of Guo, typically one or two discs are found in burial (Pingdingshan 1998: 9, fig. 4; Tianma-qucun 1994: 1, fig. 18-9; Sanmenxia 1999, vol. 1, pp. 132–3, fig. 108: 3-8, vol. 2, plate 47:5-6, plate 48: 1-4).

11. Jade *bi* discs or rings excavated from tombs of the early Spring and Autumn period tend to be plain, smaller in size, and are found in fewer numbers in burial compared to Warring States burial jades, such as tomb number 60 in Huixian, the tomb of Caihou, at Shouxian in Anhui province, and tomb number one and three of the Xiasi burial site in Henan province (Xichuan 1991, p. 235, fig 87:1). A sixth century BC tomb in Shaanxi, for example, contained eight jade *bi* discs, each smaller than eight centimeters in diameter (Yimencun 1993, p. 6, fig. 12, 14:1, plate 2: 1-3). Furthermore, only one jade *bi* disc with carved patterns in raised relief has been excavated in the Spring and Autumn period tombs, namely the tomb of Huang Junmeng at the Zhaojiahu burial site in Dangyang (Huang Junmeng 1984, p. 323, fig. 26:1). The scarcity of excavated large jade discs from the 8th to 6th centuries BC may be due in part to looting. However, the primary reason for the dearth of such objects is tied to prevailing burial practices.

12. Qufu 1982, pp. 128–32.

13. Linzi 1997, pp. 50–5.

14. Similar burial practice can be found in the King of Shang tomb number two (Linzi 1997, p. 14).

15. This tomb was disturbed before scientific excavation, however, the distribution of jade *bi* discs is still clear (Qingzhou 2010, pp. 27–32 and p. 30, fig. 8).

16. Nanyue 1991, vol. 1, pp. 149–59, 179–89.

17. Fanshan 2005; Liangzhu 1984a, pp. 1–5; Liangzhu 1984b, pp. 109–29; Liangzhu 1986, pp. 1–25.

18. Fanshan 2005, vol. 1, pp. 313–328.

19. Twenty-four jade discs were among 57 ritual jades buried in tomb number 3 of the Sidun site in Jiangsu province (Liangzhu 1984b, pp. 109–29, fig. 5).

20. Tomb number one of burial mound number one at the fifth location at the Niuheling site (Hongshan 2004, pp. 58–9, fig. 73).

21. For further discussion of the similar tomb number 52 of the State of Lu, see Qufu 1982, pp. 128–32.

22. See *Zhouli zhushu*, a note (pp. 127–220) and commentary (pp. 574–678) together with the original the *Rite of Zhou* (*Zhouli zhushu* 1987, p. 336).

23. In the *Rite of Zhou*, King Yingda (ca. 574–648) says, "*Bi* and *cong* are used in burials," (Ibid., p. 379).

24. A number of scholars use Warring States period and Han dynasty texts as a terminological and cultural explanation for Neolithic objects, despite the gap of thousands of years, and such interpretations distort our knowledge of the earliest era of jade in China.

25. Qinou 1986, 8, pp. 688–93 and p. 690, fig. 4.

26. This high ranking Chu tomb contained 115 discs or rings, including 67 jade rings, constituting the largest number of discs found in an Eastern Zhou dynasty tomb (Zenghou 1989, pp. 402–08). Furthermore, only two larger jade *bi* discs were found among the 23 jade *bi* discs found in tomb number ten of the Xujialing burial site (Xichuan 2004, pp. 318–24, color plate 74:2-3). In a Chu tomb dating to the 5th to 4th century BC in Changsha, Hubei province, one *bi* disc was placed near the head, and six *bi* discs were placed in tomb number 406 with pairs of discs placed flanking the head and the knee, the fifth disc placed in front of head, and the sixth in-between layers of the coffin behind the head.

27. Changfeng 1982, vol. 2, p. 50, fig. 3.

28. Ibid., p. 59, fig. 12.

29. For a discussion on the inherent relationship between the Neolithic period and the Shang and Western Zhou dynasties *bi* discs in Northwest China, see Yang Mei-li 1995, pp. 13–32.

30. For a discussion on the evolution of the dragon motif in the Zhou dynasty, see catalog number 29.

31. For details of the burial sites, see references in notes 12 to 19.

TABLE 1.

The distribution of jade *bi* discs in tomb number 52 of the State of Lu at Qufu, Shangdong province

	Head	Chest	Abdomen		Legs		Shank/Feet	
					Left	*Right*	*Left*	*Right*
Above the corpse/cm	19.9	18.9	31.0	31.1	19.0	19.0	16.0	17.0
Under the corpse/cm	–	–	32.8	29.8	17.7, 16.6	16.7	13.3	13.4
Type	II	II	I	I	III	III	III	III

TABLE 2.

The distribution of jade *bi* discs in tomb number 58 of the State of Lu at Qufu, Shangdong province

	Head	Chest		Abdomen		Legs		Shank/Feet
						Left	*Right*	
Diameter/cm	14.6	16.6	22.5	27.7	22.2	24.3	15.2–16.0	12.1–12.6
Type	III	III	II	II	III	II	III	III

TABLE 3.

The distribution of jade *bi* discs in the tomb of King of Nanyue

	Head	Chest	Abdomen	Legs	Shank/Feet
Above the jade suit/cm	–	–	6		–
Type	–	–	II, III		–
Inside the jade suit/cm	29.0	23.0, 14.0, 14.0, 15.8, 15.3	17.0, 15.3	14.2, 14.3	–
Type	III	III	III	III	–
Under the jade suit/cm	26.7	26.7	25.6		25.7, 25.7
Type	II	II	II		II

JADE OBJECTS IN THE JIA AND YI TOMBS IN LIULIGE, HUIXIAN, HENAN PROVINCE

Lin Shwu Shin

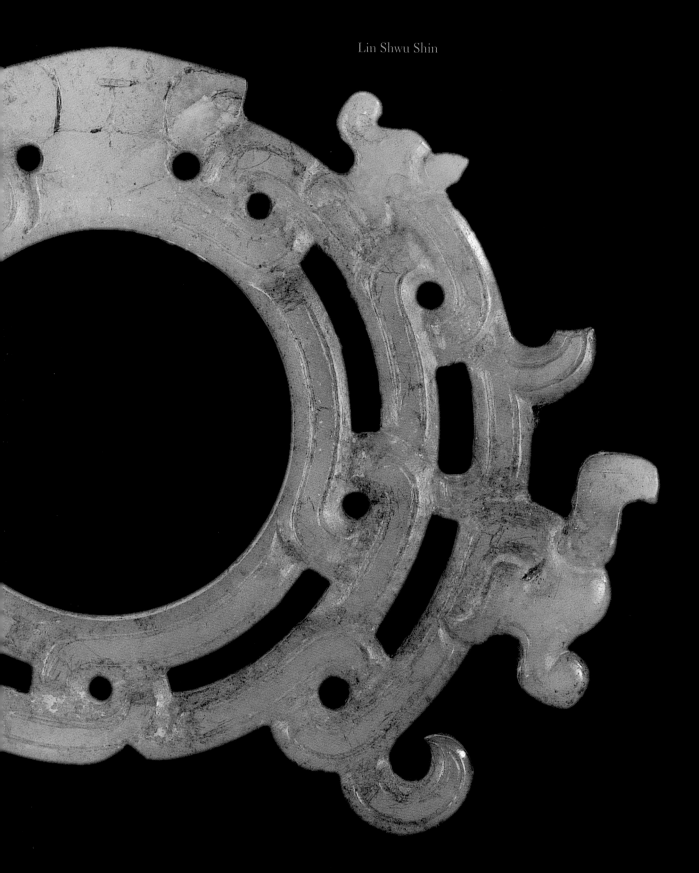

Since establishment in 1956, the National Museum of History, Taiwan has collected Chinese jade from time periods throughout Chinese history. The collection of the Museum includes jade *bi* discs[1] and *cong* tubes of the prehistoric Hongshan and Liangzhu cultures, flanged jade rings and blades of the Shang and Zhou dynasties, jade pendants in various shapes of the Spring and Autumn and Warring States periods, burial jades and adornments of the Imperial Han, Tang and Song dynasties, jade carvings of the Yuan and Ming dynasties, and jadeite ornaments of the Qing dynasty. A highlight of the later jades is a set of nine *ruyi* scepters, which are thought to have been given in tribute to Qing Emperor Qianlong (r. 1735–1796) by a delegation from Vietnam (see catalog numbers 69 and 70).

The large and well-classified collection of Chinese jade is one of the highlights of the National Museum of History, Taiwan. The sources of the collection vary, including handed-over antiquities by the government, private donations, and Museum acquisitions. The jade objects which form the subject of this essay, however, are archaeologically unearthed jades from the Jia and Yi tombs in Liulige, Huixian in Henan province (see catalog numbers 20, 28, 29, 30, 31, 32, and 33). The burials, dating to the Spring and Autumn period (770–476 BC), were originally kept in the Henan Provincial Museum and later transferred to the National Museum of History in Taipei when the government moved to Taiwan in 1949. The transfer of these cultural relics during war time was extremely dramatic. The following gives a brief account of the jades unearthed from the Jia and Yi tombs in Liulige.

In August of 1936, a farmer reported to the provincial government the find of an ancient bronze tripod in the southern suburbs of Huixian, north of Liulige. An excavation by the Henan Provincial Museum was launched at the location on September 4 of that year. Xu Jingshen, who was then a Research Fellow of the Henan Provincial Museum, was appointed as the head of the excavation. A tomb was recovered and named the Jia tomb. Bronze, pottery, and jade were unearthed from the tomb. During the excavation, another tomb, which was named the Yi tomb, was revealed. The excavation of the Yi tomb, assisted by Guo Yucai, started on October 26 and excavation of both tombs was completed on November 15, 1936.[2] The unearthed objects were handed to the Henan Provincial Museum the following day. The jades unearthed from these two tombs were transferred to Taiwan because of the war and handed over to the National Museum of History of Taiwan by the cultural relic guards of the Henan Provincial Association in Taiwan. Jade artifacts unearthed from the Jia and Yi tombs in Huixian have been well preserved in Taipei since that time. Most of the original archaeological records of the excavation, however, were lost near Wuhan during the transportation of the objects and, therefore, full and formal excavation reports have not been published.

In 2003 the Henan Provincial Museum and the National Museum of History, Taiwan cooperated on research of the Jia and Yi tombs. Unearthed objects that were separately preserved in Mainland China and Taiwan were united for research. By consulting historical documents and reviewing the remaining records of the excavation and museum journals of the time, research provided greater insights on the site.[3] The joint-research project culminated in a catalog and exhibition on the Jia and Yi tombs.[4] The publication of the unearthed objects and related information provides important source material for future studies of Eastern Zhou history and jade from China's Central Plain.

The excavation of the Jia and Yi tombs in Liulige was first widely published by Guo Baojun in his serialized book *The Shanbiao Town and Liulige*, based upon the preliminary report published in the Museum Journal of the Henan Provincial Museum.[5] In the book,[6] Guo Baojun made a record of the excavation as follows:

> "The two tombs excavated by the Henan Provincial Museum are located northeast to and 120 meters away from the tomb M55 . . . The tomb Jia is 11 meters in length in the west-east orientation, approximately 10.3 meters wide

north-south, with a depth over 11 meters . . . the outer coffin was made of cypress . . . composed with over 80 slats. With the upright rectangular rammed tomb pit, it formed a burial in the early form of 'ticou'[7] . . . sacrificial and funerary goods, including bronzes and jades, were placed surrounding the tomb occupant . . . there were a large number of jades found beside the tomb occupant."

Guo Baojun continues: "The Yi tomb was also a pit tomb in west-east orientation, located north of and 3 to 4 meters away from the Jia tomb. The outer coffin was also made of cypress . . . however the coffin top was built by wooden slats in rows, not in columns as in the Jia tomb . . . the coffin was also filled with bronzes and jades, but not as richly as in the Jia tomb."[8]

According to this record, both the Jia and Yi tombs were built in close proximity and oriented in the same direction, and both tombs are of the *ticou* type. The Jia and Yi tombs may be a joint burial of a couple divided into individual pits. The specific relationship between the two tomb occupants requires further research.[9]

During the Western Zhou dynasty (1045–771 BC), Huixian was a part of the State of Gong, and in the Spring and Autumn period it was part of the state of Wei. Located in present day Henan province and to the south of the Taixing Mountains, the area of Huixian was traditionally granted by descendant to the royal Zhou family and was therefore a place of political importance. Strategically, Huixian served as a buffer to the Zhou capital area.[10] In the Spring and Autumn period, the Wei state was located among the large states of Qi, Jin, and Chu and was therefore at the center of frequent warfare between rival states.

The burial system of the Zhou, as specified in the *Book of Zhou*,[11] was also practiced in vassal states, such as the state of Wei. Some researchers believe the west-east directional orientation of the Zhou cemeteries, with entrances usually towards the west, may have held special significance for the Zhou people as they originated from the West.[12] If such an argument holds, the arrangement of the Liulige cemetery would suggest the occupants of the Jia and Yi tombs were of very high rank. The sets of fine bronzes unearthed from the tombs and a large-scale subordinate chariot pit nearby, which has been revealed by site survey but not yet excavated, also suggests that the Jia and Yi tomb occupants were of high rank.[13] The tomb occupants may have held elite status equivalent to that of a duke of the state. Unfortunately the loss of initial excavation information limits our understanding of the specific identity of the tomb occupants.

The burial pattern of the Jia and Yi tombs shows similarities to the burials at major Zhou sites and the continuation of the Zhou tradition. The inclusion of funerary objects of diverse materials in the Jia and Yi tombs, such as shell, bone, bronze, jade, gold, carnelian, and turquoise, differ from later noble burials, which feature the early phase of the formal use of jade in sets. In the mid-late Spring and Autumn period, jade was increasingly used for everyday objects rather than limited to just highly ritualized

FIGURE 1

Pair of Earrings, *jue*, Eastern Zhou dynasty, Spring and Autumn period (770–476 BC) Jia Tomb, Huixian, Henan Province National Museum of History, Taiwan, h0000234

FIGURE 2

Ceremonial Tablet, *gui*, Eastern Zhou dynasty, Spring and Autumn period (770–476 BC) Yi Tomb, Huixian, Henan Province National Museum of History, Taiwan, h0000204

objects such as those described in the *Rites of Zhou*.[14] The jade articles found within the Jia and Yi tombs are consistent with this trend of using jade in daily life, for example, a pair of outstanding *jue* earrings (see figure 1 and catalog number 32). Unlike the Jia tomb, the Yi tomb contained no jade pendant sets, though numerous jade ceremonial tablets, including a heavily weathered, undecorated *gui* (see figure 2), were recovered.

The Jia and Yi tomb jades are representative of jades crafted in the Central Plain. The state of Wei is located at the core of the Central Plain area allowing for access to an adequate jade supply. Jade of great quality, such as Hetian jade (Xinjiang Province) and Dushan jade (Henan Province), was widely used in the Wei state. Very high quality jade was used for the objects in the Jia and Yi tombs. The characteristic motifs found on jades of the Central Plain includes a wide variety of dragon patterns, cloud patterns and quill patterns (see figure 3 and catalog numbers 33 and 34). These designs also figure prominently on the jades from the Jia and Yi tombs. Some of the jades show the mature combination of various carving techniques such as openwork, relief carving, and incising. Jades from the Jia and Yi tombs constitute the highest quality jades made in the Central Plain during the late Spring and Autumn period.

The Jia and Yi tomb jades also show evidence of stylistic characteristics of the late Spring and Autumn period. The jades are decorated with dragon heads and bodies which are usually separated by other patterns, such as engraved lines. The dragon heads usually feature a curled nose, and a closed or open mouth often represented by a hole. Eyes appear in round or oval shape. The lower jaws of the dragons are sometimes represented by a circular arc, and horns and ears are in the shapes of cloud scrolls. Belt-like quill patterns often appear on the horns and around the mouth. The dragon bodies are usually decorated with low relief scales and cloud patterns, with quill patterns sometimes evident. On rare examples, patterns are outlined with a border represented by incised parallel lines. The dragon patterns show a tendency over time to evolve from easily identifiable representations to extremely abstract or deconstructed designs.

In general, the dragon patterns on jades unearthed from the Jia and Yi tombs, though carrying on some characteristics from the mid Spring and Autumn period, also include coiled serpent designs, cloud scroll patterns with round hooks and other subsidiary elements such as engraved quill patterns and cord patterns, all of which were prevalent designs during the late Spring and Autumn period and indicate a date from this period.[15] The precise lower date of the tombs, however, is not clearly indicated by unearthed jades as styles and décor evolve over lengthy periods of time.

Some jades from the Jia and Yi tombs date to an early period. For example, a jade bird (see catalog number 20), hilt-shaped ornament (NMH h0000223) and *huang* (NMH h0000247) all clearly date to the Shang or Western Zhou dynasties. These objects may have been collected and preserved from an earlier period, perhaps by the tomb occupants or their families. According to textual records, some Shang jade was distributed to relatives of the royal Zhou family as war trophies after the Zhou took over from the Shang.[16] It is therefore not surprising that jades from the Shang dynasty appear in the Jia and Yi tombs, whose occupants were likely descendants of the royal Zhou family and the rulers of the Wei state.[17] Furthermore, jade objects move from place to place as gifts, awards, tribute, or are exchanged in marriage. Such occurrences increase the difficulty in determining the precise origin and date of even excavated jades.

The jade objects from the Jia and Yi tombs reveal a close relationship to other burial sites on the Central Plain.[18] Preliminary conclusions drawn from comparison of jade objects from these related sites suggests that the date of the Jia and Yi tombs is between the late phase of mid Spring and Autumn period or the early phase of late Spring and Autumn period, likely during the 6th century BC.[19]

This paper attempts to provide context and information about the outstanding jade objects unearthed at the Jia and Yi tombs, and to address related questions that deserve further discussion. It is the author's expectation that further research from different perspectives will help us achieve a better understanding of the Jia and Yi tombs and their position in Eastern Zhou burial systems.

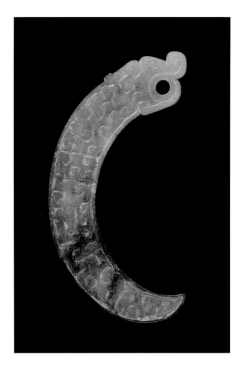

FIGURE 3
Dragon-shaped Pendant
Eastern Zhou dynasty, Spring & Autumn period
(770–476 BC)
Jia Tomb, Huixian, Henan Province
National Museum of History, Taiwan, 89-00051

NOTES

1. A flat disc with a circular hole in the center, see catalog number 4.

2. Zhao xishi. *Museum Journal*, Henan: Henan Provincial Museum, 1938, no. 13.

3. Information provided directly by Mr. Zhang Keming, who was a member of the Henan Provincial Association in Taiwan and helped escort the artifacts to Taiwan and also aided in research.

4. Guoli lishi bowuguan (National Museum of History, Taiwan) and Henan bowuguan. *Guibao zhongxian: Huixian liulige jia yi mu qiwu tuji (Re-exploring Treasures: Artifacts from the Jia and Yi Tombs of Huixian)*, Taiwan: Guoli lishi bouwuguan, 2005.

5. The 11 essays about the Jia and Yi tombs by Xu Jingshen and Guo Yucai were serialized in volumes 6 through 13 of the Henan Provincial Museum's *Museum Journal*.

6. Yangjianfang. "Guancang henan zhoumu chutu guyu," *Zhongguo guyu yanjiu luwenji, Zhongzhi meishu chubanshe*, 2001, p. 209.

7. Burials with squared frames of cypress.

8. Yangjianfang. "Guancang henan zhoumu chutu guyu," *Zhongguo guyu yanjiuluwenji, Zhongzhi meishuchubanshe*, 2001, p. 204–6.

9. Yiqun. *Huanghe zhongxia youdiqu de dongzhou muzang zhidui*, Shehui kexue wenxian chubanshe, 2001.

10. Chenpan. *Chunqiu dashi biaozhuanyi*, Zhongyanyuan lishi yuyuan, Yanjiusuo, 1969, vol. 1, 4.

11. "Shisan jing zhushu," *Zhouli zhushu*, Zhonghua shuju, 1980, juan ershier.

12. Zhongguo kexue yuan kaogu, yanjiusuo bianzhu, "Shangcunling guoguo mudi," Kexue chubanshe, 1959.

13. Zhongguo kexue yuan kaogu yanjiusuo li xi fajue dui. "1967 nian changan zhang jiapo xizhou mu de fajue," Kaogu xuebao, 1980, 4.

14. Sun Ji. "Zhoudai de zuyupei," Wenwu, 1998, 4, 15; Yangjianfang, "Chunqiu yuqi jiqifenqi," *Zhongguo guyu yanjiu lunwenji*, Zhongzhi meishu chubanshe, 2001, 2.

15. Yangjianfang. "Chunqiu yuqi jiqifenqi," *Zhongguo guyu yanjiu lunweji*, Zhongzhi meishuchubanshe, 2001, 2.

16. Zhongguo kexue yuan kaogu yanjiusuo bianzhu. "Laoyang zhongzhou luxi gongduan," Kexue chubanshe, 1959.

17. Yangjianfang. "Chunqiu yuqi jiqifenqi," *Zhongguo guyu yanjiu lunweji*, Zhongzhi meishuchubanshe, 2001, 2.

18. Relics from the Jia and Yi tombs show particular correspondence to the following burials: Tombs M115 and M412 in Zhongzhoulu, Luoyang and the Spring and Autumn period tomb in Xigonduan, Henan province (Zhongguo kexueyuan kaogu yanjiusuo bianzhu. "Luyang zhongzhoulu xigongduan," Kexue chubanshe, 1959.); the tombs M55, M80, and M60 in Liulige (Guobaojun. "Shanbiao zhenyu liulige," Kexue chubanshe, Sept., 1959.); the Spring and Autumn period tomb in Lijiacun, Xinzheng (Henansheng wenwu yanjiusuo xinzheng gongzuo zhan. "Henan xinzhengxian lijiacun faxian chunqiu mu," Kaogu, Aug. 1983.); the Guo State tombs in Sanmenxia (Henansheng wenwu kaogu yanjiusuo, sanmenxia shi wenwu gongzuo dui. "Sanmenxia guoguo mu," Wewu chubanshe, Dec. 1999, 1.); tomb M1 in Xiasi, Xichuan in Henan province (Henansheng danjiang shuikuqu wenwu fajue dui. "Henansheng xichuanxian, xiasi, chunqiu chumu," Wenwu chubanshe, Oct. 1980.); tomb M270 in Fenshuiling, Changzhi in Shanxi province (Shanxisheng wenwu gongzuo weiyuanhui jin dongdan gongzuozu. "Changzhi fenshuiling 269, 270 hao dongzhoumu," Kaogu xuebao 1974, 2); the tombs of the Marquis of Jin in Qucun and Tianma, Quwuo in Shanxi province (Beijing daxue kaogu xuexi, Shanxisheng kaogu yanjiusuo. "Tianma qucun yizhi beizhao jinzhou mudi di er, san, wu ci fajue," Wenwu 1994, 1, 8, and 1995, 5.) the Spring and Autumn period tombs in Zhenshan, Wuxian and the bronze hoard in Yanshan, Jiangsu province (Wuxian wenwu guanliwei yuanhui. "Jiangsu wu xian yanshan jiaocang yuqi," Wenwu 1988, 11.).

19. The tombs Jia and Yi have shown features which are later than the Guo State tombs in Shangcunling, Sanmenxia burials, and the tombs of the Huang Junmeng couple, though of earlier date than tomb M60 in Liulige, Huixian.

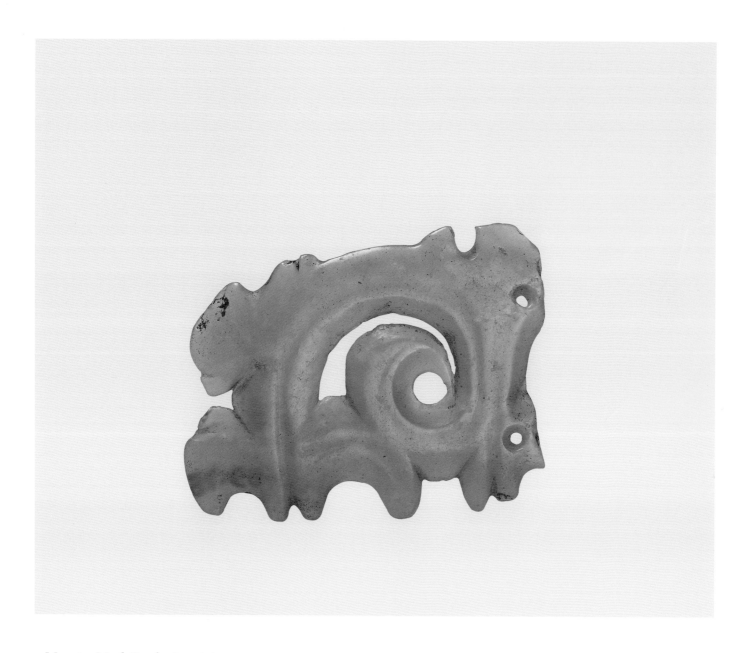

1. **Monster Mask Pendant**, Neolithic period, Hongshan culture (ca. 4500–ca. 3000 BC);
Nephrite; H 1¾ × W 2³⁄₁₆ × D ⅛ INCHES (4.4 × 5.6 × 0.3 CM); National Museum of History, Taiwan,
89-00028

This rare translucent, pale celadon-green jade is a fragment of a known type of
monster mask made in the Hongshan culture in Northeastern China. The object is
well polished with thin beveled edges. Two small holes appear on the right edge and
a groove runs along the openwork carving in the center of the jade. Two features
confirm that this asymmetrical, abstract-form jade is a fragment. First, two biconical
drilling holes are present near the uneven, broken edge on the right. These holes
were used to attach the fragment back onto the original object. An excavated example
of a similarly rejoined jade was found in tomb number 14 of Niuheliang burial site.[1]
Second, a number of published examples indicate that jades of this design represent
symmetrical monster masks.[2] The arch in the center of the fragment encircles an eye
of the fantastic creature. The notches pointing downward represent the creature's
teeth. This handsome pendant, when joined with the missing right half of the object,
would form a symmetrical zoomorphic mask. —CLP

1. Wenwu 1986, 8, p. 12.

2. For example, a monster mask jade pendant was
excavated from tomb number 27, the second burial
site at Niuheliang at Chaoyang, Liaoning province
(Hebei 1993, vol. 1, p. 12, plate 14).

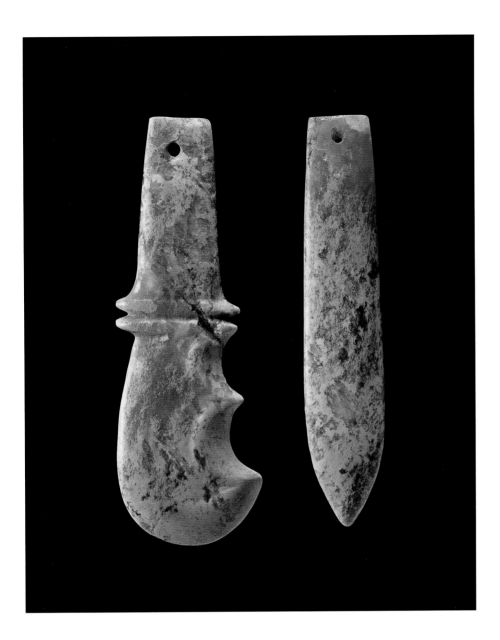

2. *Two Dagger-like Pendants*, Neolithic period, Hongshan culture (ca. 4500–ca. 3000 BC);
Nephrite; Left: H 4⁵⁄₁₆ × W 1⁹⁄₁₆ × D ⁵⁄₁₆ INCHES (11.0 × 4.0 × 0.8 CM); Right: H 4 × W ⅞ × D ⁵⁄₁₆ INCHES
(10.2 × 2.2 × 0.8 CM); National Museum of History, Taiwan, 89-00031

Two pendants are composed of partially translucent yellow and light green jade with
extensive opaque white alterations. The highly polished and glossy surface indicates
the dagger-shaped pendants were intended for ornamental or ritual use rather than
as utilitarian objects. These two dagger-like fragments are similar in length and
feature a hole in the top center of each pendant. The sickle-like pendant illustrated
on the left is divided by two rings with a trapezoidal tang above and a curvilinear
cutting edge below. A shallow depression appears on both sides of the lower section
of the pendant, with one edge formed by two arches. The right pendant is in the form
of an elongated dagger narrowing to a tip. The similarity of the material and surface
coloration suggests that both pendants were carved from the same boulder of jade and
placed within close proximity in burial. Similar pendants with curvilinear cutting
edges can be found in other Hongshan tombs,[1] and, a thousand years later, are
present in the Shang dynasty tomb of Lady Fuhao.[2] —CLP

1. Dadianzi 1996, pp. 1–5, fig. 208.

2. Fuhao 1980, pp. 194–5, fig. 5, 6, plate 164: 1,
no. 964.

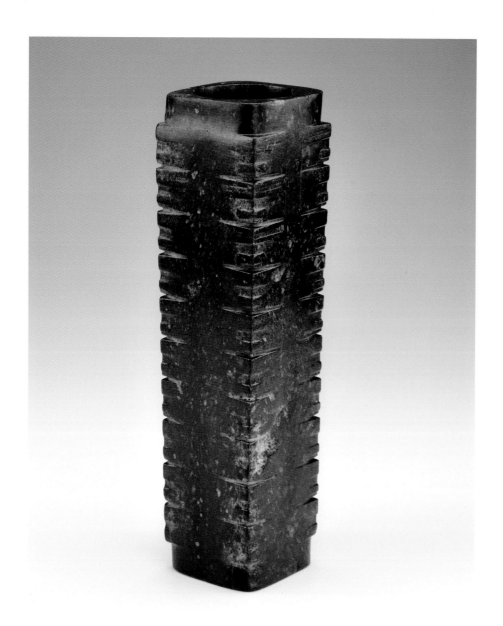

3. *Tube, cong*; Neolithic period, Liangzhu culture, ca. 3300–ca. 2100 BC; Nephrite;
H 11⁷⁄₁₆ × W 3⅛ × D 3¹⁄₁₆ INCHES (29.1 × 7.9 × 7.7 CM); Arthur M. Sackler Gallery, Smithsonian
Institution, Washington, D.C.: Gift of Arthur M. Sackler, S1987.887

This squared hollow cylinder with narrow projecting collars at each corner, known as a *cong*, is one of the most characteristic jade shapes in China. *Cong* first appear in the Liangzhu culture of the Neolithic period in the lower Yangzi river region. This exceptionally tall *cong* is composed of blackish-brown jade mottled with yellowish-white areas. The interior of the tube is carved into regular cylindrical form. The *cong* cylinder tapers from unadorned rectangular lip to similar foot. This *cong* is divided into ten distinct horizontal registers. Two layers of abstract zoomorphic mask imagery are located at the corners of each of the ten sections. The zoomorphic masks are delineated by striated lines representing a headdress, two circular eyes, and a line in raised relief representing a mouth. Like the related *bi* discs, jade *cong* appear across thousands of years of Chinese art history. The large number of *cong* tubes, *bi* discs, and *yue* axe heads appearing in burial sites, such as Sidun tomb number three dating to the Liangzhu culture, confirms the ceremonial and funerary function for such objects.[1]

— CLP

1. Liangzhu 1990, p. 4, fig. 4.

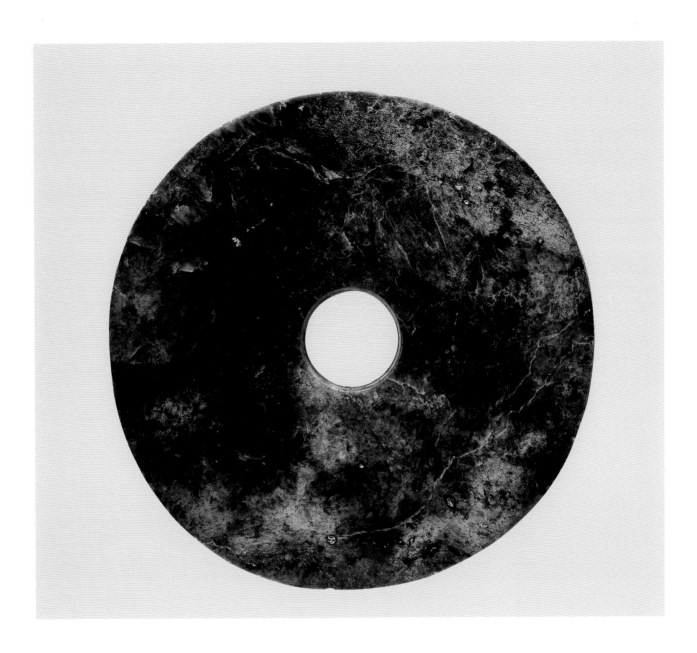

4. **Disc**, *bi*; Neolithic period, Liangzhu culture (ca. 3300–ca. 2100 BC); Nephrite; DIAM 9 × D ⅜ INCHES (22.9 × 1.0 CM); National Museum of History, Taiwan, 91-00087

With iridescent patches of green and tan on one side and tinged with mottled green and brown on the other, this unusually large and beautiful disc also features cream-colored areas of discoloration scattered on the surface of the jade. This disc of the "*bi*" type is one of the most characteristic jade shapes found in the Neolithic Liangzhu culture in Southeastern China. The disc is evenly rounded with a slightly off-center hole. Cutting marks and wide shallow grooves are apparent on both sides of the disc and an obvious slice mark is visible on the thinnest area of the rim.

Liangzhu jade *bi* discs are ceremonial and burial implements. The ritual practice of using large numbers of *bi* discs to cover the entire body of the deceased is evident in Liangzhu burials, as seen for example in Fanshan tomb number 14 in Zhejiang province,[1] and was revived 2,000 years later in the burial practices of the late Eastern Zhou and Western Han dynasties.[2] — CLP

1. Fanshan 2005, vol. 1, p. 300, fig. 243; Ibid., vol. 2, p. 337, fig. 1075.

2. For further discussion on *bi* discs, please see Chan Lai Pik's article in this catalog.

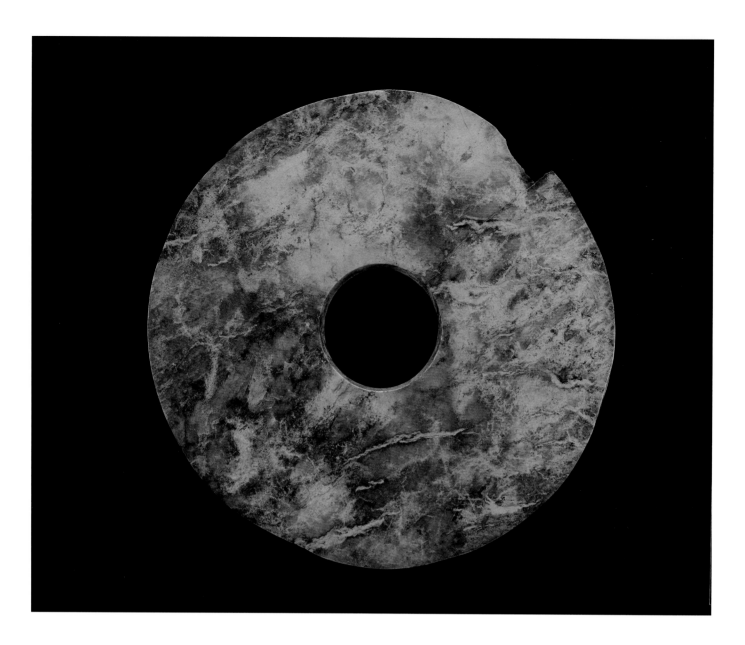

5. **Disc,** *bi*; Neolithic period, Liangzhu culture (ca. 3300–ca. 2100 BC); Nephrite; DIAM 6¾ × D ⅜ INCHES (17.1 × 1.0 CM); National Museum of History, Taiwan, 8367

This richly colored jade disc features areas of mottled yellow, gold, and tan with veins of discoloration following lines of cleavage in the material.[1] This *bi* disc is rather thick and unevenly rounded with one chip on the rim. The biconical hole is slightly off-center, and the inner ridge is polished. One side of the disc is lighter in color and less encrusted while the reverse (pictured) has a rougher surface with significant areas of cream-colored discoloration and short, horizontal whitish veins. As with catalog number four, this object is a fine example of Liangzhu jade *bi* discs and illustrates the diverse colors of nephrite jade.
— CLP

1. Previously published in *Jade: A Traditional Chinese Symbol of Nobility and Character* (*Yu: Zhongguo chuantong meide de xiangzheng*, Taipei: National Museum of History, Taiwan, 1990).

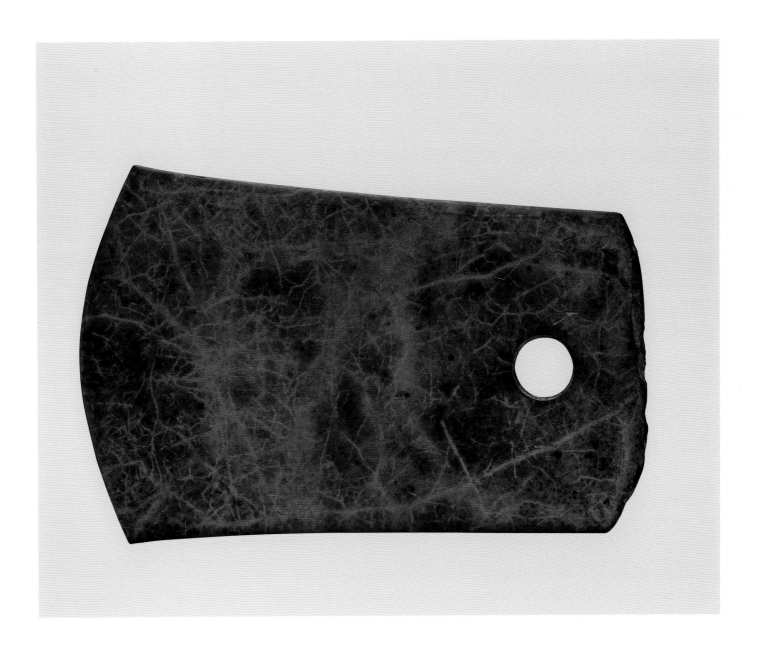

6. *Axe Head, yue*; Neolithic period, Liangzhu culture (ca. 3300–ca. 2100 BC); Nephrite;
H 5⅛ × W 7⅞ × D ¼ INCHES (13.0 × 20.0 × 0.6 CM); National Museum of History, Taiwan, 7091

The axe head is composed of opaque gray jade with an extensive network of discol-ored veins. The highly polished, slightly-flared trapezoidal jade has a large conical hole near the base. The hole was drilled from two sides with a ridge visible inside the aperture. This is the typical hole-drilling method for Liangzhu jades. The beveled and rounded cutting edge is quite thin and sharp. The shape of this ceremonial axe head is based on functional stone tools of the period. Liangzhu burials include *yue* axe heads of this type along with *bi* discs and *cong* tubes. Similar examples can be found in tomb number 139 of the Fuquanshan burial site at Qingbu in Shanghai.[1]

— CLP

1. Liangzhu 1989, p. 5, fig. 55.

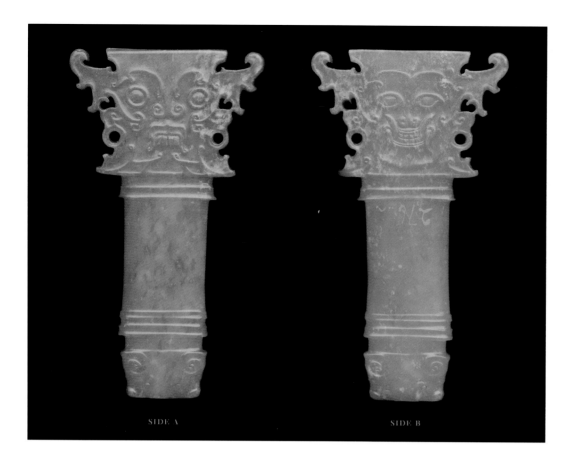

SIDE A SIDE B

7. **Monster Mask Plaque**; Neolithic period, Longshan culture, ca. 2600–ca. 2200 BC; Nephrite;
H 3⅛ × W 1¾ × D ¼ INCHES (7.9 × 4.5 × 0.7 CM); Long-term loan from the Smithsonian American
Art Museum; gift of John Gellatly, courtesy of Arthur M. Sackler Gallery, Smithsonian Institution,
Washington, D.C., LTS1985.1.276.2

Translucent olive-green jade is carved as a plaque bearing a monster mask on each side. A simplified bear head appears on both sides of the object near the base. While the monster masks vary, the two bear heads are nearly identical. The décor appearing on the plaques is delineated with raised lines.

The monsters appear intense and threatening. One monster mask (side A) features round eyes, pierced ears, fangs extending from the lower jaw, and a large nose with flaring nostrils. On the reverse (side B), the monster is shown with almond-shaped eyes, similarly pierced ears, smaller nose, and two pairs of fangs extending from both the upper and lower jaws. The monsters appear to wear a headdress. The openwork carving, created by drilling, is ingeniously shared by the designs on each side of the plaque. A channel is drilled vertically through the plaque, tapering from top to base.

Jade creatures with similar monster imagery were excavated from Neolithic Longshan and Shijiahe (ca. 2600–ca. 1900 BC) sites, as well as from Shang (ca. 1600–1046 BC) and Western Zhou (1046–771 BC) dynasty tombs.[1] Interestingly, very similar bear-head jade imagery appears on jade objects discovered at a Shijiahe site in the Yangzi river region.[2] The raised curving lines apparent on this plaque also resemble the raised lines decorating Shijiahe objects, such as the cylindrical bird (catalog number 8). This important jade plaque is the only known example that combines monster masks characteristic of Longshan culture with the Shijiahe-style bear imagery and curving raised lines, thus demonstrating the artistic and technical connection between the Longshan culture in Northern China and the Shijiahe culture to the South. —CLP

1. For Longshan and Shijiahe jade images, see Gu 2005, vol. 10, pp. 7–9. For a discussion of related Shang and Zhou imagery, such as examples from a Shang tomb at Xingan in Dayangzhou, Jiangxi province and Zhou examples from Xian, see Sun Hua 1992, fig. 4 and Zhang Changshou 1987, fig. 3, respectively.

2. Gu 2005, vol. 10, pp. 7, 9.

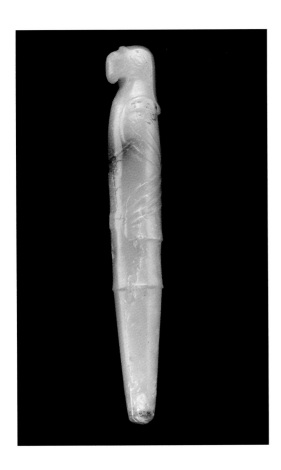

8. **Bird-shaped Handle**; Late Neolithic period, Shijiahe culture (ca. 2600–ca. 1900 BC); Nephrite; H 4⅛ × W ⅝ × D ⅝ INCHES (10.4 × 1.6 × 1.6 CM); Arthur M. Sackler Gallery, Smithsonian Institution, Washington, D.C.: Gift of Arthur M. Sackler, s1987.930

The yellowish jade bird with reddish-orange markings is characteristic of bird images from the Neolithic Shijiahe culture. The jade bird is standing upright and carved in a cylindrical shape narrowing to a point. The bird has a large hooked beak and the eyes are outlined with raised double lines. The cylinder is carved to show the contours of the neck. Wings on the lateral sides are adorned with lines extending from comma-shaped spirals, a common motif found on Shijiahe jades. A conical hole of approximately one centimeter in depth was drilled from the top of the head of the bird, and another hole runs through the legs transversally. This tapering finial may have been inspired by the awl-shaped pendants of the Liangzhu culture (ca. 3300–ca. 2100 BC) where the holes are located at the top of the pendants for suspension.[1] The tapered shape of the object may have been intended to allow the figure to be inserted into a base. The function of this object remains a matter of speculation. Bird pendants of this type were unearthed in the Neolithic Shijiahe culture and were also widely distributed in the Bronze Age.[2] Such images were passed down over many generations and can even be found in tombs from the late Bronze Age, such as at the late Shang dynasty tomb of Lady Fuhao.[3] — CLP

1. Hebei 1993, vol. 1, p. 167, fig. 239; Rawson 1995, pp. 202–3.

2. Gu 2005, vol. 10, p. 15, 21, 31, 36.

3. Fuhao 1980, fig. 162: 2, no. 942; see also an example excavated from a Shang burial site at Fengtangcun in Huaiyang, Henan province (Gu 2005, vol. 5, p. 112).

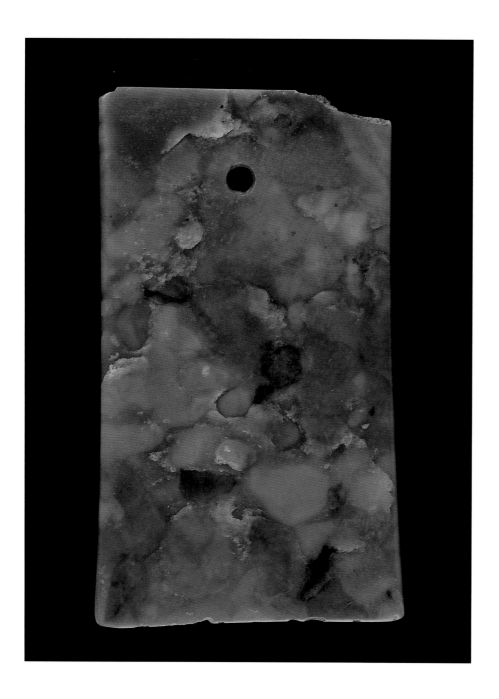

9. *Axe Head, yue*; Late Neolithic period, ca. 2000 BC; Nephrite; H 7¹⁄₁₆ × W 4¼ × D ¼ INCHES (17.9 × 10.6 × 0.5 CM); National Museum of History, Taiwan, 89-00034

This trapezoidal axe head has slightly flaring lateral edges and a wide beveled cutting edge. The hole used for affixing the axe head to a handle was drilled from one side. The surface of the axe head is highly polished resulting in a glassy sheen. The semi-translucent stone is highly variegated with puddingstone-like areas of gray, green, black, and tan. This ceremonial axe is based on utilitarian stone axes of the period. The preciousness of the material, the highly polished surface, and the tendency of jade to fracture and chip suggests that this axe functioned as a ritual object rather than as an everyday stone tool. —CLP

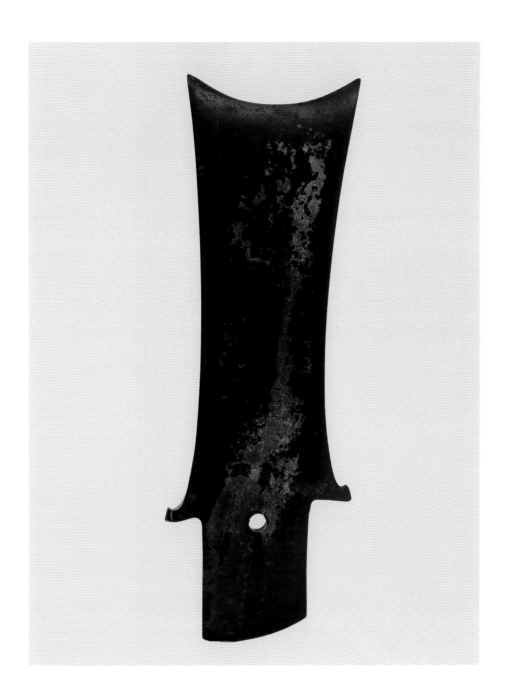

10. *Ceremonial Blade, zhang*; Late Neolithic period, Qijia culture or Erlitou period, ca. 2000–ca. 1600 BC; Nephrite; H 3⅛ × W 1¾ × D ¼ INCHES (7.9 × 4.4 × 0.6 CM); San Antonio Museum of Art, 2009.8.1

Greenish-black jade is carved into the shape of a *zhang* blade.[1] The concave cutting area tapers to a uniform beveled edge which remains sharp. Two notches extend laterally from above the tang. Beige areas of accretion resulting from burial adhere to the surface of the blade. The distinctive *zhang* blade shape first appears in the third millennia BC, likely in Shandong or Shaanxi provinces.[2] Blades of this general shape have been found at archaeological sites throughout China, though cutting edge, tang, perforations, notches, and incising are among many points of variation.[3] This *zhang* is similar to a blade found on the top of a corpse in an Erlitou period (ca. 1850–ca. 1560 BC) burial in Henan province.[4] Carved images from Guangdong province and elsewhere indicate that the blades were held in an upright manner as pictured,[5] though the hole in the center of the tang suggests the ceremonial blade could also be affixed to a handle.
—JJ

1. Formerly in the Arthur M. Sackler Collection.

2. Related examples can be found in Shimao site of Shennu, Shaanxi province (Gu 2005, vol.14, pp. 17–9).

3. Rawson 1995, pp. 188–191.

4. Kaogu 1983, 3, pp. 199–219.

5. Hong Kong, 199, figs. 13 16.

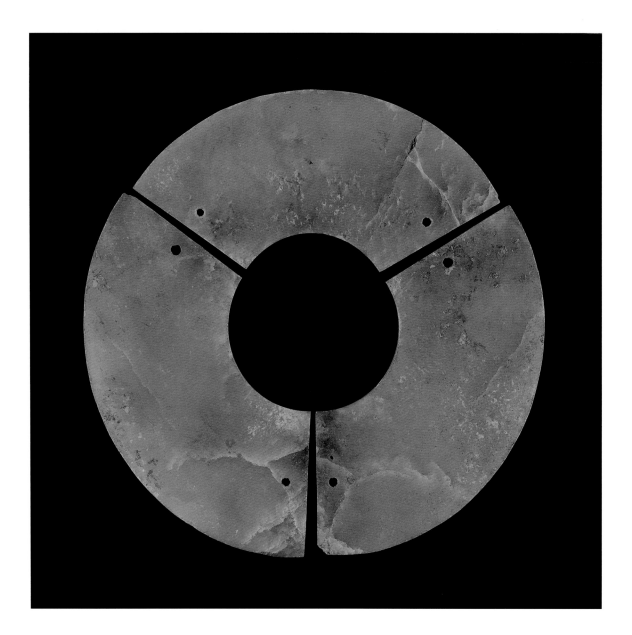

11. *Tripartite Disc*; Late Neolithic period to early Bronze Age, ca. 2000–ca. 1500 BC; Nephrite; One section: H 2¼ × W 4⅝ × D ⅛ INCHES (5.7 × 11.0 × 0.3 CM); Overall: DIAM 5³⁄₁₆ INCHES (13.2 CM); National Museum of History, Taiwan, 89-00038

Pink and green jade with gold colored veins is carved into a tripartite disc. The three flat segments, each of slightly different size, come from the same jade boulder and form a complete ring. This design is the most effective way to maximize the use of the precious material, so that three small segments can be combined to form a larger object. Similar tripartite discs have be found in Neolithic cultures in western China and at Shang dynasty (ca. 1600–1046 BC) sites.[1]

A small hole was drilled into the adjoining edges of each segment in order to bind them together. The segment pictured at the lower-right shows two drilling holes on the reverse side. The partially completed off-center conical hole was likely drilled in error. Traces of red cinnabar are apparent on both sides of the disc. Cinnabar was used in burials in both Neolithic and Bronze Age China. —CLP

1. For similar Qijia culture tripartite discs see Gu 2005, vol. 15, p. 24; Wenwu 1984, 2, pp. 84–7, fig. 12; for a Shang example, see Fuhao 1980, fig. 96: 2.

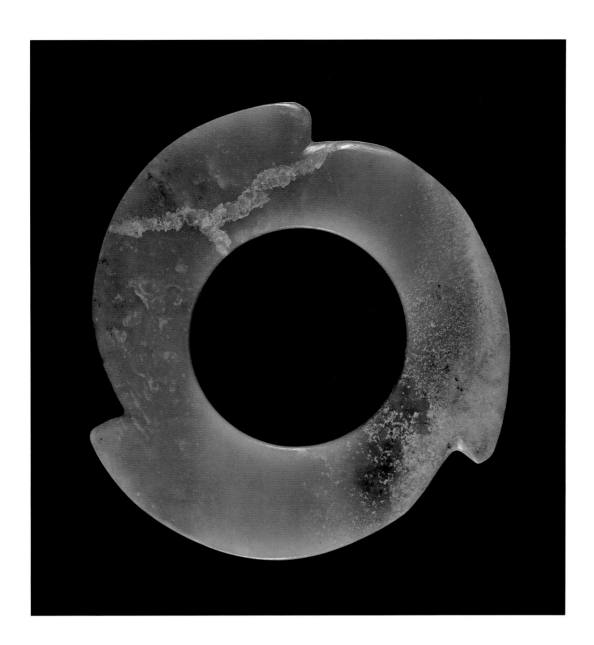

12. Notched Disc, *qi*; Late Neolithic period to early Shang dynasty, ca. 2000–ca. 1500 BC; Nephrite; DIAM 5⁹⁄₁₆ × D ³⁄₁₆ INCHES (14.1 × 0.5 CM); Notch: H ½ INCH (1.3 CM); National Museum of History, Taiwan, 89-00036

Well polished translucent grayish-green jade with mottled yellow and brown areas is carved into a notched disc with a wide circular hole. The perimeter of the disc is divided equally by three evenly distributed notches to form three arcs of approximately 70 degrees. The edge of the disc has been highly smoothed, especially the areas between the notch and the perimeter. Notched discs can be found as early as the Neolithic Hongshan (ca. 4500–ca. 3000 BC) and Dawenkou cultures (ca. 4200–ca. 2500 BC).[1] — CLP

1. Yang Mei-li 1993; Ren 1993.

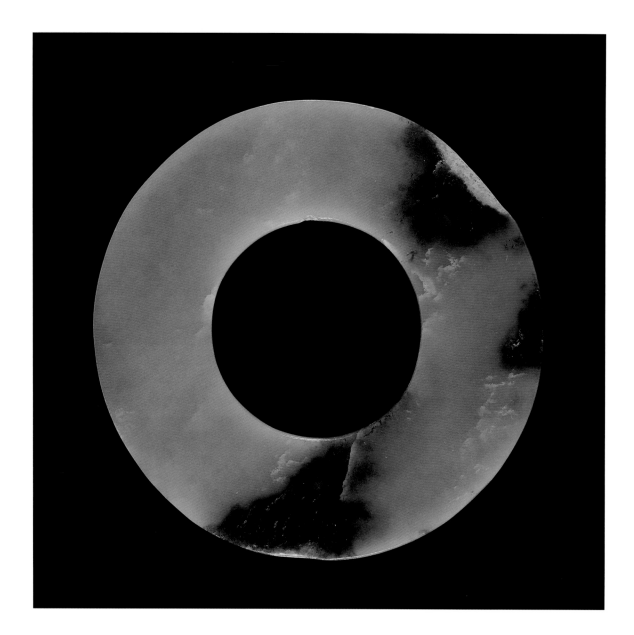

13. **Disc,** *bi*; Late Neolithic period, ca. 2000 BC, possibly Northwestern China; Nephrite; DIAM 5⁷⁄₁₆ × D ³⁄₁₆ INCHES (13.8 × 0.5 CM); National Museum of History, Taiwan, 89-00040

Translucent celadon jade with dark brown areas and white inclusions is carved to form a *bi* disc. The irregularly rounded disc is well-polished. The wide conical hole is slightly off-center and the inner perimeter is unevenly finished. The original and unpolished appearance of the jade boulder is evident in two rough areas on the outer rim of the disc. Similar *bi* discs have been found at burial sites of the late Neolithic period and the Shang dynasty (ca. 1600–1046 BC),[1] such as those excavated at the Qijia culture (ca. 2200–ca. 1800 BC) tomb number 17 at Minhe in Qinghai province.[2]

— CLP

1. Further related examples have been excavated from tomb number 22 of area II at the Taosi site in Xiangfen, Shanxi province (Gu 2005, vol. 3, p. 46); the Shang dynasty tomb of Xincunxiang, Xinzheng in Henan province (Gu 2005, vol. 5, p. 20); and from the late Western Zhou tomb number 27 at Liangdaicun in Hancheng, Shaanxi province. The jade *bi* disc HLM27: 4 probably dates to the Qijia culture (ca. 2200–ca. 1800 BC) (Sun Binjun 2006, p. 57, fig. 3).

2. Gu 2005, vol. 15, p. 131.

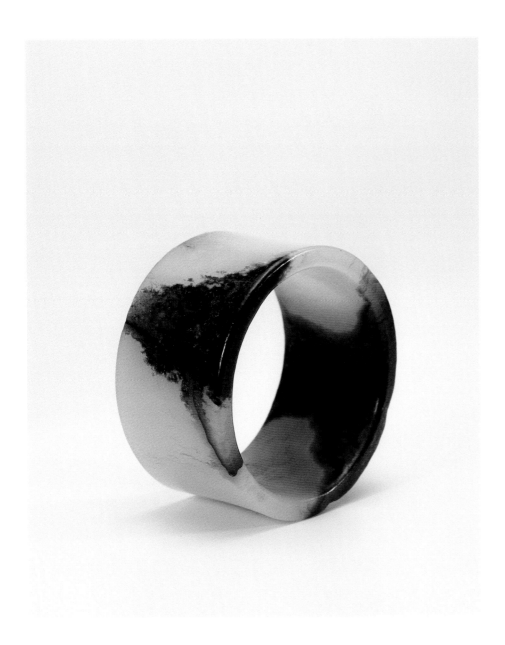

14. *Cylindrical Ring*; Shang dynasty style; Nephrite; H 1⁵⁄₁₆ × W 2⁵⁄₁₆ (3.3 × 5.9 CM); National Museum of History, Taiwan, 7068

White jade with russet and brown areas[1] is carved in the form of a cylindrical ring.[2] The outer wall of the ring is slightly concave and the inner perimeter is straight and evenly finished. A similar yet larger cylindrical ring was excavated from Sanguancun, Anji in Zhejiang province.[3]

— CLP

1. The dark colored areas appearing on the surface may have been enhanced in a later period.

2. Previously published in *Jade: A Traditional Chinese Symbol of Nobility and Character* (*Yu: Zhongguo chuantong meide de xiangzheng*, Taipei: National Museum of History, Taiwan, 1990, p. 28).

3. Gu 2005, vol. 8, p. 148.

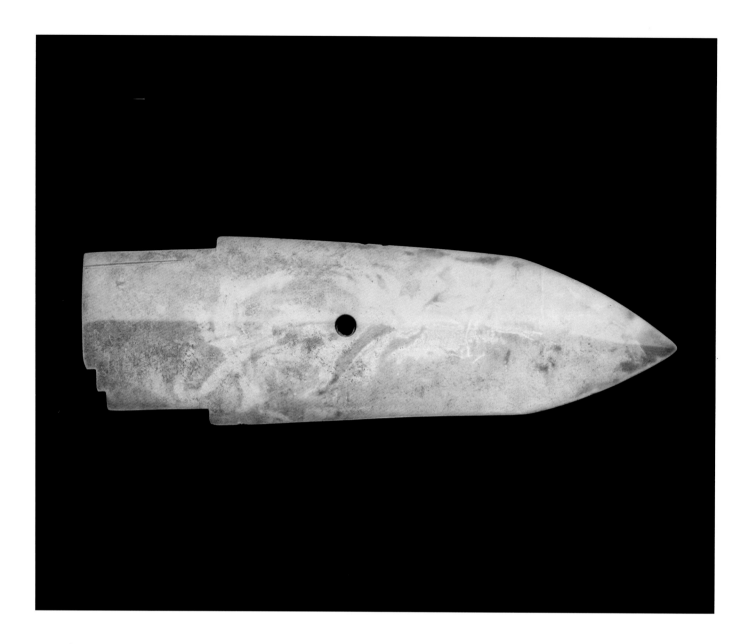

15. **Dagger-axe,** *ge*; Late Shang dynasty, Anyang phase, ca. 13th–11th century BC; Nephrite;
H 3³/₁₆ × W 12¼ × D ⁵/₁₆ INCHES (9.7× 31.1 × 0.8 CM); Arthur M. Sackler Gallery, Smithsonian Institution,
Washington, D.C.: Gift of Arthur M. Sackler, S1987.700

This large and wide dagger-axe is composed of smoothly polished opaque tan and olive green jade with fluid-like areas of light discoloration. This *ge* blade is beveled to sharp edges on both sides with a median ridge extending from the tang to near the tip.[1] The lower corner of the tang is carved to form two steps and the upper edge of the tang is incised with a long cutting mark. The prominent biconical hole, likely used for mounting, is located near the center of the blade. On the reverse side, a central groove extends from the tang to near the tip and is the result of slicing the object from opposite directions from a single block of jade.

A unique feature of this dagger-axe is the traces of irregular light imprints on the surface of the blade. These areas of discoloration were likely formed when the object came into direct contact with acidic bodily fluids which seeped from the corpse in burial.[2] The bodily fluids lead to chemical changes on the surface of the jade, leaving areas of light discoloration.

— CLP

1. A very similar *ge* with two-stepped tang is now in the Grenville Lindall Winthrop's collection at the Arthur M. Sackler Gallery, Harvard Art Museums, 1943.106.

2. For discussion of degradation of proteins during liquefaction of body tissues producing high pH in tombs, see Garines and Handy 1975, p. 434; personal discussion of this piece in 2010 with Janet G. Douglas, the Conservation Scientist at the Department of Conservation and Scientific Research at the Freer Gallery of Art and the Arthur M. Sackler Galleries, Smithsonian Institution.

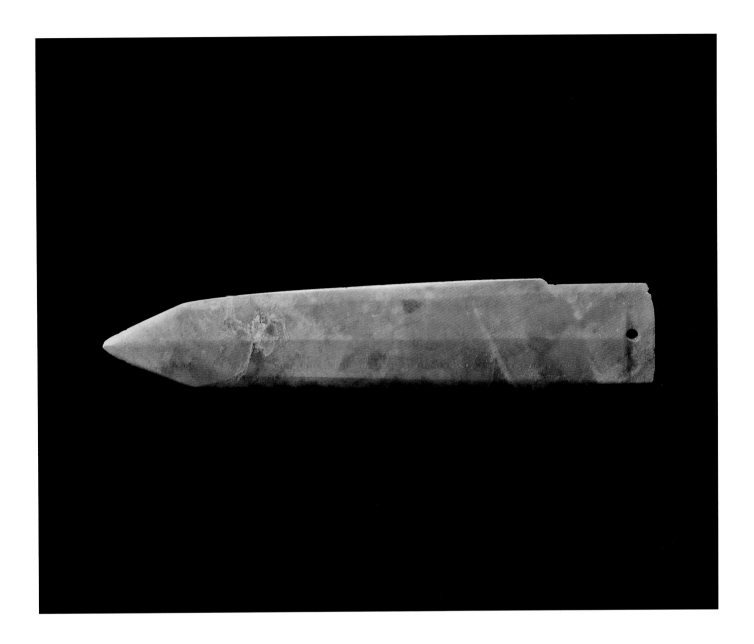

16. **Dagger-axe,** *ge*; Shang to Western Zhou dynasty, ca. 1600–771 BC; Nephrite; H 1¹⁄₁₆ ×
W 5½ × D ³⁄₁₆ INCHES (2.7 × 14.0 × 0.5 CM); National Museum of History, Taiwan, 89-00044

The surface of the jade blade is pale grayish-green with a whitened opaque area at
the tip. This relatively small and elongated *ge* dagger-axe has beveled cutting edges
and a raised central rib on each side. The slender, symmetrical blade narrows at the
one-stepped tang and the butt-end has a central hole drilled from one side.

While the shape of the blade is based on utilitarian metal weapons of the period,
the rarity of jade and the tendency of the material to chip and fracture suggests that
such blades served ceremonial purposes. Jade dagger-axes of this type vary greatly in
size, ranging from two inches to nearly 40 inches.[1] — CLP

1. Jade *ge* of ten cm in length or smaller have been
found in tomb number 120 at the Qiangzhangda
burial site of Tengzhou, Shangdong province
dating to the 11th century BC (Gu 2005, vol. 4,
pp. 102–103). A *ge* of 29.2 cm in length was exca-
vated from the Lady Fuhao tomb dating to the
late Shang dynasty (Ibid., vol. 5, p. 43, 114; vol. 3,
p. 111). A *ge* of 43.3 cm in length was excavated at
the Daluchencun burial site in Henan province,
and a 54.4 cm long blade was found at the burial
site of the Marquis of the State of Jin in tomb
number 63 at Quwo, Shanxi province (Ibid.,
vol. 5, p. 43, 114; Ibid., vol. 3, p. 111.).

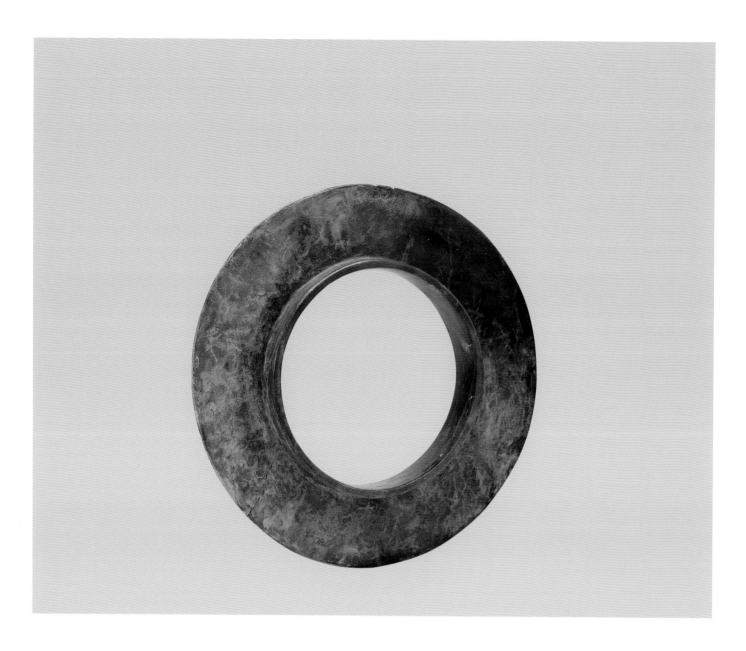

17. *Collared Disc*; Shang dynasty (ca. 1600–ca. 1050 BC); Nephrite; DIAM 4¾ × D ⅝ INCHES
(12.1 × 0.8 CM); National Museum of History, Taiwan, 89-00042

This thin jade disc features a short collar projecting from the central aperture on both sides of the object. The surface of the jade is highly polished overall. The mottled yellow-tan jade has white veins of discoloration present throughout the surface. The interior wall of the circular hole has been smoothed and polished which may have facilitated wearing the disc on the wrist as a bracelet. Twenty collared discs of this type have been found among the 755 jade objects discovered at the Royal Consort Lady Fuhao's tomb, dating to the Shang dynasty (ca. 1600–1046 BC).[1] Other collared discs have also been found at Shang dynasty burial sites at Anyang, Henan province and elsewhere.[2]

— CLP

1. Fuhao 1980, pp. 119–122, color plate 15:1.

2. For examples of collared discs excavated at Anyang, see Kaogu 1989, 7, pp. 591–7, fig. 4:1, 2. Eighteen collared discs were excavated from pit numbers one and two at the Sanxingdui ritual site in Sichuan province and nine further examples were excavated from the Xingan burial site in Jiangxi province. The size and smooth polish of the concentric hole and the position of such discs found in burials suggest that Shang collared discs of this type may have functioned as bracelets (Xingan 1997, pp. 141–3; So 2001, pp. 172–4).

18. *Tube, cong*; Late Neolithic period to Western Zhou dynasty, ca. 2000–771 BC; Nephrite;
H 1¹³⁄₁₆ × W 2⅜ × D 2⅜ INCHES (4.6 × 6.0 × 6.0 CM); National Museum of History, Taiwan, 89-00037

This truncated tube is composed of partially translucent light green and tan jade with discoloration resulting from burial on corners and sections of the rim. The inner wall of the cylinder is well rounded and smoothed. The undecorated, short square *cong* with low rounded collars on both ends is an archaic shape based on Neolithic Liangzhu *cong* tubes (see catalog number 3). *Cong* tubes of this shape were revived during the Shang and Western Zhou dynasties. Numerous examples can be found in late Shang burial sites such as Lady Fuhao's tomb[1] and tomb number 54 of the Huayuanzhuang burial site at Anyang, Henan province.[2] — CLP

1. For examples from Lady Fuhao's tomb, see Gu 2005, vol. 5, p. 89.

2. Additional examples of from Western Zhou tombs include tomb number 32 of Zhangjiapo in Changan, Shaanxi province; tomb number 2009 in the Necropolis of the State of Guo in Sanmenxia; and in the Necropolis of the State of Ying at Pingdingshan, Henan province (Gu 2005, vol. 14, p. 42; Ibid., vol. 5, p. 168; Ibid., vol. 5, p. 174).

19. *Turtle*; Late Shang dynasty, Anyang phase, 13th to 11th century BC; Nephrite; H 1¹⁵⁄₁₆ × W 1⁵⁄₁₆ × D ½ INCHES (5.0 × 3.4 × 1.2 CM); Arthur M. Sackler Gallery, Smithsonian Institution, Washington, D.C.: Gift of Arthur M. Sackler, S1987.638

Semi-translucent, olive-green jade is carved into the form of either a turtle or terrapin.[1] Turtle-like images first appear in the Neolithic Hongshan (ca. 4500–ca. 3000 BC) and Liangzhu (ca. 3300–ca. 2100 BC) cultures and persist through the Shang (ca. 1600–1046 BC) and Western Zhou dynasties (1046–771 BC).[2] The hole drilled on the underside of the turtle was used for suspension. The red areas present on the stone are traces of cinnabar, a material used in burial practices during this period.[3]

The creature is depicted realistically with extended neck, protruding eyes, and four limbs mainly hidden under the shell. A central ridge runs along the top of the sculpture from head to tail. The surface of the jade is highly smoothed and lacks patterning or incising. The characteristic Shang dynasty double-incised lines used to ornament most jade animal carvings are completely absent on this simple figure. Several other examples of jade turtles can be found in the Neolithic Liangzhu culture and in late Shang dynasty tombs.[4]

— CLP

1. Previously published in *Chinese Jade Animals* (Chung Wah-pui, Carol Michaelson, and Jenny F. So. Hong Kong: Urban Council of Hong Kong, 1996, pp. 50–1, no. 12); *4,000 Years of Chinese Art* (Hartford, 1958, no. 32).

2. A jade terrapin was excavated from tomb number one at Hutougou burial site in Fuxin, Liaoning province (Gu 2005, vol. 2, p. 118).

3. Two turtle-shaped jade sculptures from tomb number one of burial mound number one at the fifth location in Niuheliang site in Chaoyang, Liaoning were placed in the hands of the deceased (Wenwu 1997, 8, p. 4–8; Gu 2005, vol. 2, p. 120–1.).

4. For Liangzhu culture examples, see Fanshan 2005, vol. 1, p. 190–1; vol. 2 p. 260, fig. 715–6. Similar Shang dynasty examples can be found at the Northern cemetery of Xiaotun Beifangzi in Henan province (Fuhao 1982, fig. 67 (F 11:8, F 11:5) and fig. 68 (M819:8)); For a Western Zhou dynasty example, see Gu 2005, vol. 14, p. 67.

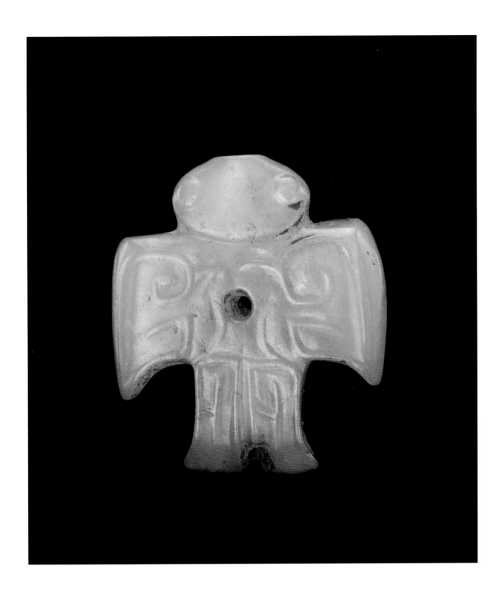

20. **Bird-shaped Pendant**; Late Shang dynasty, Anyang phase, 13th to 11th century BC;
Jia Tomb, Huixian, Henan Province; Nephrite; H 1¼ × W 1³⁄₁₆ × D ³⁄₁₆ INCHES (3.2 × 3.0 × 0.5 CM);
National Museum of History, Taiwan, H0000230-2

The slightly circular contour of this bird suggests that it was carved from a circular
block of jade.[1] Interestingly, this late Shang dynasty jade bird pendant was unearthed
in a tomb dating to the Spring and Autumn period (770–476 BC). The aerial view of
an animal's symmetrical body has been employed in jade carving since the Neolithic
Liangzhu (ca. 3300–ca. 2100) and Lingjiatan (ca. 3600–ca. 3300 BC) cultures located
along the Yangzi river.[2] Characteristics of early jade carvings of this type include a
central hole drilled through the figure, symmetrical designs, and a large oval head
with widely spaced eyes. Jade animal carvings in this style dating to the Anyang phase
include birds, toads, and turtles.[3] This small jade bird has a conical aperture at the
center of the body and two-end drilling holes running horizontally from mouth to
tail, thus providing two different methods of display.[4] — CLP

1. Previously published in *Jade: A Traditional
Chinese Symbol of Nobility and Character* (*Yu:
Zhongguo chuantong meide de xiangzheng*, Taipei:
National Museum of History, Taiwan, 1990, p.
31) and *Re-exploring Treasures: Artifacts from the
Jia and Yi Tombs of Huixian* (Taipei: National
Museum of History, Taiwan and Henan Museum,
2005, p. 189).

2. For example, two Liangzhu jade birds excavated
from tomb number 14 and 15 of the Fanshan burial
site in Zhejiang province (Fanshan 2005, vol. 1,
p. 121, fig. 97: 4 and vol. 2, p. 189, color plate 520-1;
Ibid., vol. 1, p. 144, fig. 118: 25, 119: 4, and Ibid.,
vol. 2, p. 210, fig. 574-5). A jade pendant in the
shape of an eagle was excavated from a Lingjiatan
burial site at Hanshan in Anhui province (Gu 2005,
vol. 6, p. 4).

3. Fuhao 1980a, fig. 145: 5, 147: 1–3.

4. The long cylindrical hole passing through the
bird's body was likely carved later, perhaps in the
Warring States period (475–221 BC). The stylized
raised lines found on the body of the bird are
consistent with a Shang dynasty (ca. 1600–1046 BC)
date. The bifurcate, fish-like tail has been used for
bird pendants since the late Shang dynasty and
continued into the Western Zhou dynasty.

FRONT

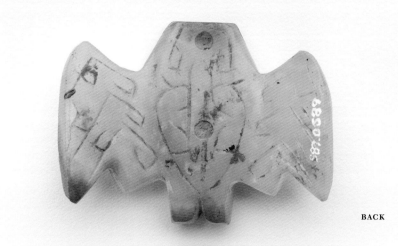

BACK

21. *Bat-shaped Pendant*; Late Shang dynasty, Anyang phase, 13th to 11th century BC; Nephrite; H 1³⁄₁₆ × W 1⁵⁄₈ × D ½ INCHES (3.0 × 4.2 × 1.2 CM); Arthur M. Sackler Gallery, Smithsonian Institution, Washington, D.C.: Gift of Arthur M. Sackler, S1987.689

Jade bat images in Neolithic period and Bronze Age China are rare.[1] The ears and the ziz-zag contour of the wings distinguish this image as a bat rather than a bird. The late Shang method of representing the animal from an aerial view is evident in this object (see also catalog number 20). The patterning found on the surface of the jade, executed with the characteristic incised double lines, is highly ordered and symmetrical. Curved double incised lines, known as *juanyunwen*, were employed in a wide range of media, including bronze, ivory and stone, during the late Shang dynasty.

The arched shape of this jade bat gives the body volume and creates the impression of flight.[2] The sharp, single-incised lines on the belly of the bat differ from the smooth double-lines on the front and may have been added later. The shallow central groove on the underside was used either as a support for horizontal display, or perhaps is a discarded drilling hole. Two functional drilling holes at the bat's mouth and jaw are designed for suspension. The earliest bat-shaped jade carvings can be found in the Neolithic Hongshan (ca. 4500–ca. 3000) tomb number one at the Hutougou burial site in Fuxin, Liaoning province.[3]

— CLP

1. Previously published in *Chinese Jade Animals* (Chung Wah-pui, Carol Michaelson, and Jenny F. So. Hong Kong: Urban Council of Hong Kong, 1996, pp. 54–5, no. 16).

2. For a related jade image of a bat dated to the Shang dynasty, see Toronto 2000, p. 70, fig. 4. Another Hongshan bat was excavated at Hutougou in Fuxin City, Liaoning province (Ma Maojie, ed., 2008, p. 170).

3. Gu 2005, vol. 2, pp. 113–4.

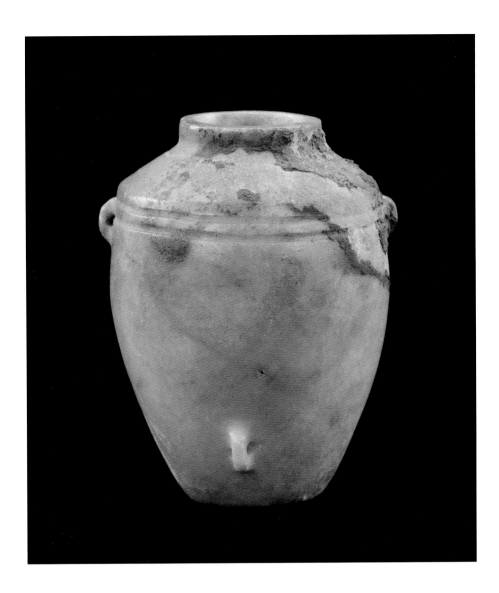

22. *Miniature Jar*; Late Shang dynasty, early Anyang phase, ca. 13th century BC; Marble;
H 2¹⁵⁄₁₆ × W 2³⁄₁₆ × D 2³⁄₁₆ INCHES (7.4 × 5.6 × 5.6 CM); Arthur M. Sackler Gallery, Smithsonian
Institution, Washington, D.C.: The Dr. Paul Singer Collection of Chinese Art of the Arthur M.
Sackler Gallery, Smithsonian Institution; a joint gift of the Arthur M. Sackler Foundation, Paul Singer,
the AMS Foundation for the Arts, Sciences, and Humanities, and the Children of Arthur M. Sackler,
S2010.40

A finely carved and perfectly symmetrical opaque jar is carved from ivory-white marble. The hollow vessel has rough areas of accretion resulting from burial beside bronze objects. Two small lugs are located near the shoulder of the vessel with a third closer to the base and between the upper lugs. Two incised lines encircle the vessel just below the shoulder.[1]

The broadest definition of the term "jade" in China includes numerous beautiful hard stones, including marble. Miniature jade vessels in the Shang (ca. 1600–1046 BC) and Zhou (1046 BC–221 AD) dynasties imitate much larger bronze or ceramic prototypes. The shape of this marble jar, for example, is very similar to an excavated Shang dynasty white ceramic vessel.[2] Furthermore, bronze vessels and a miniature marble vessel with broken lugs, all of very similar size and shape to this example, have been found in the Royal Consort Lady Fuhao's tomb dating to the late Shang dynasty.[3]

— CLP

1. The use of small lugs and parallel incised lines are characteristic of pottery vessels in the Neolithic and early Bronze Age. For examples, see the lower layer of Xiajiadian culture (ca. 2000– ca. 1400 BC) in the Northern Steppe area (Chao 1996, p. 57–8).

2. Yinxu 1994, p. 233, fig. 111: 1: 1.

3. Beijing 1980a, plate 41: 1; Ibid., p. 198, fig. 98: 5, plate 169: 2.

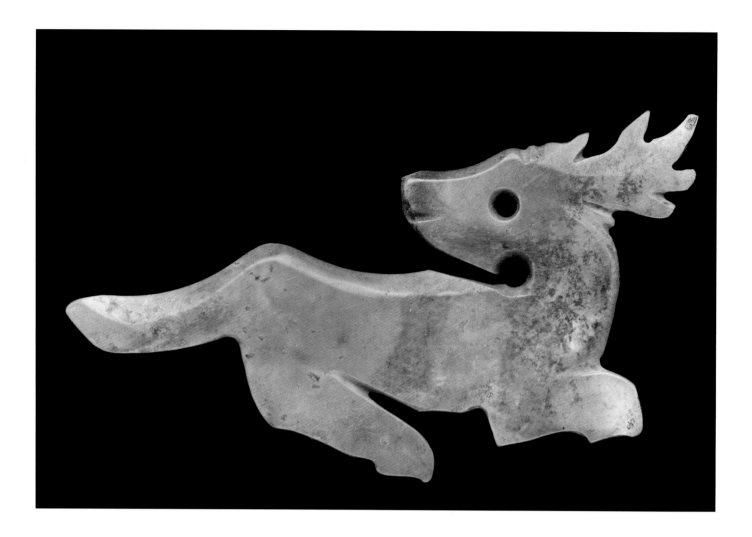

23. *Pendant in the Form of a Stag*; Early Western Zhou dynasty, ca. late 11th century to early 10th centry BC; Muscovite (massive sericite); H 1⁹⁄₁₆ × W 3⅜ × D ³⁄₁₆ INCHES (4.0 × 8.5 × 0.4 CM); Arthur M. Sackler Gallery, Smithsonian Institution, Washington, D.C.: Gift of Arthur M. Sackler, s1987.872

The stag motif was particularly prevalent in jade carvings of the Western Zhou dynasty (1046–771 BC). A large number of Western Zhou deer-shaped jade pendants were excavated from tomb number one at Rujiazhuang, Shaanxi province.[1] The deer represented on this pendant appears in a running or leaping posture and looks backwards in an alert manner.

Two circular holes cleverly define the eye and the neck contour of the deer. A sharp beveled sloping edge running along the back and tail of the deer provides a sense of volume for the otherwise flat pendant.[2] The tail was designed to function as a small knife, a feature found on some animal-form jades beginning in the Shang dynasty (ca. 1600–1046 BC).[3] The sudden popularity of deer imagery in the Zhou dynasty may be related to the interaction between cultures in Northern and North-western China.[4] Deer were a popular subject of petroglyphs found in the Altai region, Mongolia, Siberia, and border areas between China and the Eurasian Steppes. Stag imagery was prevalent in the Eurasian context in first millennium BC.[5]

— CLP

1. Yuguo 2010, pp. 140–142.

2. Chan 2009, pp. 58–9.

3. For example, a jade reptile with a knife-like tail was found in the late Shang dynasty tomb of the Royal Consort Lady Fuhao (Fuhao 1980, color plate 20: 2).

4. So 1995, pp. 110–1.

5. For further discussion about the possible cultural interaction between people in Siberia, Central Asia, and West Asia, see Chan 2009, pp. 62–5.

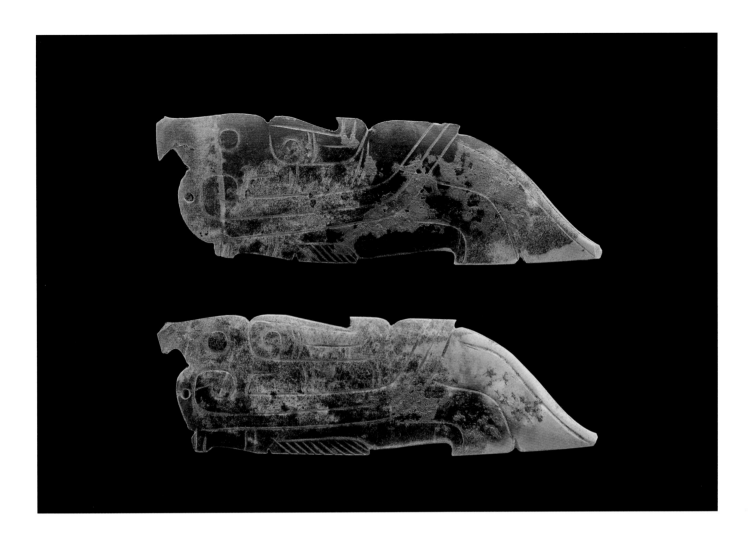

24. *Pair of Bird Silhouettes*; Western Zhou dynasty (1046–771 BC); Nephrite; H 1¹⁄₁₆ × W 3¹⁄₁₆ × D ⅛ INCHES (2.7 × 5.2 × 0.3 CM); National Museum of History, Taiwan, 89-00045

A pair of grayish-green bird-shaped pendants appear virtually identical. Close examination reveals variation in the stone suggesting that the pendants were carved from different areas of the same jade boulder. The bird silhouettes are similarly carved on both sides. Small drilled circular holes can be found at the breast of each bird. The birds are shown in a crouching posture with incised lines outlining the beak, eyes, feet, wings, and tail. The downward bifurcate tails of the birds are very similar to jade fish images of the Shang (ca. 1600–1046 BC) and Western Zhou dynasty tombs.

The mottled cream and opaque areas of surface discoloration on the tails of both pendants suggest that the objects were located in close proximity within the burial site and thus experienced similar changes to the stone over time. Archaeological evidence confirms that rectangular bird silhouettes of this type are typically found in pairs.[1]

These bird silhouettes may have served both a ritual and decorative function. When used in a ritual context, bird silhouettes of this type function as burial objects in a similar fashion to the more common jade fish images of the period.[2] Alternatively, the decorative function of such objects is evident in tomb number one at Rujiazhuang burial site in Shaanxi province where a pair of jade pendants were placed around the head and neck of the tomb owner to form part of a necklace.[3]

The profile bird design of these pendants derived from late Shang dynasty prototypes, though Western Zhou examples show one variation. In Shang bird images, the beak is hook-shaped, while in Western Zhou representations, the beak is transformed into a trumpet-shaped snout without apertures.[4] — CLP

1. Chan 2009, pp 133–5.

2. An example of the ritual use of these objects is found in tomb number 6231 of the Tianma qucun burial site in Shanxi province, where two pairs of bird silhouettes were placed on the hands and feet of the deceased to serve a burial function (Tianma Qucun 2000, vol. 2, p. 431, fig. 60); For a discussion of jade imagery in burial practices, see Chan 2009, p. 135.

3. Baoji 1988, vol. 1, p. 239, fig. 72: 4.

4. Chan 2009, p. 128.

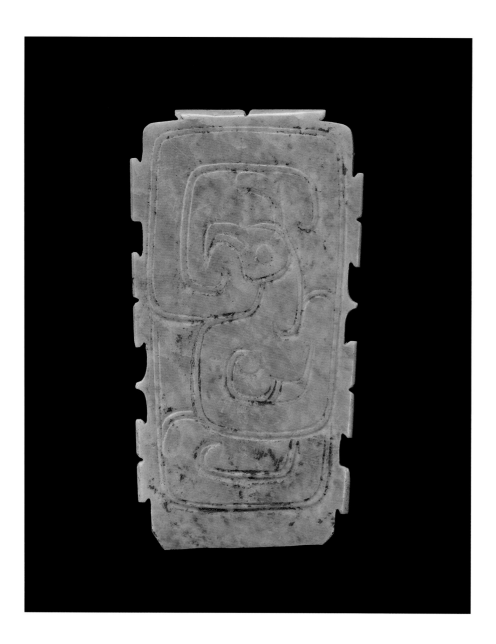

25. *Crested Bird Plaque*; Western Zhou dynasty (1046–771 BC); Nephrite; H 2³⁄₁₆ × W 1¼ × D ³⁄₁₆ INCHES (5.6 × 3.2 × 0.5 CM); National Museum of History, Taiwan, 89-00046

The flat grayish-green jade plaque is similarly carved on both sides with the image of a crested bird. The Western Zhou crested bird motif is typically represented with double-incised lines, as evident in this example. The use of evenly spaced double incised lines in jade carving developed in the Shang dynasty (ca. 1600–1046 BC). The head of the bird is surrounded by an elongated curling plume and the lower area of the bird is enveloped by its long tail. Such crested bird imagery emerged as standard iconography in the Western Zhou dynasty. Very similar examples of bird representations can be found in tombs from the states of Yan and Guo in the Western Zhou dynasty.[1]

The edges of the plaque are notched. The narrowing trapezoidal shape may have been designed so that the jade could be inserted into a base and displayed vertically. Several examples of crested bird plaques which were inserted into bases composed of turquoise and jade were found at tomb number one of Rujiazhuang burial site and confirm such a method of display.[2] — CLP

1. Fangshan 1995, p. 235, fig. 144: 5–6; Sanmenxia 2002, p. 104, fig. 2.

2. Ruguo 2010, pp. 8–13.

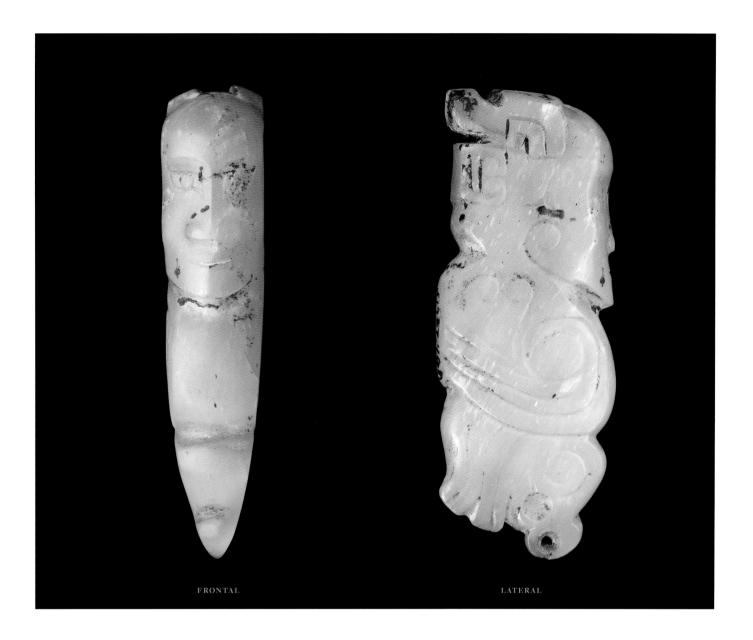

FRONTAL LATERAL

26. *Pendant in the Form of a Human-Bird Hybrid*; Western Zhou dynasty (1046–771 BC);
Nephrite; H 2¼ × W ⅞ × D ½ INCHES (5.7 × 2.2 × 1.2 CM); Arthur M. Sackler Gallery, Smithsonian
Institution, Washington, D.C.: Gift of Arthur M. Sackler, s1987.480

Semi-translucent, grayish-green jade with small white areas is carved into figural
form. The subject is a composite creature with human head and bird body. While
human-bird composite iconography is evident on bronze weapons and jade silhou-
ettes of the period, this important object is one of the few known three-dimensional
examples of Western Zhou anthropomorphic jade.[1] The crouching creature has
a human head surmounted by horns and a bird body. The small hole at the base
of the figure is incorporated into the bird claw. Spirals extend on lateral sides to
represent wings. The crescent-shaped profile, broad nose and mouth, and stylized
eyes with incised pupils are characteristic facial features found on human and
human-hybrid images excavated from Western Zhou sites.[2] — CLP

1. A 0.9 cm thick anthropomorphic jade figure was
excavated from the state of Rui in the late Western
Zhou dynasty (Hancheng 2007, pp. 74–5, fig. 19).

2. For example, a jade figure with typical Western
Zhou human facial features was excavated from
tomb number 26 at Liangdaicun in Hancheng,
Shaanxi (Wenwu 2008, 1, fig. 19).

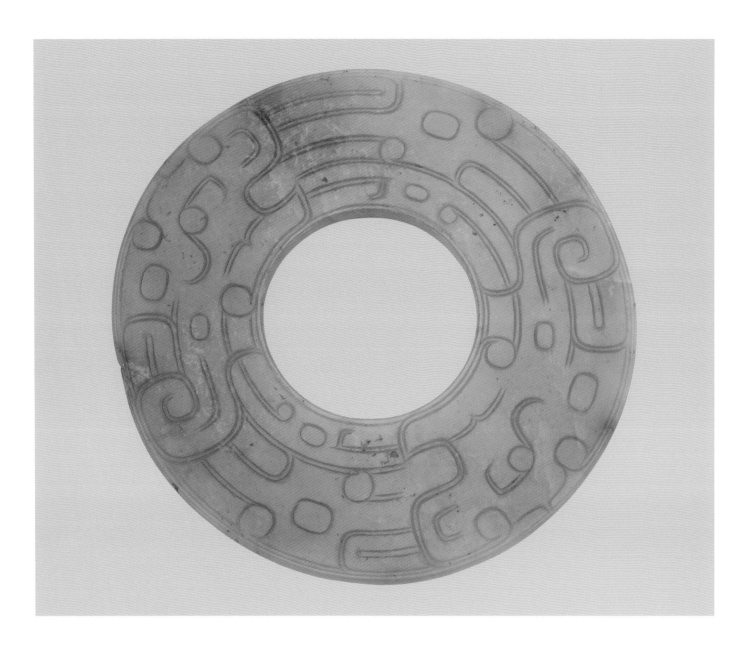

27. **Ring with Dragons,** *bi*; Early Eastern Zhou dynasty, late Spring and Autumn period, 7th to 6th century BC; Nephrite; DIAM 6¹¹⁄₁₆ × D ¼ INCHES (17.0 × 0.6 CM); Arthur M. Sackler Gallery, Smithsonian Institution, Washington, D.C.: Gift of Arthur M. Sackler, S1987.674

This thin, translucent pale gray-green jade *bi* disc with tan markings is similarly carved on both sides.[1] The subject of the carving is highly stylized dragon heads. The dragon heads can be difficult to recognize and the representations vary. Two of the dragon heads can be identified by spiral shaped upturned muzzles outlined with double lines. The muzzles also form the hair of two larger dragon heads. These larger dragons are shown with open mouth and circular eye. Numerous other highly abstracted features of dragon heads further decorate the surface of the disc.

Western Zhou dragon images appearing on discs, such as this example, are highly abstracted. The imagery carved on this disc represents a transitional period between the more easily recognizable dragon images of the late Western Zhou dynasty (1046–771 BC)[2] to the increasingly abstracted and deconstructed images of the Eastern Zhou dynasty (770–221 BC).[3]
— CLP

1. Previously published in *Jade: A Traditional Chinese Symbol of Nobility and Character (Yu: Zhongguo chuantong meide de xiangzheng*, Taipei: National Museum of History, Taiwan, 1990, p. 48).

2. For a related jade disc excavated from tomb number 63 in the Necropolis of the Marquis of the State of Jin at Quwo in Shanxi province, see Gu 2005, p. 113; See also a similar disc in the collection of the Seattle Art Museum, 39.11, published in Watt 1989, p. 41.

3. For a contemporaneous disc excavated from tomb number G1 of Huangjunmeng, see Kaogu 1984, 4, pp. 302–32, fig. 16.1.

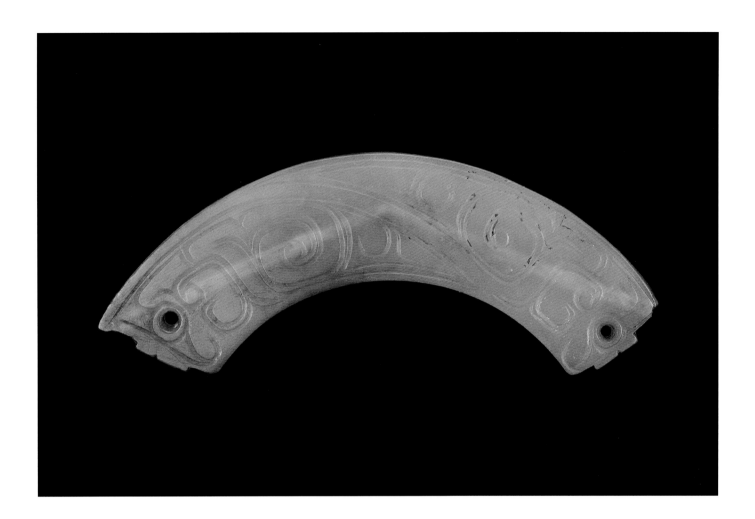

28. *Arc-shaped Pendant, huang*; Western Zhou dynasty (1046–771 BC); Jia Tomb, Huixian, Henan Province; Nephrite; H 1⁹⁄₁₆ × W 3¾ × D ⅛ INCHES (4.0 × 9.5 × 0.3 CM); National Museum of History, Taiwan, H0000247. Important National Treasure of Taiwan

This arc-shaped pendant, or *huang*, is composed of translucent grayish-white jade.[1] The pendant dates to the Western Zhou dynasty and was excavated in 1936 from the Jia tomb at Huixian, Henan province.[2] Both sides of the pendant are carved with nearly identical zoomorphic imagery. Two creatures rendered in highly abstract and symmetrical form twist and curl across the surface of the pendant. The small holes on each end of the pendant function both as representations of the creatures' eyes and as the original means of suspension. Two notches on both ends of the pendant form the crest of each creature. The interlocking zoomorphic forms evident in jade in this period may have been the source for similar imagery appearing on contemporaneous bronzes.[3]

While the pendant dates to the Western Zhou dynasty, it was reworked in the Eastern Zhou dynasty. During the Western Zhou such *huang* pendants were suspended horizontally in sets. During the following Eastern Zhou dynasty the orientation of *huang* was reversed from concave to convex position. Rather than employing the two small holes drilled on either side of the pendant dating to the Western Zhou, the Eastern Zhou craftsman drilled two small linear channels within the jade that cross near the center of the object. These channels, which are very obvious in the translucent jade, were used for mounting. A Shang dynasty bird pendant from the same tomb (see catalog number 20) was similarly reworked in the Eastern Zhou dynasty with the addition of a linear channel passing through the center of the jade. — CLP

1. Previously published in *Re-exploring Treasures: Artifacts from the Jia and Yi Tombs of Huixian* (Taipei: National Museum of History, Taiwan and Henan Museum, 2005, p. 164).

2. See Lin Shwu Shin's essay in this catalog.

3. Rawson 1990a, pp. 113–7.

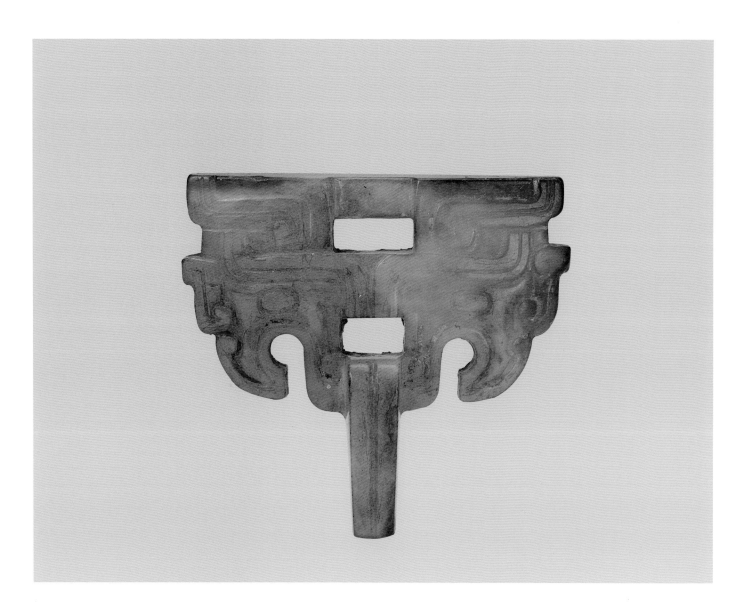

29. *Taotie Ornament*; Eastern Zhou dynasty, Spring and Autumn period (770–476 BC);
Jia Tomb, Huixian, Henan Province; Nephrite; H 1¼ × W 1½ × D ⅜ INCHES (3.2 × 3.8 × 1.0 CM);
National Museum of History, Taiwan, H0000232. Important National Treasure of Taiwan

Translucent yellowish-tan jade with brown markings is carved into the form a symmetrical zoomorphic ornament.[1] The subject of this carving is a *taotie*, the mythical creature that emerges as a major and enduring motif in Chinese art during the late Bronze Age. The oval eyes, arched eyebrows, hooked and elongated nose, open mouth, and horns are readily identifiable. The two rectangular holes in the center of the image may have functioned as a means of fastening the jade to other media. Small *taotie*, such as this example, may have formed part of a ring-holding set. Similar golden *taotie* plaques holding a jade ring were excavated from tomb number 27 of Liangdaicun at Hancheng, Shaanxi province dating to late Western Zhou or early Eastern Zhou dynasties.[2] A jade *taotie* ornament of similar shape but of later date and larger size was excavated from Han Emperor Wu's Maoling tomb in Shaanxi province.[3]

— CLP

1. Previously published in *Jade: A Traditional Chinese Symbol of Nobility and Character* (*Yu: Zhongguo chuantong meide de xiangzheng*, Taipei: National Museum of History, Taiwan, 1990, p. 36) and *Re-exploring Treasures: Artifacts from the Jia and Yi Tombs of Huixian* (Taipei: National Museum of History, Taiwan and Henan Museum, 2005, p. 207).

2. For further discussion of similar objects, see Hancheng 2007, fig. 48. A twisted H-shaped ring holding jade ornament was excavated from the Warring States tomb of Xianweiqu in Xian, Shaanxi province (Liu 2006, p. 188).

3. Gu 2005, vol. 14, p. 132.

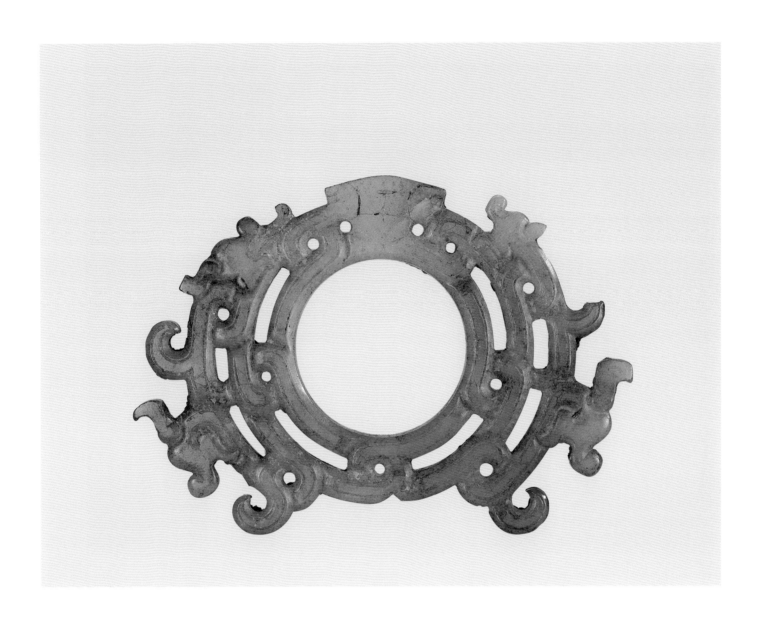

30. *Reticulated Dragon Pendant*; Eastern Zhou dynasty, Spring and Autumn period (770–476 BC); Jia Tomb, Huixian, Henan Province; Nephrite; H 2³⁄₁₆ × W 3 × D ⅛ INCHES (5.6 × 7.6 × 0.3 CM); National Museum of History, Taiwan, H0000222. Important National Treasure of Taiwan

Translucent yellow-tan jade is elegantly carved to form an openwork jade pendant.[1] Both sides of the pendant are similarly carved. Traces of cinnabar employed in burial are apparent in recessed areas. Though excavated from the same tomb as catalog number 31, this unique object is designed and carved differently.

The complex design of the pendant can be viewed in three circular bands. The inner band simply forms a circle. The middle band is comprised of the interlocking bodies of sinuous dragons. The outer band features four interlocking dragons clambering about the outer rim. Four C-shaped hooks are also located on the outer rim and form part of the dragons' bodies.

The extensive use of openwork carving, comprising eleven circular holes and eight slits of various lengths, provides a sense of airiness to the pendant. While there is no known comparable excavated example, the same interwoven dragon design can be found in an openwork *huang* pendant excavated from tomb number 60 at Liulege burial site in Henan province.[2] This design likely originated from the interlocking dragon prototypes evident in the Western Zhou dynasty.[3] — CLP

1. Previously published in *Jade: A Traditional Chinese Symbol of Nobility and Character* (Yu: Zhongguo chuantong meide de xiangzheng, Taipei: National Museum of History, Taiwan, 1990, p. 36) and *Re-exploring Treasures: Artifacts from the Jia and Yi Tombs of Huixian* (Taipei: National Museum of History, Taiwan and Henan Museum, 2005, p. 207).

2. Guo 1959, p. 112, fig. 3.

3. A similar pendant was excavated from tomb number five at the burial site of Yongningpu, Hongtong in Shanxi province (Gu 2005, vol. 3, p. 82).

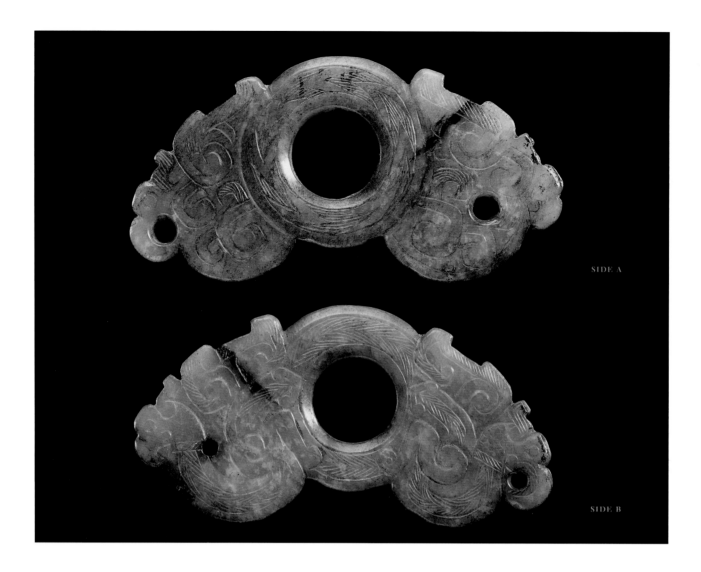

SIDE A

SIDE B

31. *Pendant with Bird Motif*; Eastern Zhou dynasty, Spring and Autumn period (770–476 BC); Jia Tomb, Huixian, Henan Province; Nephrite; H 1 9/16 × W 2 7/8 × D 1/8 INCHES (4.0 × 7.3 × 0.3 CM); National Museum of History, Taiwan, H0000211. Important National Treasure of Taiwan

Semi-translucent, grayish-green jade with black veins is carved into a pendant featuring incised bird imagery.[1] This object was excavated from the Jia tomb in Liulige, Henan province in 1936. The central section on each side of the pendant is carved to form a disc which is surrounded by finely incised arrow-shaped lines. Meticulously carved bird images can be found on the left and right of the central aperture.

The carving on both sides of the object varies. One side is more elaborately carved (side B) featuring details such as scale-like feathers around necks of the birds, a band of fine lines along their breasts, and legs depicted in low relief. Similar fine lines appearing on bird imagery can be found on an Eastern Zhou dynasty small *huang* pendant in the collection of the Arthur M. Sackler Gallery, Smithsonian Institution.[2] The other side of the pendant (side A) is slightly more simplified. Incised C-scrolls are used to decorate the birds. The two holes found on either end of the object were used for suspension. The hole on the right of side B cleverly forms the shape of the bird's beak.

Small openwork jade pendants decorated with zoomorphic imagery were popular in the Eastern Zhou dynasty (770–221 BC) and continued into the Han dyansty (206 BC–220 AD). Examples of small rings with a pair of birds or dragons on lateral sides have been found at numerous sites.[3]

— CLP

1. Previously published in *Jade: A Traditional Chinese Symbol of Nobility and Character* (Yu: Zhongguo chuantong meide de xiangzheng, Taipei: National Museum of History, Taiwan, 1990, p. 36) and *Re-exploring Treasures: Artifacts from the Jia and Yi Tombs of Huixian* (Taipei: National Museum of History, Taiwan and Henan Museum, 2005, p. 207).

2. Accession number s1987.533.

3. Similar objects were found in the following locations: pit number 189 at the sacrificial site of Jiyunzhan at Houma, Shanxi province (Gu 2005, vol. 3, p. 210); from the tomb of the Marquis of Yi from the state of Zheng in Suizhou, Hubei province (Gu 2005, vol. 10, p. 72.); and from Xigongqu burial site at Luoyang in Henan province (Gu 2005, vol. 5, p. 211).

32. *Pair of Earrings, jue*; Eastern Zhou dynasty, Spring and Autumn period (770–476 BC); Jia Tomb, Huixian, Henan Province; Nephrite; H 13/16 × D 15/16 INCHES (2.1 × 2.4 CM); National Museum of History, Taiwan, H0000234. Important National Treasure of Taiwan

These meticulously carved earrings are composed of semi-translucent brown jade with cloudy yellow patches.[1] The earrings are nearly identical in shape and decoration, though the color of the stone varies.[2] The thick, tubular shape includes a slit for attachment to the ear. Such tubular-form earrings are occasionally found in Neolithic sites, yet are rare in the Erlitou (ca. 1850–ca. 1560 BC) and Erligang (ca. 1600–ca. 1400 BC) periods.[3] *Jue* earrings in the Eastern Zhou dynasty, such as this pair, a re elaborately carved on all sides, primarily with stylized dragon heads. The circles carved on the surface of the earrings, for example, represent dragons' eyes. Other discernible features of the dragons include scales, elongated snout, and stratified wing-like appendages.

— CLP

1. Previously published in *Jade: A Traditional Chinese Symbol of Nobility and Character* (*Yu: Zhongguo chuantong meide de xiangzheng*, Taipei: National Museum of History, Taiwan, 1990, p. 36) and *Re-exploring Treasures: Artifacts from the Jia and Yi Tombs of Huixian* (Taipei: National Museum of History, Taiwan and Henan Museum, 2005, p. 207).

2. A very similar pair of earrings, also dating to the Spring and Autumn period, were discovered at the tomb of Heng, the ruler of the State of Huang, at Baoxiangsi, Henan province (Gu 2005, vol. 5, p. 185).

3. Rawson 1995, p. 243.

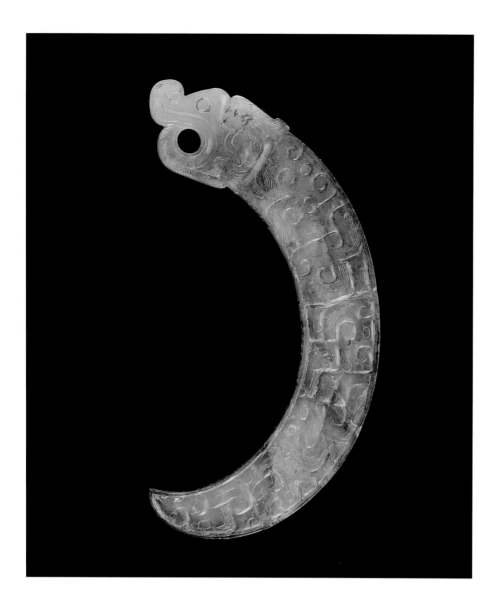

33. *Dragon-shaped Pendant*; Eastern Zhou dynasty, Spring and Autumn period (770–476 BC); Jia Tomb, Huixian, Henan Province; Nephrite; H 4⅛ × W 2¼ × D ⅛ INCHES (10.5 × 5.7 × 0.3 CM); National Museum of History, Taiwan, H0000241

Semi-translucent, pale yellowish jade with light tan markings is carved to form a C-shaped pendant. The carved decoration on both sides of the pendant is very similar. The dragon is arched from a relatively large head to a tapering tail. The dragon head features a hole in the form of the creature's mouth. This circular hole suggests that the pendant was suspended vertically. The dragon's high forehead, stratified horn, uprising muzzle, and short lower jaw are characteristic of dragon imagery in the Spring and Autumn period. Interconnected curls representing numerous dragon faces cover the entire pendant. Areas incised with fine lines represent the dragons' lower jaws and circles represent the dragons' eyes. A similar late Eastern Zhou C-shaped pendant was unearthed at tomb number one at the Xiaoxiwu burial site in Hangzhou, Zhejiang province.[1] —CLP

1. Gu 2005, vol. 8, p. 190.

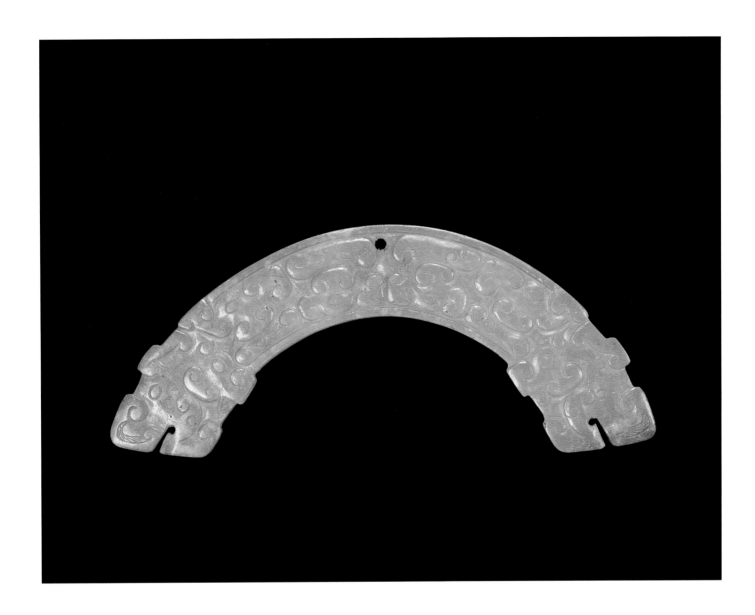

34. *Dragon-shaped Pendant, heng*; Eastern Zhou dynasty, Warring States period (475–221 BC); Nephrite; H 1⅜ × W 3⅜ × D ¼ INCHES (3.5 × 8.6 × 0.6 CM); National Museum of History, Taiwan, 75-03784

Highly polished translucent pale yellowish-green jade is carved into the form of a *heng* pendant.[1] Both sides of the pendant are similarly carved with symmetrical dragon imagery. Vividly rendered dragon heads with a single horn, striated snout, and open mouth are found on both ends of the arc.[2] Six smaller and more abstracted dragon heads also decorate the surface of the pendant. The oval circles on the pendant indicate eyes of the dragons. The large dragon heads at the terminal ends of the arc share an ear with an adjoining dragon head. A small hole at the top center of the pendant was used for mounting the *heng* in a convex orientation, unlike the opposite positioning of pendants in the Western Zhou dynasty. — CLP

1. Previously published in *Jade: A Traditional Chinese Symbol of Nobility and Character* (Yu: Zhongguo chuantong meide de xiangzheng, Taipei: National Museum of History, Taiwan, 1990, p. 36) and *Re-exploring Treasures: Artifacts from the Jia and Yi Tombs of Huixian* (Taipei: National Museum of History, Taiwan and Henan Museum, 2005, p. 207).

2. A similar example with more abstracted dragon heads was unearthed at the burial site of Shuang-fengbao at Linli, Hunan province (Gu 2005, vol. 10, p. 179).

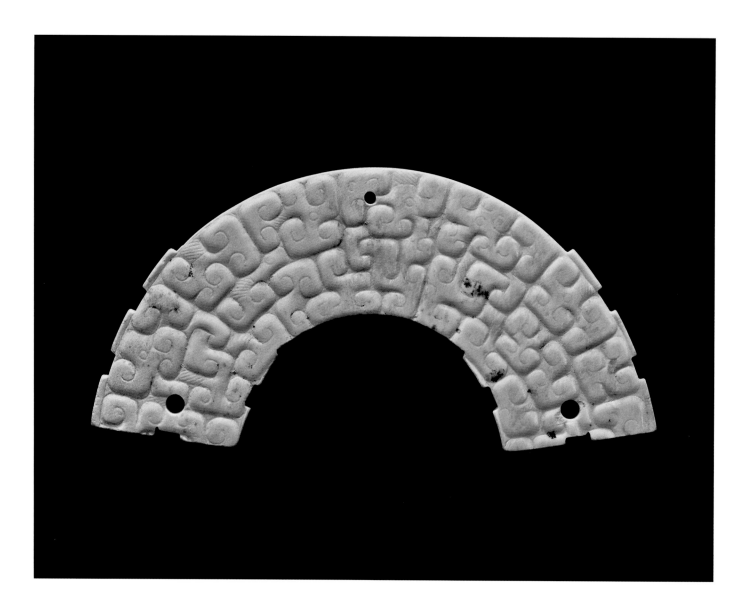

35. **Dragon-shaped Pendant,** *heng*; Eastern Zhou dynasty, Spring and Autumn period
(770–476 BC); Nephrite; H 1⅞ × W 3⅞ × D ⅛ INCHES (4.8 × 9.8 × 0.3 CM); National Museum of History,
Taiwan, 89-00047

This opaque white arc-shaped pendant with areas of light discoloration was cut into
an almost semi-circular form.[1] The raised and interlocking curvilinear designs
decorating the entire surface of both sides of the pendant represent the heads of
numerous dragons and include facial features such as eyes, eyebrows, mouth, snout,
and jaw. The head of each dragon can be identified by the incised circles represent-
ing eyes. The curling dragon forms apparent on this pendant represent an early stage
in the evolution of the dragon motif (see catalog number 34). From the Western
Zhou (1046–771 BC) to Han dynasties (206 BC–220 AD), the stylized dragon motif
evolved into raised comma-shaped spirals, becoming increasingly abstract and
difficult to identify.[2] A hole located at the top of the pendant was used for suspension.
Two larger holes on each end of the arc were used for the attachment of other
pendants.

— CLP

1. A similar pendant can be found in the Spring and
Autumn period tomb of Minister Zhao of the State
of Jin at the Jinshengcun burial site, in Taiyuan,
Shanxi province (Gu 2005, vol. 3, p. 177).

2. See Chan Lai Pik's essay in this catalog.

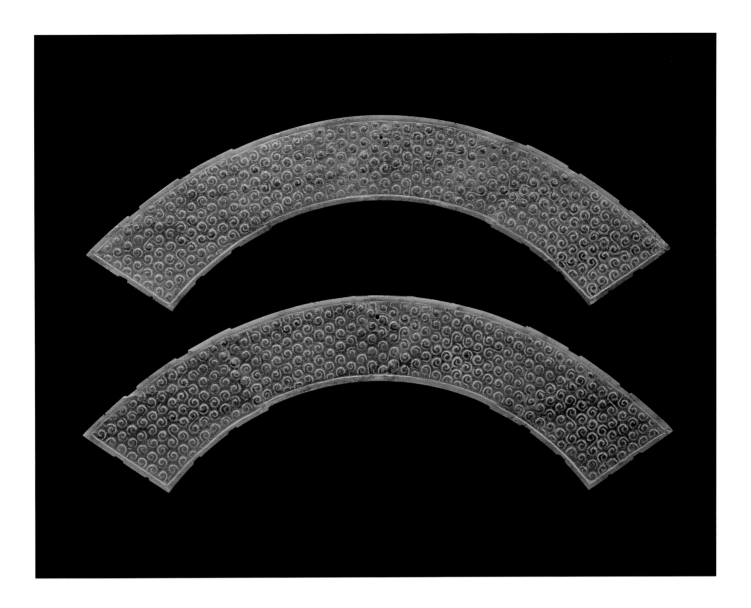

36. *Pair of Arc-shaped Pendants,* *huang*; Eastern Zhou dynasty, Warring States period
(475–221 BC); Nephrite; H 3½ × W 10⅞ × D ³⁄₁₆ INCHES (8.9 × 27.6 × 0.5 CM); National Museum of
History, Taiwan, 89-00048

Grayish-green jade is carved to form an exceptionally large pair of arc-shaped
pendants. Inspection of the stone indicates that the pendants were carved from
non-adjoining sections of the same boulder. The pendants also vary slightly in shape.
The arc-shaped pendants are similarly carved on both sides with regularly distributed
raised knobs in low relief. The notches found on the terminal ends of the arches
are stylized representations of the dragon's mouth, eyebrow, and jaw. The stylistic
evolution of dragon-head forms appearing on *huang* pendants is apparent in catalog
numbers 34, 35, and 36 in which the dragons are increasingly abstracted.[1] A small
hole drilled near the upper edge of each pendant was used for suspension. Arc-shaped
pendants from the mausoleum of the Prince of Chu at Shizishan, Xuzhou in Jiangsu
province resemble the design of these pendants.[2] — CLP

1. See Chan Lai Pik's essay in this catalog.

2. Gu 2005, vol. 7, pp. 118–9. Another pair of
arc-shaped pendants excavated from tomb
number two at Wangshan burial site of Jiangling in
Hubei province is very similar to this pair (Ibid.,
vol. 10, p. 122).

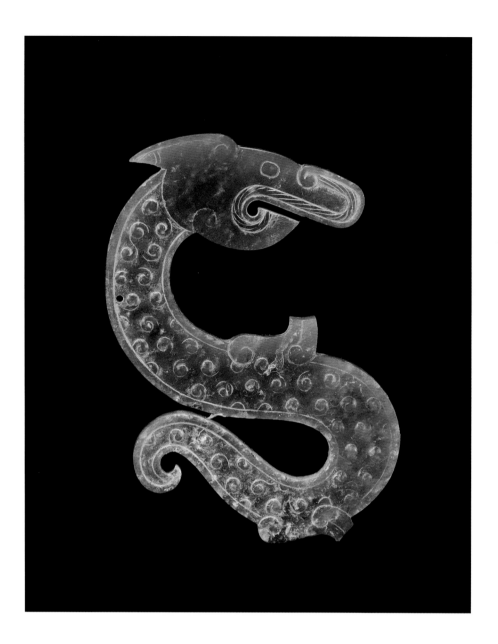

37. **Dragon-shaped Pendant**; Eastern Zhou dynasty, Warring States period (475–221 BC); Nephrite; H 2¾ × W 1¹⁵⁄₁₆ × D ⅛ INCHES (7.0 × 4.9 × 0.3 CM); National Museum of History, Taiwan, 89-00050

Deep olive-green translucent jade is carved into the form of a curled dragon. The elegant curvilinear body of the dragon is S-shaped with a coiling tail that gradually tapers. Both sides of the pendant are similarly carved. The relatively large head of the dragon is accentuated by incised facial features such as oval eyes, stratified lines along the muzzle, a pointed horn, open mouth, and the horizontal outline of the lower jaw. Similarly shaped dragon and phoenix pendants were excavated from tomb number 2129 at the burial site of Siqi, in Homa, Shanxi province.[1] The elongated body is uniformly carved with comma-shaped spirals atop low relief knobs. Two short and irregular appendages extend from the body. A very small hole was drilled along the upper portion of the body and was likely used for mounting. Curved dragon pendants were very popular during the Eastern Zhou dynasty and derived from the arc-shaped *huang* pendants of the preceding Western Zhou dynasty (1046–771 BC).

— CLP

1. Gu 2005, vol. 3, p. 207. An S-curved pendant of slightly different shape was found in tomb number seven at the burial site of Niujiapo, Zhangzi in Shanxi province (Ibid., p. 222).

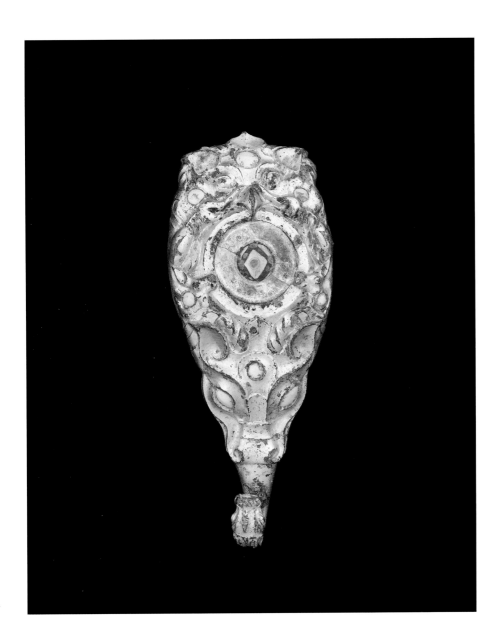

38. Belt Hook, *daigou*; Eastern Zhou dynasty, late Warring States period, ca. 4th to 3rd century BC; Gilt bronze, nephrite, turquoise, and glass; H 5⁹⁄₁₆ × W 2⁵⁄₁₆ × D 1⅛ INCHES (14.2 × 5.8 × 2.9 CM); Arthur M. Sackler Gallery, Smithsonian Institution, Washington, D.C.: Gift of Arthur M. Sackler, s1987.436

This beautiful teardrop-shaped bronze belt hook features the image of a dragon with horns and supine head and is gilded and embellished with luxurious materials including jade, turquoise, and imported glass.[1] A three-colored brown, blue, and white glass bead fills the center of the small inlaid jade *bi* disc. The jade disc is decorated with raised spirals and positioned in the center of the belt hook. The mosaic glass bead is of a type known as "dragonfly glass" and was manufactured in West Asia and imported to China during the Warring States period (475–221 BC).[2] Turquoise inlay is used for the dragon's eyes and embellishes the periphery of the belt hook. The curved and protruding hook is also in dragon form and extends from the mouth of a larger dragon. A zoomorphic creature with sharp beak occupies the opposite end of the belt hook. The use of bronze, gold, jade, turquoise, and imported glass reflects the wealth and refined taste of the elite of Eastern Zhou society. A similar yet more elongated belt hook was excavated at the burial site of Guweicun in Huixian, Henan province.[3] — CLP

1. Previously published in *Traders and Raiders on China's Northern Frontier* (So, Jenny F. and Emma C. Bunker. Washington, D.C.: Arthur M. Sackler Gallery, Smithsonian Institution, 1995, p. 154 5).

2. Kwan 2001, pp. 30–1.

3. Zhang Minghua 2004, p. 205.

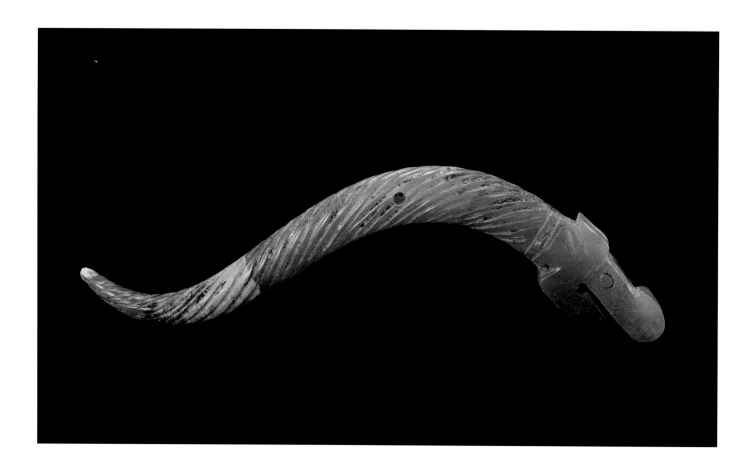

39. **Dragon-shaped Pendant**; Eastern Zhou dynasty, Warring States period (475–221 BC);
Nephrite; H 1 × W 3⅝ × D ³⁄₁₆ INCHES (2.5 × 9.2 × 0.5 CM); National Museum of History, Taiwan,
89-00051

This sinuous dragon is composed of semi-translucent pale yellow-green jade with an opaque area on the creature's tail. The dragon body curves gracefully from head to tail. The head features a pair of round eyes, protruding muzzle, open mouth, and pricked ears. A double-incised line delineates the dragon's neck and body. Twisting grooves run along the curved body to the pointed tail, a carving style characteristic of fifth to forth century BC jades.[1] Such parallel groove ornamentation likely originated in gold work of the era.[2] This elegant pendant has a hole drilled in the center of the body which perfectly balances the object when mounted. A similar dragon-shaped pendant with grooved tail was excavated from the tomb of Tanggonglu at Luoyang, Henan province.[3]

— CLP

1. Rawson 1995, p. 263.

2. Ibid.

3. Gu 2005, vol. 5, p 215.

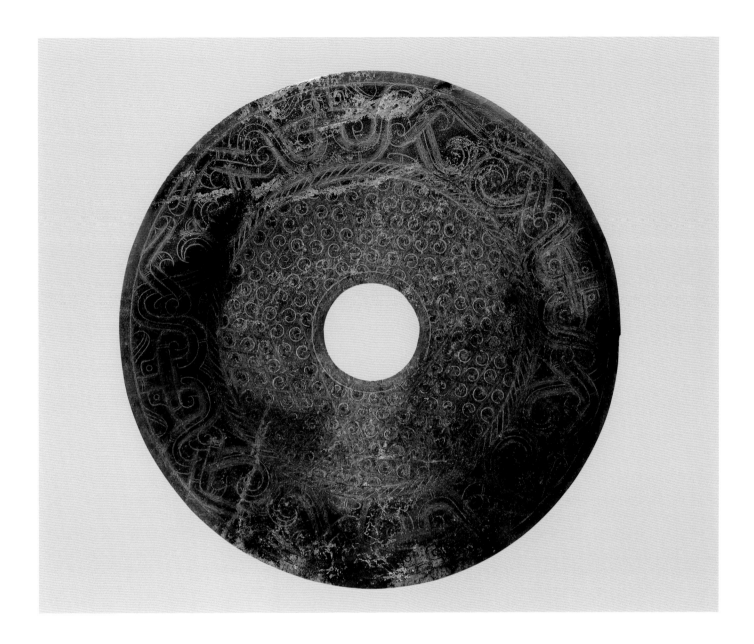

40. **Disc,** *bi*; Warring States period to Western Han dynasty, 475 BC–9 AD; Nephrite; DIAM 8¾ × D 3/16 INCHES (22.2 × 0.5 CM); National Museum of History, Taiwan, 89-00052

Semi-translucent brownish-green jade with areas of white discoloration is carved into *bi* disc form. The extensive carved decoration on the disc is identical on both sides and consists of two zones. The inner zone is comprised of a hexagonal grid of raised knobs within incised comma-shaped spirals. The outer zone is decorated with four symmetrical zoomorphic masks. An incised band resembling rope separates the inner and outer zones.

This type of *bi* disc was prevalent only between the Warring States period (475–221 BC) and the Western Han dynasty (206 BC–9 AD). The discs were mainly used in burial and placed on or underneath the corpse.[1] The earliest examples of discs of this type can be found in Shangdong province.[2] —CLP

1. See Chan Lai Pik's essay in this catalog.

2. Gu 2005, vol. 4, p. 206.

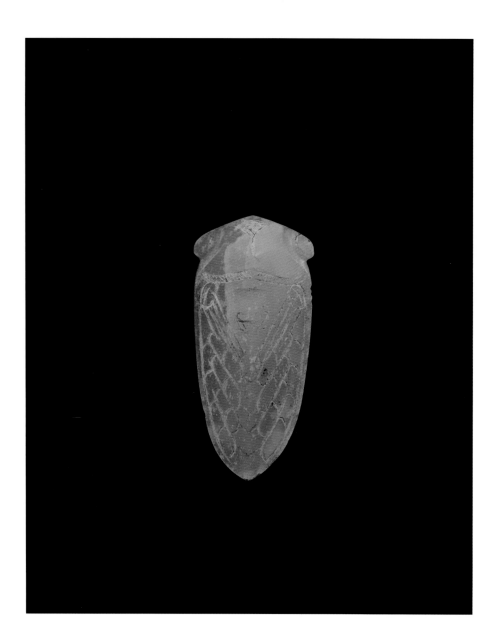

41. *Cicada*; Qin dynasty to Western Han dynasty (221–9 BC); Nephrite; H 2¼ × W ⅞ × D ⁵⁄₁₆ INCHES (5.7 × 2.2 × 0.8 CM); San Antonio Museum of Art, 2010.29

Cicada were a popular subject for jade carvers in the Han dynasty (206 BC–220 AD). There is a great deal of variation in jade figures of cicada and some, such as this example, were likely re-worked in later periods.[1] The size and shape of this cicada, with bulging rounded eyes and tapering body, are consistent with an early date. The carving on the wings on the insect's back, executed with rough single lines, are likely later additions. A jade cicada of similar style was excavated at a Western Han tomb at Sushantou in Tongshan, Jiangsu province.[2]

Jade cicada appear in burials during the Shang dynasty (ca. 1600–1046 BC), and the earliest excavated example of the placement of a jade cicada in the mouth of the deceased appears in burials dating to the middle Western Zhou dynasty (1046–771 BC).[3] The cicada's unusual lifecycle of years of dormancy followed by reemergence from the ground is the reason for the insect's association with the after life. Later, jade cicadas also served a decorative purpose and cicada remain a popular theme in Chinese jade carving.

—JJ

1. This cicada was formerly in the Alfred Bauer Collection and the Arthur M. Sackler Collection.

2. Gu 2005, vol. 7, p. 138.

3. Xia 1983, p. 134.

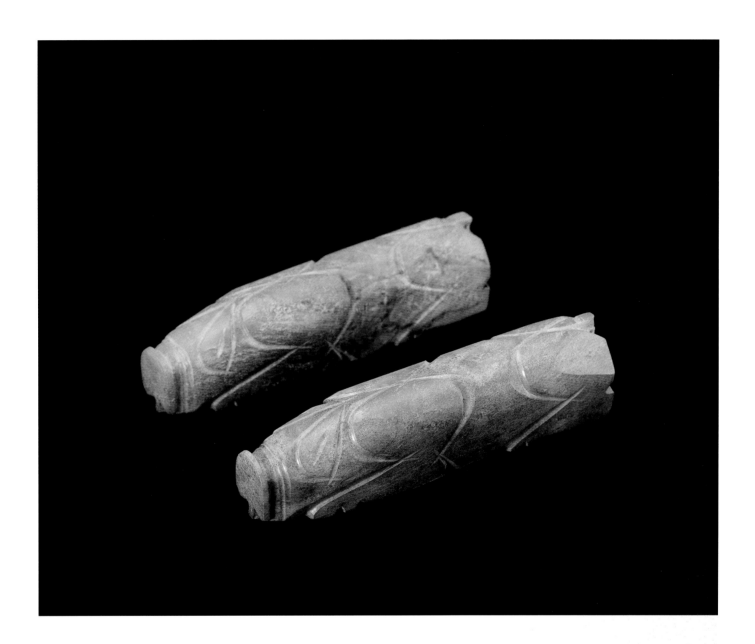

42. *Pair of Mortuary Pigs*; Late Western Han to Eastern Han dynasty, ca. 100 BC–220 AD; Nephrite; H 1⅛ × W 4⁹⁄₁₆ × D 1⅛ INCHES (2.9 × 11.6 × 2.9 CM); National Museum of History, Taiwan, 89-00053

Jade pigs are usually found in pairs in Han dynasty burials. The pigs were placed in the hands of the deceased. Interestingly, a similar burial practice of holding jade animals in the hands was practiced as early as the forth millennium BC in the Neolithic Hongshan culture in Northeastern China.[1]

The two pigs are similar in size and shape and are carved as rectangular blocks. With just a few deeply carved slanting lines, the artist defines the distinctive snout, face, ears, limbs, and bodies of the pigs. A small hole is present in a section of jade near the tail of each pig. The term "Eight Cuts" (*hanbadao*) is frequently used to describe the carving technique found on Han dynasty burial jade pigs. "Eight Cuts" refers to the simple and restrained carving style. Numerous similar jade porcine burial objects have been found in late Western Han and Eastern Han tombs.[2]　　— CLP

1. Gu 2005, vol. 2, pp. 120–1; So 1996, pp. 33–4.

2. Liu Yunhui 2009, p. 313, fig. 282; p. 314, fig. 283; p. 315, fig. 285, p. 316, fig. 286; p. 317, fig. 287; p. 318, fig. 288.

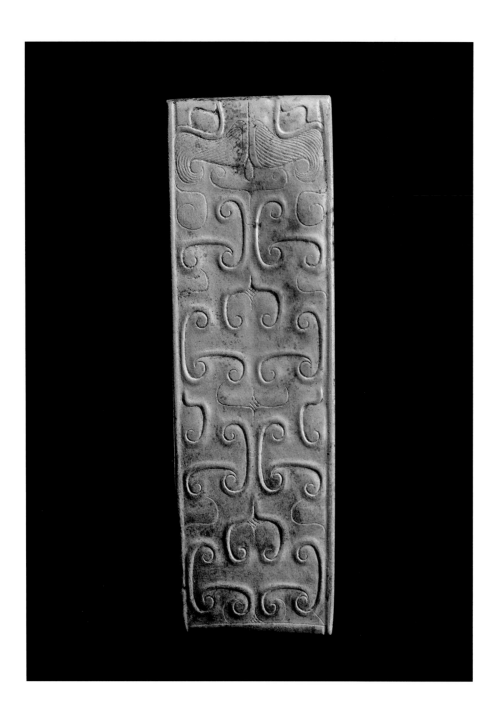

43. *Sword Slide*; Western Han dynasty (206 BC–9 AD); Nephrite; H 3¼ × W 1¹⁄₁₆ × D ½ INCHES
(8.3 × 2.7 × 1.3 CM); National Museum of History, Taiwan, 89-00056

The use of jade for sword fittings in China dates back to the Eastern Zhou dynasty
and remained popular during the Han dynasty. This grayish-green jade sword
slide with large opaque chalky white and tan areas was used to adorn a scabbard.
Angular C-shaped interlocking scrolls executed in raised relief decorate the surface.
A symmetrical low-relief zoomorphic mask can be identified on the upper band.
Lateral borders are defined by lines in raised relief. Similar objects are widely
distributed in Western Han tombs such as tomb number 15 at the Yangling
Mausoleum in Xianyang, Shaanxi province.[1]
— CLP

1. See also burial tomb number 240 in Changsha,
Hunan province dating to the late Western Han
dynasty (Changsha 1957, pp. 127–8, fig. 107,
plate 93: 12).

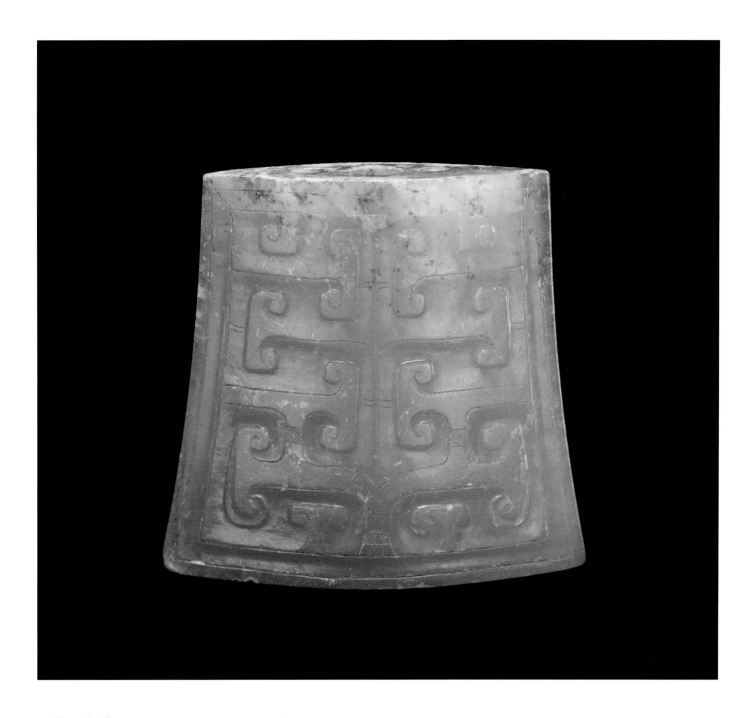

44. *Sword Chape*; Western Han dynasty (206 BC–9 AD); Nephrite; H 2⅛ × W 2¼ × D ¹¹⁄₁₆ INCHES (5.4 × 5.7 × 1.7 CM); National Museum of History, Taiwan, 89-00057

Translucent celadon-green jade with yellowish-brown patches is carved into a chape which would have formed the base of a sword sheath. The trapezoidal-form chape flares slightly at the base. The surface is carved with inter-locking angular spirals in low relief and an abstract *taotie* motif is evident near the lower edge of the chape. The finely polished slanting and incised spirals are well organized and symmetrical. The chape is hollow, permitting attachment to the scabbard. Similar examples were excavated from Western Han tombs at the Mancheng burial site in Hebei province and Zaoyuannanling in northern Xian, Shaanxi province.[1] —CLP

1. Mancheng 1980, p. 118; Liu Yunhui 2009, p. 181, fig 123.

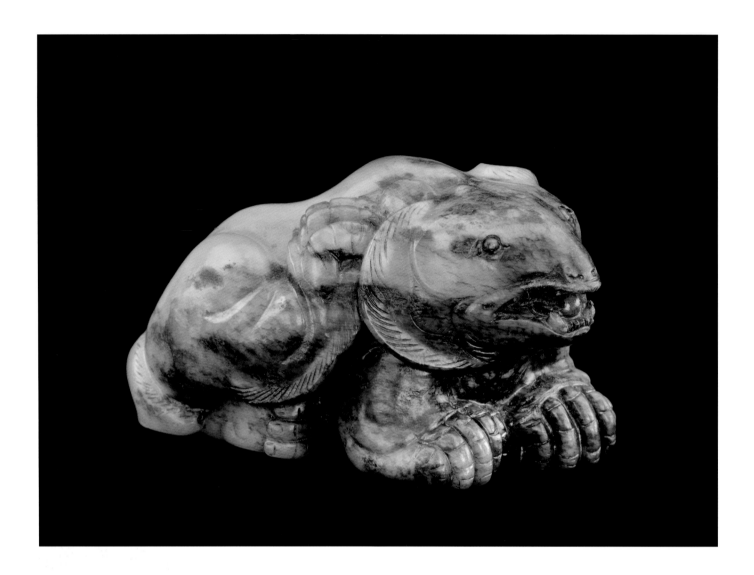

45. *Bear*; Late Western Han dynasty to early Eastern Han dynasty, 1st century BC to 1st century AD; Nephrite; H 1¹⁵⁄₁₆ × W 3¾ × D 1⁵⁄₁₆ INCHES (4.9 × 9.6 × 4.9 CM); Arthur M. Sackler Gallery, Smithsonian Institution, Washington, D.C.: Gift of Arthur M. Sackler, S1987.25

This remarkable jade bear is undoubtedly one of the finest known Han dynasty animal carvings.[1] The large and lively bear was carved from opaque yellowish-white jade with gray streaks. The bear is shown crouching with his left front leg leaning forward and his right rear paw raised to scratch behind his ear. The hindquarters of the bear are shown in three-quarters view which allows both rear paws to be seen. The bear turns his large triangular head slightly sideways. The head is framed by a ring of intaglio lines representing thick tufts of hair. The bear appears alert with open mouth, protruding tongue, well-delineated teeth, and semi-circular ears. The arch of the bear's spine forms a graceful curve extending from behind the head to the tail. The muscular body appears realistic, for example each paw features elongated claws and thick cushion-like paw pads.

This magnificent jade bear differs stylistically from a jade bear excavated from the tomb of the Han Emperor Yuandi (r. 48–33 BC),[2] and more closely relates to animated representations of muscular Han dynasty jade creatures such as a *bixie*, also from the Yuandi tomb, and an Eastern Han jade *bixie* from Shaanxi province.[3] The relatively large size of this Han jade sculpture suggests that it may have been used as a functional weight for stabilizing light materials.[4] A bronze bear weight from the Han dynasty was excavated in Hefei, Anhui province.[5] —CLP

1. Previously published in *Chinese Jade Animals* (Chung Wah-pui, Carol Michaelson, and Jenny F. So. Hong Kong: Urban Council of Hong Kong, 1996, pp. 74–5, no. 41); Salmony 1963, pl. 34:2a–b; Lawton, et. al., 1987, no. 68 and elsewhere. Previously in the collection of Desmond Gure.

2. Liu 2009, pp. 272–5, fig. 243.

3. Ibid., pp. 276–9, 280–2, fig. 244–5; Hebei 1991–3, vol. 4, no. 264.

4. Such Han dynasty weights were used for securing thin lacquer, reed mats, and other items (Sun Ji 2005, pp. 210–3).

5. Ibid., p. 212, fig. 33–7: 8.

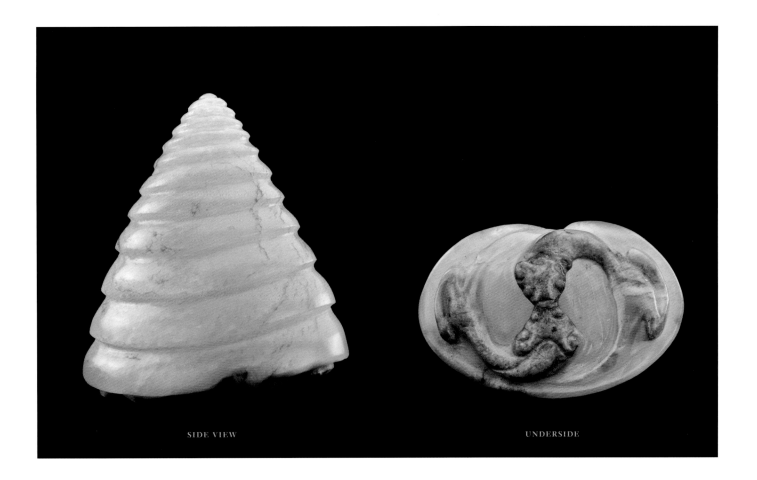

SIDE VIEW UNDERSIDE

46. ***Shell-shaped Object***; Han dynasty (206 BC–220 AD); Nephrite; H 2¹⁄₁₆ × W 1¾ × D 1⅛ INCHES (5.3 × 4.5 × 2.9 CM); Arthur M. Sackler Gallery, Smithsonian Institution, Washington, D.C.: Gift of Arthur M. Sackler, S1987.770

Semi-translucent, pale greenish-white jade with gold-colored veins is carved as a whorled shell. The conical spiral-like sculpture has layers of grooves running from tip to base. The underside of the shell reveals that the shape is actually composed of two intertwined dragons. Each creature is depicted in Han style as a *chi* dragon with feline-like head and body. This imaginative and creative combination of shell and *chi* dragon imagery may relate to Han dynasty cosmology. Several images found on a Han dynasty tomb tile show deities in shell-like form.[1] The artist cleverly incorporates a brown area on the stone in the depiction of the two creatures, forming a strong contrast with the white shell. — CLP

1. For a rare example of a female deity with a sinuous body extend from a spiral shell, see a Han dynasty tomb tile discovered at Wanchengqu, Huanchengxiang at Nanyang, Henan province, in Yang Yuan 2010, pp. 177–8.

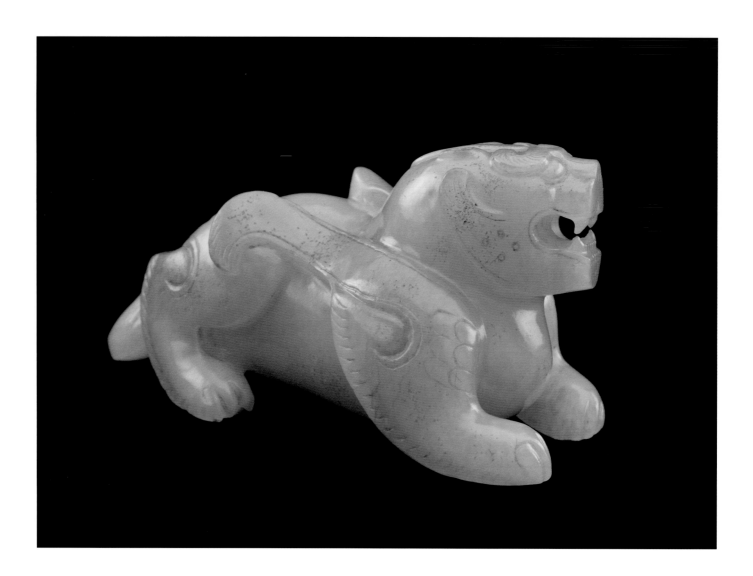

47. *Bixie*; Han dynasty (206 BC–220 AD); Nephrite; H 1⅞ × W 3¹³⁄₁₆ × D × 1¹⁵⁄₁₆ INCHES
(4.8 × 9.7 × 4.9 CM); Arthur M. Sackler Gallery, Smithsonian Institution, Washington, D.C.:
Gift of Arthur M. Sackler, S1987.797

This "mutton fat" white jade zoomorphic creature with tan markings is a chimera-like *bixie*. The *bixie* appears to march forward while turning his head to the left. The creature appears alert, with open mouth, flaring nostrils, and intense forward gaze. Details such as the tongue, pointed teeth, and paws are carefully rendered. A long tail is curled behind the *bixie*. Short step-like parallel stratified lines embellish the four limbs, a stylistic feature found on other Han dynasty animal sculptures.[1] Tiny circles decorate the creature's cheek. A pair of wings extend from frontal limbs, further indicating the mythical nature of the animal. Winged fantastic creature imagery likely originated in Central Asia and was imported into China in the Eastern Zhou dynasty.[2]

Large scale sculptures of beasts such as *bixie* dominate the passageways of Southern Dynasties (265–589) tombs. Southern Dynasties *bixie* are generally forward-facing and more muscular and elongated than this example. A stone sculpture of a *bixie* in similar posture dating to the Eastern Han dynasty (25–220) was found at Dianjiangtai in Yaan, Sichuan province.[3] Several stylistic characteristics present on this jade animal carving, such as the stratified line decoration, are consistent with Han images. The Chinese characters *jixing*, meaning auspicious, are incised on the belly of the animal and may have been carved in a later period. —CLP

1. Parallel stratified lines are present on a jade bear, bird, and other animals excavated from the tomb of Han emperor Yuandi (r. 48–33 BC), near Xian in Shaanxi province. For examples, see Liu 2009, p. 260, fig. 237; pp. 266–7, fig. 241; pp. 272–3, fig. 243; pp. 276–9, fig. 244; Hebei 1993, vol.3, fig. 147, 150 and 151.

2. Li Ling 2004, pp. 87–129.

3. Xu 1992, p. 113, fig. 11.

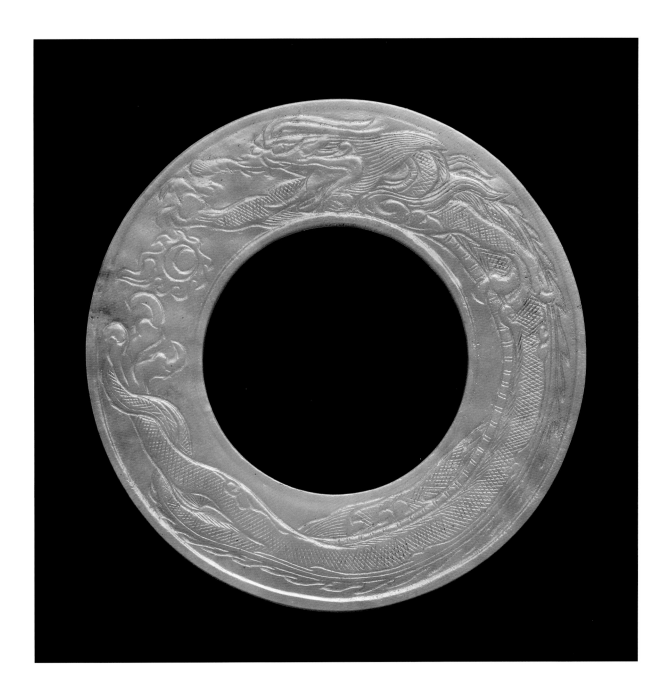

48. **Disc,** *bi*; Tang dynasty (618–907); Nephrite; DIAM 3¹¹⁄₁₆ × D ³⁄₁₆ INCHES (9.4 × 0.4 CM); Arthur M. Sackler Gallery, Smithsonian Institution, Washington, D.C.: Gift of Arthur M. Sackler, S1987.756

Composed of beautiful translucent "mutton fat" jade, this *bi* disc with large central hole has two raised narrow borders near the outer and inner perimeters.[1] Carving on both sides of the disc are very similar. A powerful flying dragon with open mouth and outstretched claws chases a flaming pearl. The vigorous dragon decorating the disc has a sinuous body with scale patterns and terminates in an intertwined tail. The rendering of this energetic flying dragon is characteristic of the Tang dynasty.[2] A *bi* disc of very similar material and décor is in the collection of the Shanghai Museum.[3]

— CLP

1. A late Tang glass disc with very similar decor was excavated from the tomb of Tang Emperor Jing (d. 888) (Shaanxi 1998, fig. 111-2).

2. A similar flying dragon image can be found on mural paintings in the Royal tomb at Changling in Shaanxi Province (Chu 2009, p. 314, fig. 513: 1).

3. Shanghai Museum, p. 33.

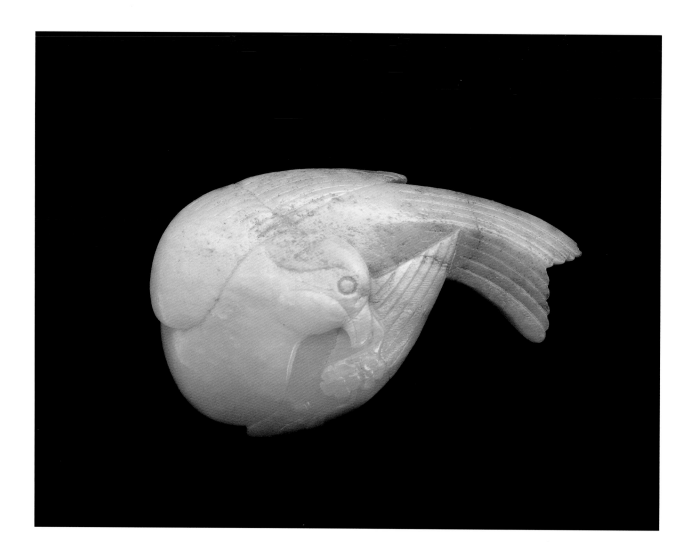

49. *Bird*; Tang dynasty (618–907); Nephrite; H 1¾ × W 3 × D 13⁄16 INCHES (4.5 × 7.6 × 2.0 CM); Arthur M. Sackler Gallery, Smithsonian Institution, Washington, D.C.: Gift of Arthur M. Sackler, s1987.799

Yellowish-green jade with golden brown markings is carved into the form of a bird. The tear-drop shaped jade is sensitively carved, with the resting bird appearing calm and content. The bird has an oval head, round incised eye, and a pointed and slightly hooked beak holding a stem with two flowers. The plumage is decorated with finely incised lines. The artist cleverly provides both aerial and lateral perspectives of the bird. The head of the bird turns backwards and rests against its body. The wings extend from the breast and are folded onto the tail. The bird's claws are represented on the underside of the figure, with two small drilling holes, likely used for mounting, located between the claws.

This beautiful jade carving is a fine example of *panmou*, the appreciation of an object through handling. Holding the object in the hands allows one to combine both visual and tactile appreciation. The size and convex shape of the bird is ideal for holding in the hands. Holding the sculpture creates a direct relationship between viewer and object and provides yet another dimension in the enjoyment of jade.

— CLP

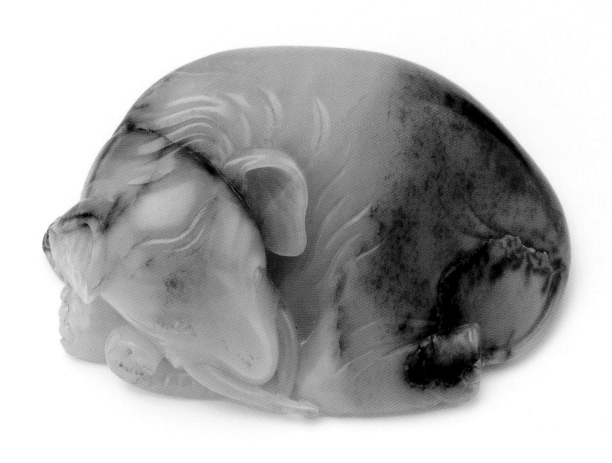

50. *Elephant*; Song dynasty (960–1279); Nephrite; H 2¹⁄₁₆ × W 4⅝ × D 3 INCHES (5.3 × 11.8 × 7.6 CM); Arthur M. Sackler Gallery, Smithsonian Institution, Washington, D.C.: Gift of Arthur M. Sackler, s1987.825

Lustrous "mutton fat" white jade with yellow and tan markings is carved into the form of a resting elephant.[1] With lowered head, curled trunk, and folded legs, the beautifully carved elephant appears relaxed. The trunk, flanked by two pointed and crossed tusks, sweeps up to touch a cheek. Beautifully curved grooves running along the back and trunk suggest the deeply folded skin of a pachyderm. The face of the elephant appears life-like with rounded eyes, wrinkled forehead, and flat ears. The long tail is tucked around the body. This fine jade animal figure is well proportioned and the carving restrained and elegant.

— CLP

1. Previously published in *Chinese Jade throughout the Ages* (Rawson, Jessica and John Ayers. London: The Oriental Ceramic Society, 1975, no. 205); *Chinese Jade Animals* (Chung Wah-pui, Carol Michaelson, and Jenny F. So. Hong Kong: Urban Council of Hong Kong: 1996, pp. 124–5, no. 100); *Mostra d'arte Cinese* (Venice 1954, no. 233). Previously in the collection of Desmond Gure.

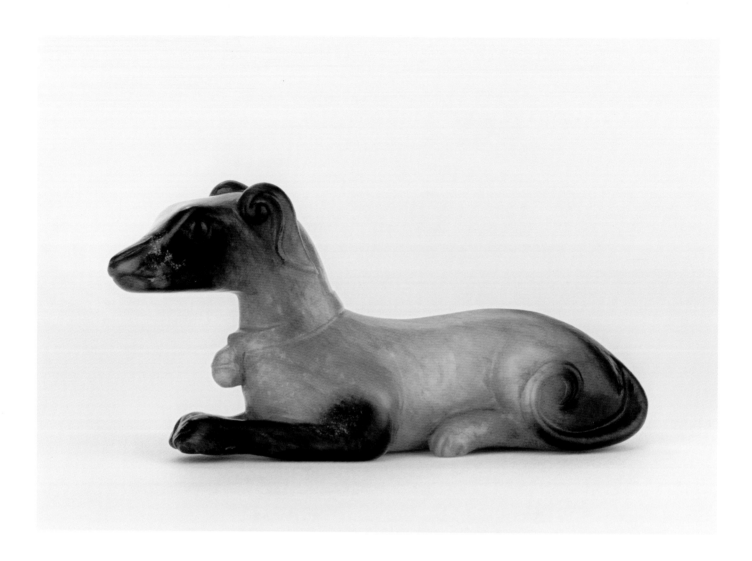

51. *Hound*; Five Dynasties period to Early Northern Song dynasty, ca. 10th to 11th centuries; Nephrite; H 1 9/16 × W 3 5/16 × D 1 INCHES (3.9 × 8.4 × 2.5 CM); Arthur M. Sackler Gallery, Smithsonian Institution, Washington, D.C.: Gift of Arthur M. Sackler, s1987.24

A recumbent hound is composed of grayish-green jade with dark brown markings on the limbs and muzzle.[1] The hound is seated and appears alert with raised head leaning slightly forward and with wide round eyes. Subtle vertical lines outline the hound's ribs. A bell hangs on a collar, indicating that the dog was kept as a pet. The artist skillfully incorporates the color of the stone into the design of the figure.[2] Images of hounds in China can be seen as early as the Han dynasty. Consistent with Chinese paintings in the Northern Song dynasty (960–1127), this elegant and naturalistically rendered image of a hound reflects the importance of realistic representation during the Song dynasty.[3]

— CLP

1. Previously published in *Chinese Jade throughout the Ages* (Rawson, Jessica and John Ayers. London: The Oriental Ceramic Society, 1975, no. 204); Gure, Desmond, "Selected Examples from the Jade Exhibition at Stockholm," in *Bulletin of the Museum of Far Eastern Antiquities* 36, 1964, pl. 25:1; Previously in the collections of Mrs. E. R. Randon and Desmond Gure.

2. Dark areas appearing on the figure may have been enhanced by heating.

3. Wenwu 1955, 8, p. 99, fig. 6.

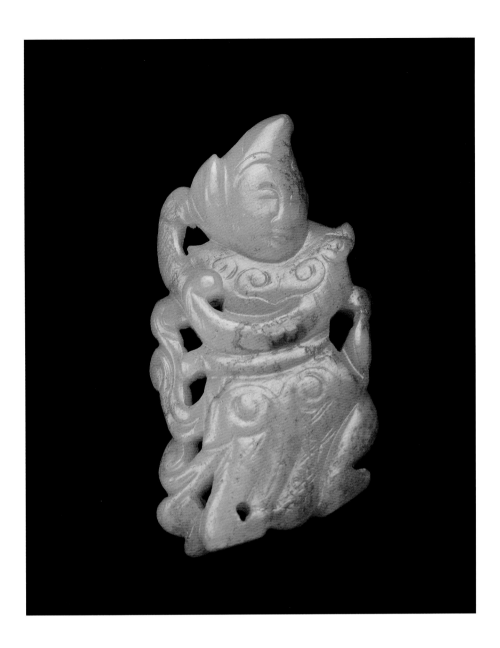

52. *Ornament in the Form of a Foreigner*; Jin dynasty (1115–1234); Nephrite;
H 2⅛ × W 1⅛ × D ½ INCHES (5.4 × 2.8 × 1.2 CM); Arthur M. Sackler Gallery, Smithsonian Institution,
Washington, D.C.: Gift of Arthur M. Sackler, S1987.792

Yellowish-white jade with scattered tan areas is carved in the form of a male dancer.
A channel is drilled vertically through the jade and would have been used to suspend
the object. The dancer's clothing differs from that of Han Chinese of the period. The
pointed hat, long robe, pointed boots, and round flared collar indicate that he is a
foreigner. The robe is covered with cross-hatching and spirals decorate the garment
near the thighs. Both of his hands are covered by extremely long sleeves which rise in
elegant curves. The shape of the curled sleeves is echoed in the long flowing belt that
extends from his waist. His left ankle is bent and his right foot lightly touches the
ground. The figure's posture and clothing combine to create a sense of energetic
movement. This remarkable figure is similar to an example unearthed in Shanghai
at the Yuan dynasty *Jiading fahua* pagoda.[1] Close comparison between a Jin dynasty
figure excavated at Heilongjiang province[2] and descriptions of Jin clothing in the
"History of Jin" (*Jinshi*),[3] as well as extant Jin dynasty mural paintings, suggest a Jin
dynasty date for this image. — CLP

1. Wenwu 1999, 2, pp. 12–3.

2. A similar style jade figure dressed in Chinese
long robe can be found in Xiangluchiang at Xunke
xian in Heilongjiang province (Li Chengi 2008,
p. 97).

3. Examples of mural painting and descriptions
from the "History of Jin" can be found in Huang
Nengfu and Qiao Qiaoling, *Yiguan tianxia:
zhongguo fuzhuang shi*, p. 208. This object was
also dated to the Jin dynasty in the excavated jade
catalog (Gu 2005, vol. 7, p. 208).

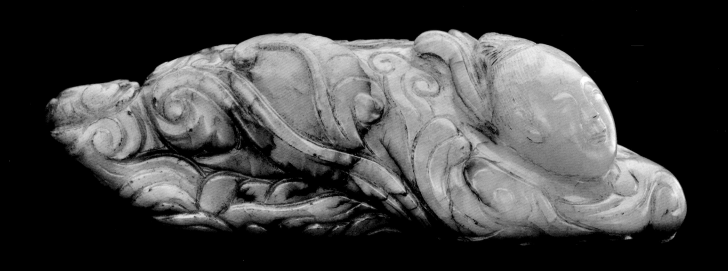

53. *Apsara*, *feitian*; Late Song to early Ming dynasty, ca. 12th to 15th centuries; Nephrite; H 1¼ × W 3⅞ × D 1⁵⁄₁₆ INCHES (3.1 × 9.8 × 3.4 CM); Arthur M. Sackler Gallery, Smithsonian Institution, Washington, D.C.: Gift of Arthur M. Sackler, s1987.814

Yellowish-white jade with black veins is carved in the form of an apsara in horizontal posture.[1] Apsaras are angel-like deities of the Buddhist tradition and were an especially popular subject in the religious art of the Tang dynasty. A hole drilled to the right of the figure's head (not pictured) was used for suspending the object. The apsara wears a long robe covering the arms and hands and is enveloped by a long flowing scarf. The movement created by the undulating textiles and the swirling clouds near the body and base creates the impression that the deity is in flight. The underside of the figure is similarly carved with billowing clouds. The auspicious *lingzhi* fungus, a symbol of immortality, is depicted in a simplified manner near the base and upon the figure's body, thus combining magical *lingzhi* fungus imagery with a Buddhist deity.[2] Early Chinese sculptures of apsaras carved in precious stone appear by the Jin dynasty.[3] Elegantly rendered features, such as beautifully stratified hair gathered into a top knot, smiling eyes, slightly opened mouth, and oval face are characteristics similar to jade images traditionally dated to the Yuan dynasty.[4]

— CLP

1. Previously published in *Chinese Jade throughout the Ages* (Rawson, Jessica and John Ayers. London: The Oriental Ceramic Society, 1975, p. 75, no. 220) and elsewhere.

2. See also a figure of Sudhana excavated from the Yuan dynasty Xilin pagoda site near Shanghai which combines *lingzhi* fungus with a Buddhist image (Gu 2005, vol. 7, p. 214).

3. An apsara-shaped *shoushan* stone carving was excavated at the Jin dynasty Suibin burial site at Zhongxing, Heilongjiang province. (Kaogu 1979, 4, p. 333, plate 7: 6), though James Watt dated it as Liao (916–1125) (Watt 1980, p. 115, fig. 98), and Zhao Pinchun dated it as Tang (Li and Zhao 2008, p. 92). Another jade apsara was excavated from a Jin dynasty (1115–1234) house foundation at the city-site of Wunushan in Huanren, Liaoning province (Gu 2005, vol. 2, p. 160).

4. Examples suggesting a later date include: (a) Two Daoist figures appearing on a jade bowl at the Cleveland Museum of Art which is traditionally dated to the Yuan dynasty but may actually be a late Song or early Ming interpretation of a 10th to 11th century prototype (So 2011, pp. 10–4); (b) An image of Sudhana dated to the Yuan dynasty excavated at Xilin pagoda in Songjiang, Shanghai (Gu 2005, vol. 7, p. 214); (c) A jade female figure excavated from the Yuan dynasty Yuandadou burial site in Beijing (Gu 2005, vol. 1, p. 41); (d) Similarly carved object excavated from the tomb of a son of Qing Emperor Qianlong at Miyun, Beijing (Gu 2005, vol. 1, p. 54); (e) A comparison of the spirals and foliate scrolls on this figure with other excavated examples suggests stylistic affinity to 13th to 15th century Chinese jade carving. The long foliate leaves at the back are closely related to Yuan style jade carving, as seen on the only excavated example of *chunshan qiushui* jade carvings excavated from the tomb of Qianyu at Dafuxiang, Jiangsu province (Yang Boda 2005, vol. 2, p. 484, fig. 197). The spiral scrollwork is comparable to the late 14th century Ming jades, such as a jade belt excavated from the tomb of Wangxingzu, Nanjing (Kaogu 1972, 4; Hebei 2005, p. 485, fig. 199).

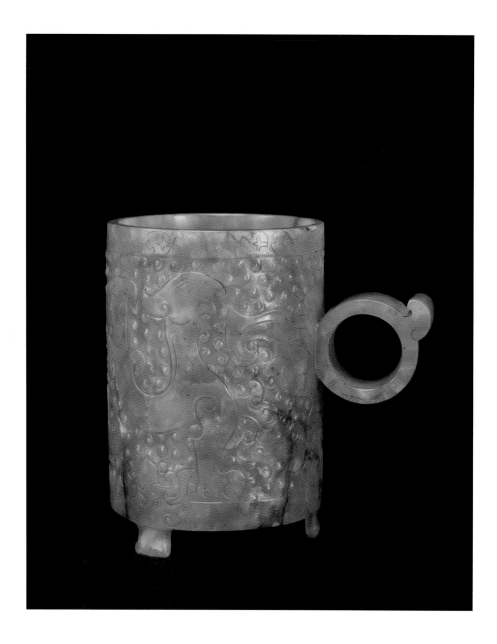

54. *Handled Cup,* *lian*; Song dynasty (960–1279); Nephrite; H 3⅝ × W 4¼ INCHES (9.2 × 10.8 CM); A Private American Collection

Translucent celadon jade with russet, brown, and cream markings is carved in the form of a cylindrical cup resting on three short legs.[1] Archaistic décor carved in low relief appears between narrow upper and lower bands of incised curvilinear patterns. The hooked handle forms the trunk of an elephant-like creature. Two crested birds with open beaks and interlocking tails flank the elephantine handle. Regularly distributed comma-shaped spirals carved in relief form a dense ground for the zoomorphic imagery. The shape and imagery appearing on this beautiful vessel are intentional references to Chinese antiquity, particularly archaic bronzes. — JJ

1. Previously published in *Chinese Jade throughout the Ages* (Rawson, Jessica and John Ayers. London: The Oriental Ceramic Society, 1975, p. 100); BMFEA 1964, no. 36, p. 17; *Chinese Jade through the Wei Dynasty* (Salmony, Alfred. New York: Ronald Press, 1963, plate 39). Formerly in the Wilfred Fleisher Collection and ex-Giuseppe Eskenazi.

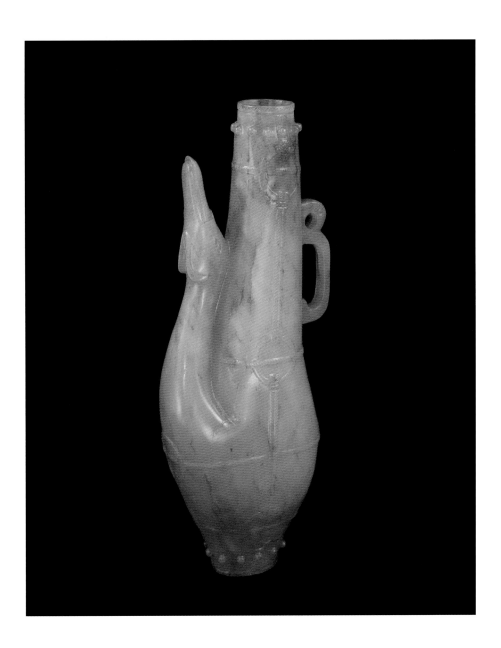

55. *Archaistic Bird-form Ewer*; Southern Song dynasty (1127–1279); Nephrite; H 6¼ ×
W 2½ (15.9 × 6.4 CM); A Private American Collection

Semi-translucent yellowish-green jade with golden veins is carved into the form of a
goose-shaped vessel.[1] This elegant, slender ewer features the realistically modeled
head and elongated neck of a goose extending from the vessel's body. While the vessel
has been hollowed, the neck and head are solid and do not form a working spout. An
S-shaped bird-form handle appears on the upper shoulder of the vessel. Four horizon-
tal bands of incised lines mimicking rope surround the object. Rings replicating
metalwork are used to join the vertical and horizontal strands of simulated rope. The
circular mouth and foot are surrounded by knobs representing knots of tied rope. This
pear-shaped vessel is an imagined archaistic form, as such vessels due not appear in
the Shang and Zhou dynasties. The naturalistic design of the goose-shaped spout is
similar to a bronze vessel recorded in the Song dynasty catalogue entitled *Illustrated
Xuanhe Antiquities (xuanhe bogutu)* (1107–1123)[2] suggesting this vessel is based on
a Southern Song interpretation of archaic forms. A bronze vessel of similar shape is
represented in a Ming dynasty painting entitled "Enjoying Antiquities" by Tu Chin
(ca. 1465–1505).[3]

— CLP

1. Formerly in the Collection of Professor Cheng
Te-K'un, PhD (1907–2001) who taught Chinese
archaeology in China, at Cambridge University,
and in Hong Kong.

2. Wangfu (1079–1126), 1987 (reprinted), p. 512.

3. Art historical catalogs such as *xuanhe bogutu*
flourished in the Wanli period (1573–1619). The
manufacturing of archaic vessel types in the late
Ming dynasty (16th–17th century) was based on
reprinted antiquities catalogs. The pear shaped
archaistic bronze vessel depicted in the painting
is plain in design and lacks the animal form spout.
The painting is in the collection of the National
Palace Museum, Taipei (Taipei 2003, pp. 68–9,
fig. 1-44).

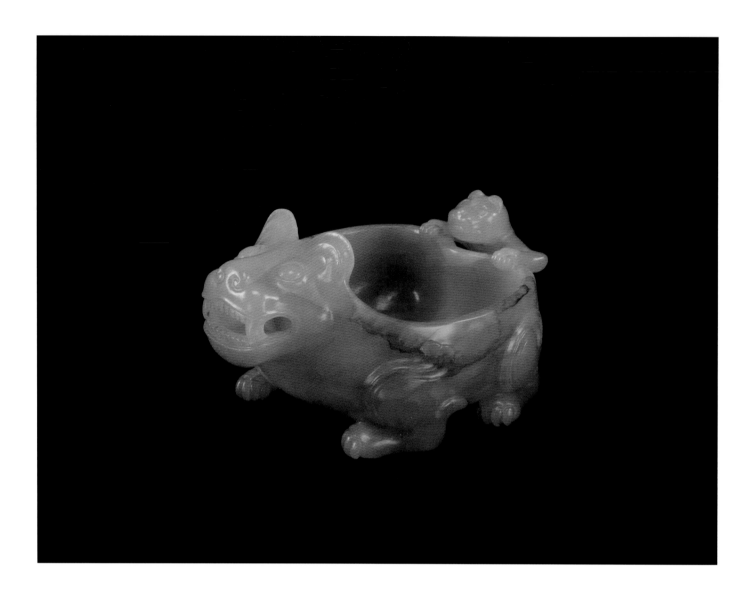

56. *Archaistic Pouring Vessel*; Southern Song dynasty (1127–1279); Nephrite; H 2⅞ ×
W 3⅝ INCHES (7.3 × 9.2 CM); A Private American Collection

Semi-translucent yellowish-white jade with tan markings is carved in the form of an
archaistic vessel.[1] The feline creature stands on four feet, his head forming the spout.
Great attention is paid to the rendering of the animal's face, such as round protruding
eyes, broad nose, and open mouth with sharp teeth. A young feline creature, perhaps
a cub clinging vigorously to his mother, forms the handle. This jade vessel is a
miniature reinterpretation of larger bronze prototypes. Both the shape of the vessel,
which incorporates crouching animal figures, and the restrained surface ornamenta-
tion suggest that the source of inspiration for this object is *yi* bronze vessels of the
Zhou dynasty.[2] —JJ

1. Previously exhibited at The Oriental Ceramic
Society and the Victoria and Albert Museum.

2. The shape of this jade vessel is similar to
Western Zhou *yi* vessels such as the bronze vessel
excavated from Zhuangbai village at Fufeng,
Shaanxi province (Li 1994, p. 246, fig. 207; Rawson
1990, vol. IIB, pp. 713–716).

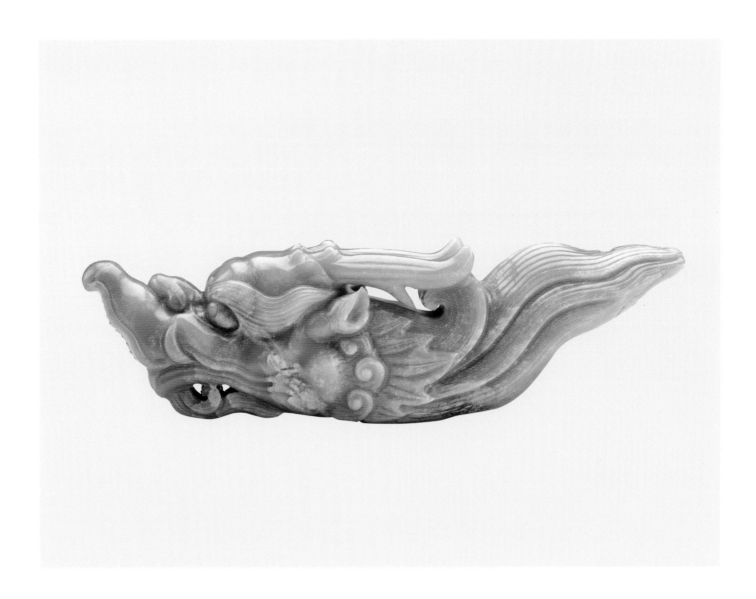

57. *Dragon Head Finial*; Yuan dynasty (1271–1368); Nephrite; H 2¹¹⁄₁₆ × W 9⁹⁄₁₆ × D 2 INCHES (6.9 × 24.3 × 5.1 CM); Arthur M. Sackler Gallery, Smithsonian Institution, Washington, D.C.: Gift of Arthur M. Sackler, S1987.819

This grayish-green jade head of a dragon is unusually large.[1] The original rectangular shape of the jade block has been retained in the sculpture. Rectangular dragon head jade carvings can be found as early as the Tang dynasty (618–906).[2] Numerous features of Yuan dynasty dragons are evident in this example, such as a pair of goat-like horns, muscular forehead, conical ears, flat nose with wide flaring nostrils, fierce eyes, pointed muzzle, three curling beards extending beneath the ears, and hair flowing from the back of the head. A deep groove on the underside of the dragon head indicates that the sculpture was originally attached to other components.

Comparable examples of large Yuan dynasty dragon head sculptures can be found in the marble carvings at Yonglegong in Hebei province[3] and at Kondui in the Transbaikal region of Inner Mongolia.[4] Marble dragon heads decorated balustrades, a practice which continued at the Imperial palaces in the Qing dynasty.[5] The massive size and weight of this jade dragon head, and the preciousness of the material, suggests that the object was used either as an indoor architectural element or to embellish furniture.

— CLP

1. Previously published in *Chinese Jade Animals* (Chung Wah-pui, Carol Michaelson, and Jenny F. So. Hong Kong: Urban Council of Hong Kong, 1996, pp. 148–9, no. 128). Previously in the collection of Desmond Gure.

2. Zhang 2004, p. 139.

3. Excavated 1999 (*Zhongguo wenwu bao*, December 12, 1999).

4. Steinhardt 2010, p. 71, fig. 98.

5. Beijing 2007, p. 37.

58. *Reticulated Belt Set*; Ming dynasty (1368–1644); Nephrite; Largest: H 2 × W 5 ½ ×
D ¼ INCHES (5.1 × 14.0 × 0.6 CM); Smallest: H 2 × W 1 × D ¼ INCHES (5.1 × 2.5 × 0.6 CM); Overall:
H 2 × W 35 1/16 × D ¼ INCHES (5.1 × 89.1 × 0.6 CM); National Museum of History, Taiwan, 96-00110

Thirteen tan and grayish-white hued nephrite jade plaques are intricately carved in openwork style.[1] Originally, they would have been set into a belt. Consistent with a popular Ming dynasty jade carving technique, the openwork plaques are carved and finished on both sides. Each plaque is contained within a uniform border with an additional interior quatrefoil border appearing in many plaques. Lotuses and scrolling vines form a dense ground. The primary motif on the plaques is the auspicious Chinese character *xi*, meaning happiness. The two largest and two smallest plaques vary from the others. The small plaques feature a floral motif only and no script while the two largest plaques feature *xi* in the center flanked by the character *wan*, which literally means "ten-thousands" but in this context means many or much. The remaining eight plaques are carved with a central *xi* character flanked by two swastikas, which are also known in Mandarin Chinese as *wan*. The swastika is an ancient Indian symbol thought to have come to China via the Buddhist tradition. The swastika appears in later Chinese art as both an auspicious decorative motif and a reference to Buddhism.
—JJ

1. A single oval jade plaque at the British Museum is of similar date and material (Rawson 1995, p. 335).

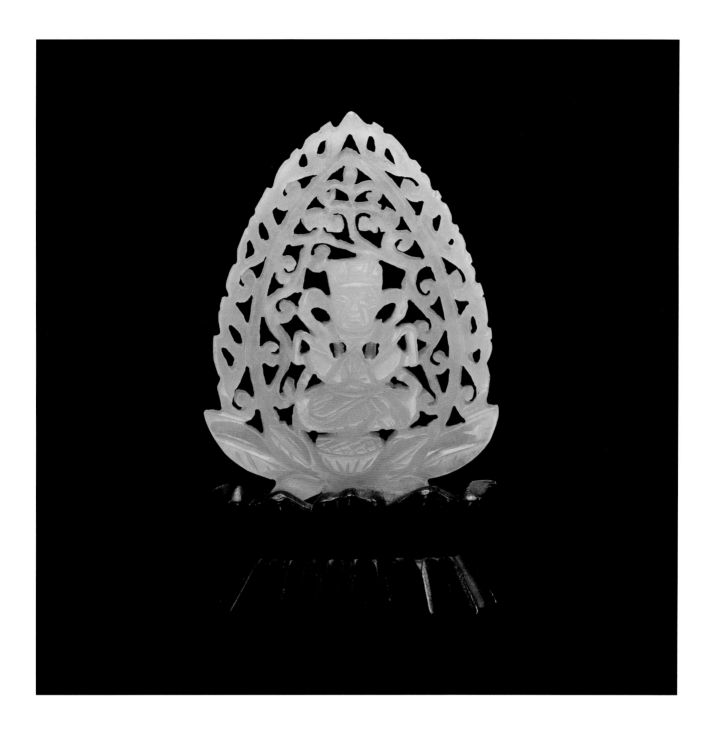

59. *Seated Buddha*; Ming dynasty (1368–1644); Nephrite; Overall: H 2¾ × W 1⅝ × D ⁷⁄₁₆ INCHES (7.0 × 4.1 × 1.1 CM); Jade: H 2 × W 1⅝ × D ¼ INCHES (5.1 × 4.1 × 0.6 CM); National Museum of History, Taiwan, 71-00934

A Buddha is seated in meditation with hands pressed together in supplication. The Buddha is shown in front of a reticulated teardrop-shaped halo with notches surrounding an inner border. Vine-like scrolls form the central motif of the mandorla. The Buddha's facial features are outlined with short incised lines. Ribbon-like scarves can be seen near the arms and shoulders of the Buddha. A lotus flower with noticeable central seed-pod forms the seat of the figure. The reverse side of the image was left uncarved. The sculpture is set into a modern wooden base. This well-polished pale-green jade sculpture features openwork carving and strong deliberate lines consistent with jade objects of the period. —JJ

60. **Hair Ornament,** *fashi*; Ming dynasty (1368–1644); Nephrite; H 1⅞ × W 3⅛ × D 2⅜ INCHES (4.8 × 7.9 × 6.0 CM); Arthur M. Sackler Gallery, Smithsonian Institution, Washington, D.C.: Gift of Arthur M. Sackler, s1987.800

This simple yet elegant olive-green hair ornament is beautifully carved and highly polished. This hair ornament is hollowed inside and was intended to enclose a topknot. Two holes on the sides of the ornament were used for the insertion of a hairpin. The surface of the hair ornament is unadorned except for two incised lines which create the impression of rope encircling the headdress. Hair ornaments of this type originated in the Five Dynasties (907–960),[1] and were popular in the Song dynasty (960–1279).[2] During the Ming dynasty, small headdresses were worn and hidden by a cloth crown, as illustrated in Ming dynasty mural paintings such as those found at Baoen pagoda at Pingwu, Sichuan province.[3] These Ming dynasty hair ornaments were made of varied materials including gold, silver, agate, amber, and wood. A similar Ming dynasty amber headdress with rope-like decoration was excavated from the tomb of Xu Fu at Bancangcun, Nanjing in Jiangsu province.[4] A similar headdress made of gold with a jade hairpin was excavated from the tomb of Mu Changzuo at Mount Jiangjun in Nanjing dating to 1625.[5] —CLP

1. Sun Ji 2005, p. 368.

2. For an example of a Song dynasty jade hair ornament, see an object excavated from the burial site of Wuxian, Tianping in Jiangsu province (Zheng 2004, p. 157).

3. Sun Ji 2005, p. 370.

4. Gu 2005, vol. 7, p. 198.

5. Knight, Li, and Bartholomew 2007, p. 43.

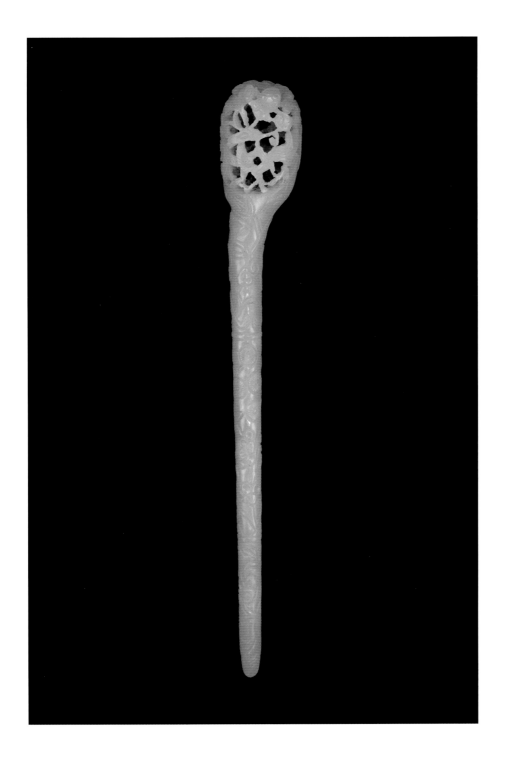

61. *Hairpin*; Late Ming dynasty, 16th to 17th century; Nephrite; H 8 × W 1 × D ⅞ INCHES
(20.3 × 2.5 × 2.2 CM); A Private American Collection

Translucent whitish-celadon jade is carved in the form of a hairpin with solid tapering stem and hollow openwork spherical head.[1] The stem is decorated in three distinct bands with the upper band featuring a coiling dragon, the central and largest band carved with images of the Three Friends of Winter (pine, bamboo, and prunus), and the lower band adorned with plants and *lingzhi* fungus. Both sides of the spherical head feature an image of a crested bird. The birds are surrounded by clouds, *lingzhi* fungus, and plants. Jade hairpins were fashionable in the Ming dynasty and were an adornment limited to the elite. —JJ

1. Previously published in *Jades from China* (Forsyth, Angus and Brian McElney. Bath: The Museum of East Asian Art, 1994, p. 368). Formerly in the Peony Collection.

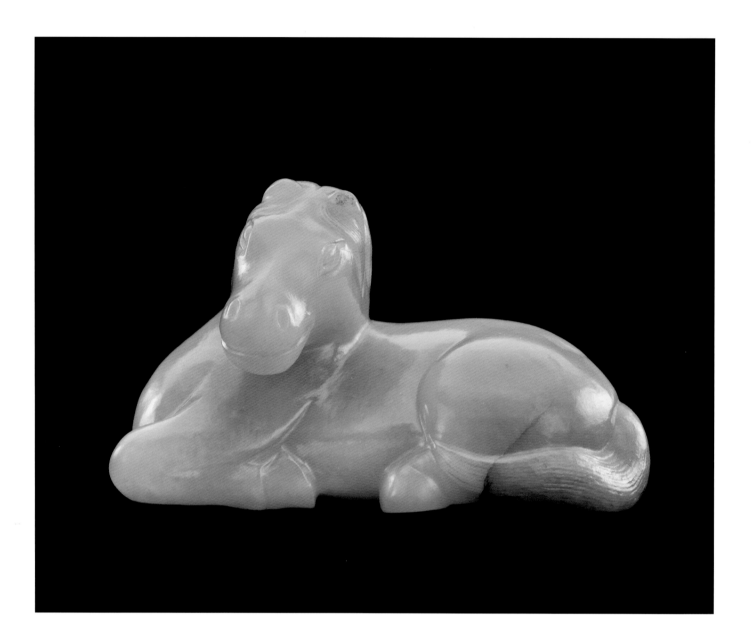

62. *Horse*; Late Ming–early Qing dynasty, 17th century; Nephrite; H 1¹³⁄₁₆ × W 3¹⁄₁₆ × D 1¹¹⁄₁₆ INCHES (4.6 × 7.7 × 4.3 CM); Arthur M. Sackler Gallery, Smithsonian Institution, Washington, D.C.: Gift of Arthur M. Sackler, s1987.812

Pale celadon jade with tan and red areas is carved into the form of a recumbent horse. The horse appears relaxed, perhaps even smiling. The hooves and legs are tucked under the body and the mane and tail are carved with fine lines. The soft contours of the sculpture capture the volume of the horse's body. Recumbent jade horses were popular in the Ming and Qing dynasties, with fine examples in the Sir Joseph Hotung Collection at the British Museum and the Seattle Art Museum.[1]

— JJ

1. Hotung Collection (Rawson 1995, p. 376–7, fig. 26: 20); Seattle Art Museum (Watt 1989, p. 82, no. 57).

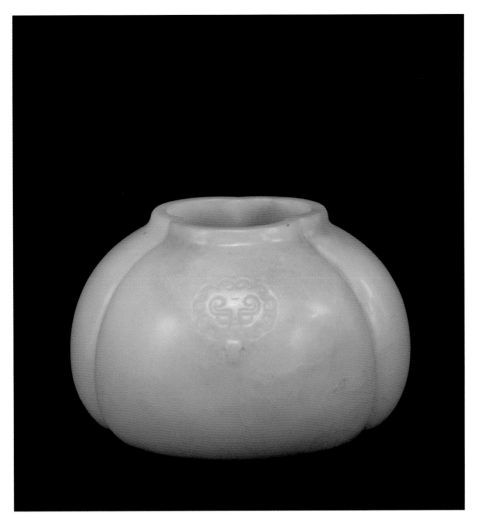

63. *Lobed Water Pot*, Signed Lu Zhigang; Late Ming dynasty, 16th century; Nephrite; H 1¾ × W 2¾ INCHES (4.4 × 7.0 CM); A Private American Collection

Semi-translucent, yellowish-white jade is beautifully carved into the form of a three-lobed water pot. The drum-like body is round and the surface is highly polished. The base of the vessel is plain and smooth except for lines in raised relief comprising the first name of the artist "Zhigang."

In the lower reaches of the Yangzi river in the late Ming dynasty, economic prosperity and a growing middle class increased patronage of the arts. Lu Zhigang, who signed his name on this water pot, was among the very few jade carvers named in poetry, collector's notes, and local histories of the period. Lu Zhigang was born in Taican, near Suzhou, around the late Jiajing to early Wanli periods of the Ming dynasty (ca. 1550–1592) and was renowned for his jade carvings, particularly among the literati. Lu Zhigang was well known for his creation of jade water vessels, hairpins, and cicadas.[1]

The water pot is incised with a *taotie* mask appearing on the center of two of the three lobes. Each of the *taotie* includes a small hook protruding from the mask. The *taotie* motif was particularly prevalent the Eastern Zhou (770–221 BC) and Han dynasties (206 BC–220 AD). The elegant and archaistic design of this water pot is similar to vessels described by Ming literati such as the painter Gaolian (1573–1620) in his book *Zunsheng bajian* (1591). — CLP

1. Yang Boda 2005, vol. 3, p. 880.

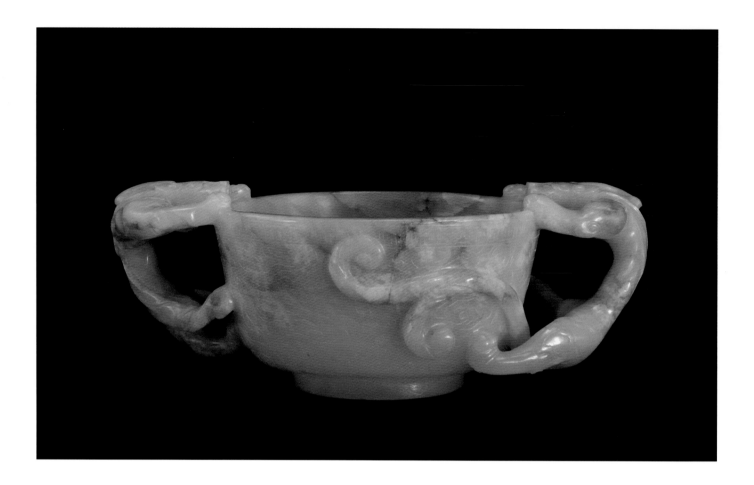

64. *Two Handle Dragon Cup*; Ming dynasty (1368–1644); Nephrite; H 2 × W 5⅝ INCHES
(5.1 × 14.3 CM); A Private American Collection

This semi-translucent, yellowish-green jade cup with two animal-form handles is a fine example of a well known jade vessel shape appearing in the Ming dynasty.[1] The cup stands on a short circular foot with two fairly symmetrical single-horned *chi* dragons clinging to the lateral sides. Each feline-like dragon has muscular arms and legs. The dragons bite the rim of the cup and their limbs powerfully grasp the vessel, creating two handles. The bifurcated, scrolling tail of each dragon extends along the surface of the cup in high relief. A band of incised *hui* scrolls appear along the mouth of the rim, and numerous incised *chi* dragons surrounded by cloud-shaped patterns appear in low relief on the exterior of the cup. The design of this vessel may originate in ceramic and metalwork prototypes produced in the Song dynasty.[2] The underside of the cup is incised with a ring of twelve seal script characters inside the foot rim which wish blessings for sons and grandsons forever.

Chinese and Persian art have greatly influenced each other over the centuries, including the development of jade carving styles.[3] An example of this artistic interaction is evident in a jade cup now in the collection of the British Museum that relates directly to this dragon cup. The British Museum's example is very similarly carved, though only bearing one *chi* dragon handle and composed of darker jade. It is dated as 1417–1449 and thought to have been produced in Central Asia.[4] The name Ulugh Beg Gurgan is engraved in Persian on the side of the British Museum's cup.[5] The British Museum cup was probably based on a Ming imperial jade model, similar to this *Two Handle Dragon Cup*, and was likely produced either in Khotan or in the Timurid Empire in the 15th century. Central Asia was an active source of jade and jade carvings in the 15th century and kingdoms such as Khotan served as a crossroads of jade carving styles and designs.
— CLP

1. Previously in the Peony Collection.

2. Similar Song dynasty metalwork and ceramics prototypes include a single-handled bronze cup with scroll patterns excavated from the gold and silver metalwork hoard in Pengzhou, Sichuan (Pengzhou 2003, color plate 46: 1) and a very similar two handled celadon cup (Kerr 2009, p. 266, fig. 148–9).

3. For example, Imperial records show that a delegation in 1445 from Ming Emperor Zhengtong to Ulugh Beg Gurgan came bearing gifts including jade vessels.

4. British Museum accession number OA 1959.11-20.1 (36), see Pinder-Wilson 1992, p. 36.

5. Ulugh Beg Gurgan (1394–1449) was grandson of King Timur of the Central Asian Timurid dynasty (1370–1526).

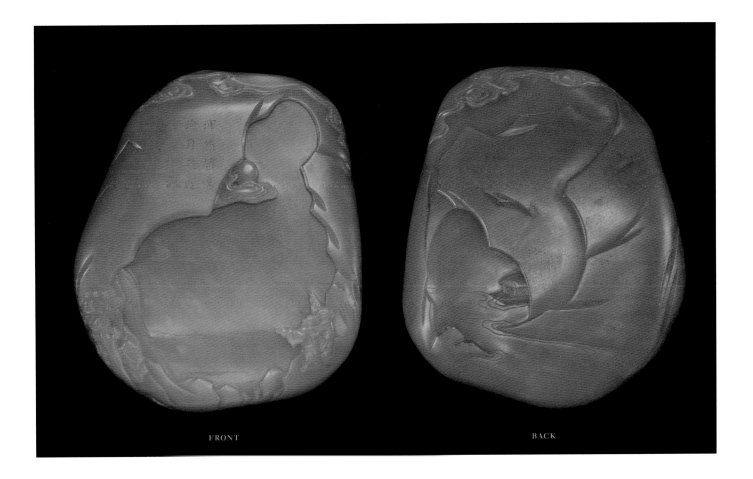

FRONT BACK

65. *Inkstone*; Qing dynasty, 17th to 18th century; Nephrite; H 5¾ × W 4 ½ × D 2⅜ INCHES
(14.6 × 10.8 × 6.0 CM); A Private American Collection

This beautiful pale celadon-green jade inkstone is polished to a silky luster.[1] The
smooth satin surface of the ink pool would not be practical for grinding ink and
confirms that the object served a purely aesthetic rather than utilitarian purpose.
The restrained and subtle carving allows the viewer to fully appreciate the natural
beauty of the stone.

An elegant and understated landscape appears on the front of the inkstone. Two
scholars are shown in the lower right and appear to be enjoying the beauty of a full
moon partially covered by a cloud. The men both point with one hand and have an
arm wrapped around each other in a casual and familiar manner uncommon in
Chinese art. In the lower section, a waterfall to the left flows gently into the ink well.
A pine tree and rocky landscape form the lower border. Delicately incised irregular
lines represent ripples and waves on the water.

In the upper left, an inscription comprised of four verses of four characters each
describe the natural beauty of the jade, the appearance of the full moon and pines,
and the virtues of a long life. A small oval seal incised with the two characters *chunhe*,
meaning "gentle spring," is placed to the left of the beautifully carved calligraphic
inscription.

On the reverse side of the inkstone a boat emerges from a rocky grotto sur-
mounted by swirling clouds. Scenes of the solitary fisherman are based on Chinese
literati landscape paintings. Beginning in the Yuan dynasty (1271–1368), images of a
fisherman in a boat represent the idealized life of the recluse who abandons worldly
concerns. The Yuan dynasty painter Wu Zhen (1280–1354) is particularly well known
for such imagery.[2] The friendship represented by the two gentlemen enjoying natural
beauty also represents a literati ideal.

— CLP

1. Previously published in *Jades from China*
(Forsyth, Angus and Brian McElney. Bath: The
Museum of East Asian Art, 1994, p. 410). Formerly
in the Peony Collection.

2. Cahill 1997, p. 184.

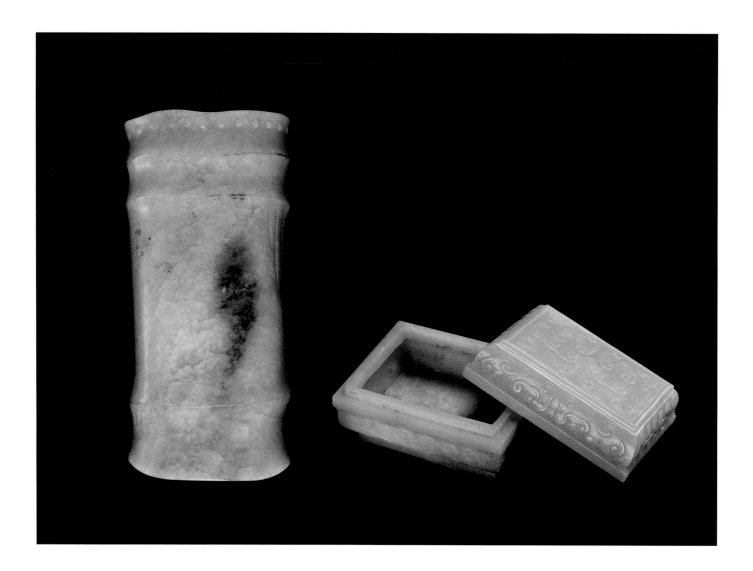

66. *Bamboo Wrist Rest*; Qing dynasty (1644–1911); Nephrite; H 4⁵⁄₁₆ × W 2¹⁄₁₆ × D ½ INCHES (11.0 × 5.2 × 1.3 CM); National Museum of History, Taiwan, 71-00962

This wrist rest would be a suitable desk item for a scholar or official. The slightly convex wrist rest serves an ergonomic purpose by elevating and steadying the hand while painting or practicing calligraphy. Wrist rests are normally made of split bamboo. This grayish-white nephrite example with brown and tan markings is carved to appear like a bamboo wrist rest, including several leaves and deeply carved joints. —JJ

67. *Covered Box*; Qing dynasty (1644–1911); Nephrite; H 1½ × W 2½ × D 2 INCHES (3.8 × 6.4 × 5.1 CM); National Museum of History, Taiwan, 71-01005

Box and cover are carved from the same tannish-green block of nephrite. The top and sides of the lid and sides of the box are carved with motifs such as *lingzhi* fungus and C-scroll clouds. This covered box is an appropriate item for a scholar or official's desk. Boxes of this size and shape were sometimes used to hold vermillion seal paste. —JJ

68. *Spinach Jade Brushpot*; Qing dynasty, 18th century; Nephrite; H 6¾ × W 6¼ INCHES (17.1 × 15.9 CM); A Private American Collection

"Spinach jade" of even tone with black spots, consistent with jade sourced in Manasi, Xinjiang, is very deeply carved with figures in a rocky landscape. An unadorned band extending around the lip of the brushpot is carved to appear like swirling clouds. Nine human figures appear in the landscape in two distinct scenes. In the first figural scene (pictured), two elderly gentleman meet below a temple or residence. A third gentleman approaches from the right, joined by a young attendant. In the second scene, three men are shown in the rocky landscape, joined by two attendants. Architectural features, such as stairs, railings, and tiled roofs are well proportioned, carved with precision, and create a strong sense of depth. The thick walls of the brushpot are so deeply carved as to become translucent in areas. The brushpot rests on five evenly spaced short wide rounded feet. This *tour de force* of jade carving would be an appropriate and prized object on a scholar or official's desk.

—JJ

69–70. **Scepters,** *ruyi*; Qing dynasty, Qianlong period (1735–1796); Nephrite; H 15⅝ × W 3 INCHES (39.7 × 7.6 CM), without pendants and tassels; National Museum of History, Taiwan, H0000254 and H0000256

Ruyi, which literally means "as you wish," is a symbol of learning and self-cultivation in China.[1] *Ruyi* were in use by the Han dynasty (206 BC–220 AD). Literati painting of the Ming and Qing dynasties often show the idealized learned gentleman carrying a *ruyi* scepter. *Ruyi* were prized gifts to and from the Emperor and were appropriate objects for a scholar's studio.

The heads of the *ruyi* are in the shape of the immortality-granting *lingzhi* fungus and are decorated with dragons and flaming pearls. Auspicious symbols also decorate the handles of the *ruyi*, including pairs of fish and bats. Jade links attach two jade pendants to each *ruyi*, with silk tassels attached to the lower pendants.

These *ruyi* are from a group of nine *ruyi* believed to have been given as tribute to Emperor Qianlong in the fifteenth year of his reign (1750) from a Vietnamese delegation. Of the group of *ruyi*, four are composed of nephrite, three are agate, one is crystal, and another is made of jadeite. All of these stones would have been considered "jade," or "*yu*," in the broadest definition of the term meaning beautiful and precious hard stone. A similar *ruyi* was excavated from the tomb of one of Emperor Qianlong's sons at Miyun in Beijing.[2] —JJ

1. Previously published in *Jade: Ch'ing Dynasty Treasures* (*Qing dai yu diao zhimei*, Taipei: National Museum of History, Taiwan, 1998, pp. 220–222 and p. 289).

2. Gu 2005, vol. 1, p. 95.

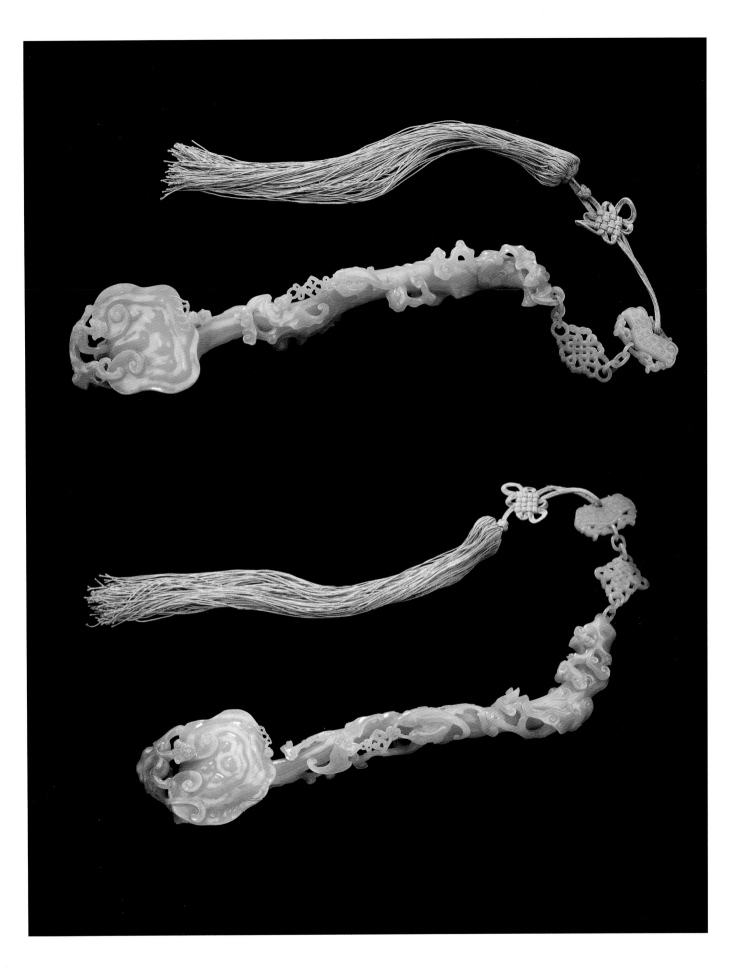

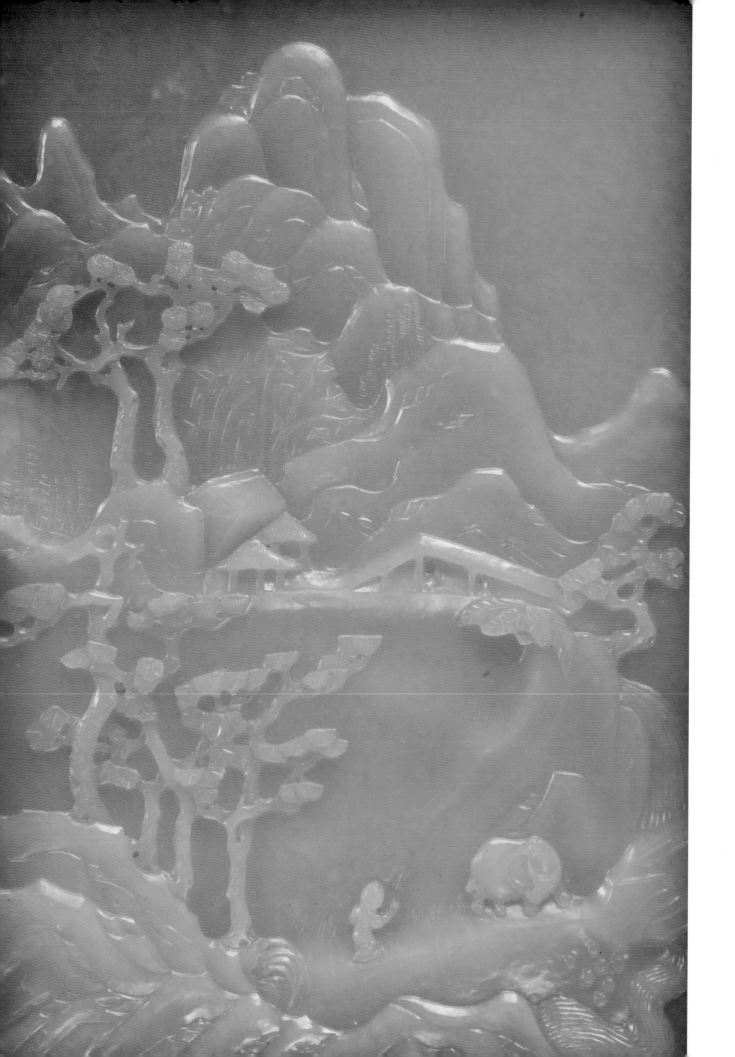

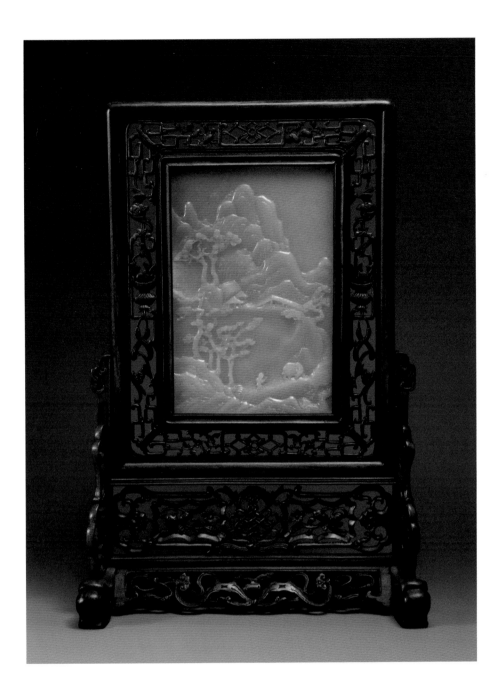

71. *Table Screen*; Qing dynasty, Qianlong period (1735–1796); Nephrite panel and wooden stand;
Jade: H 8½ × W 5¾ × D ½ INCHES (21.6 × 14.6 × 1.3 CM); Overall: H 17¾ × W 12¼ × D 5½ INCHES
(45.1 × 31.1 × 14.0 CM); George Walter Vincent Smith Art Museum, Springfield, Massachusetts,
George Walter Vincent Smith Collection, GWVS 60.23.109

The celadon jade panel is carved with a landscape scene showing a boy herding an
ox. The ox appears recalcitrant and looks back at the boy, who has one armed raised
prodding the ox forward. Gnarled pine trees and bamboo rise from the rocky land-
scape, with two pavilions and a raised walkway nestled in the mountains. On the
reverse side, a poem by Emperor Qianlong is inscribed in gold calligraphy by
Imperial officer Jueluo Guifang. The poem, written in five-character regular verse,
promotes a pastoral ideal. Many of the characters are abraded and illegible. The
panel is framed by an openwork-carved wooden stand bearing auspicious symbols
such as bats and the endless knot motif. This jade table screen would be an appropri-
ate decorative addition to a scholar's studio or the home of a noble. —JJ AND CLP

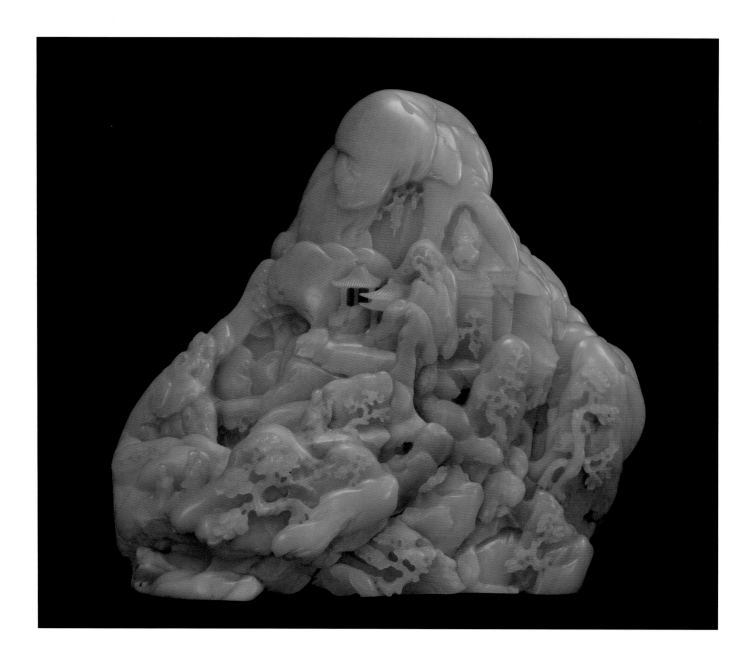

72. *Boulder Carved as a Mountain Landscape*; Qing dynasty, 18th century; Nephrite;
H 9⅞ × W 10 × D 3½ INCHES (25.1 × 25.4 × 8.9 CM); A Private American Collection

Even-toned celadon jade with patches of russet and cream is carved to form a rocky
landscape. The natural shape of the jade boulder has been retained in the sculpture.
Three elderly gentlemen are represented walking along a mountain path. The man at
the lower left appears to carry a peach while the man just below the pavilions appears
to carry a *ruyi*, suggesting that these figures are the popular Daoist gods Shoulao,
Fuxing, and by association, Luxing. Beautifully carved pine, prunus, and other plants
grow out of the rocky promontory. A flaming vessel, perhaps related to the Daoist
search for immortality, is located at the right of the peak. The structures partially
hidden in the mountains are well carved and proportioned. The reverse side of the
sculpture is also carved as a rocky landscape with pine trees and a cleft in the rocks
suggests a waterfall. Jade boulders carved in the form of mountain landscapes became
popular during the mid Qing dynasty. A similar yet simplified jade boulder landscape
was excavated from the ruins of the Old Summer Palace (*Yuanmingyuan*) in Beijing.[1]

— JJ

1. Gu 2005, vol. 1, p. 97.

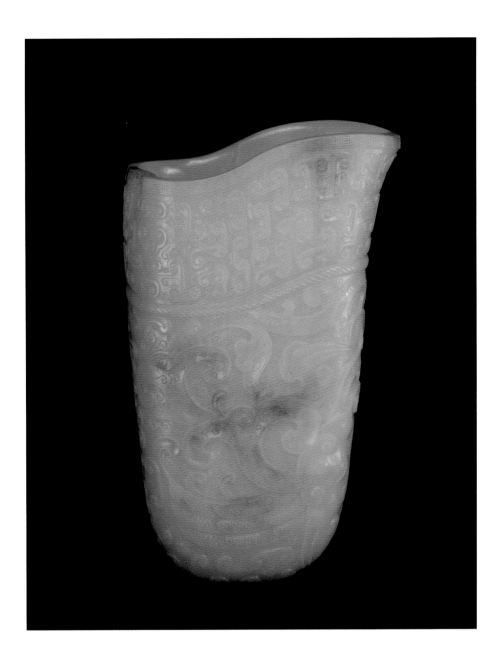

73. *Imperial Archaistic Rhyton*; Qing dynasty, 18th century; Nephrite; H 6¾ × W 4½ × D 2⅜ INCHES (17.1 × 11.4 × 6.0 CM); A Private American Collection

Composed of exceptionally beautiful white jade of even tone with russet markings, the exterior of this rhyton is superbly carved with a dense ground of geometric patterns and zoomorphic imagery.[1] A rhyton is a drinking vessel, the shape originally based on a horn. A narrow band of interlocking *leiwen* patterns encircles the curvilinear rim. C-scrolls of varying size adorn the area between the *leiwen* and a narrow band in raised relief simulates twisted rope. The archaistic decor carved on the lower section of the vessel, which extends to cover the base of the object, is arranged symmetrically. A large bird with outstretched wings is the primary creature represented on the rhyton. The high quality of the jade and the exquisite design and carving of the rhyton indicate that this outstanding object was made in an Imperial workshop and was likely intended for the Imperial Collection. —JJ

1. Previously published in *Chinese Sculpture and Works of Art* (New York: Eskenazi, 2008). Previously in the collection of Lady Horlick. A similar rhyton with a band of *leiwen* on the rim, simulated twisted rope design, and related dense archaistic patterning is dated to ca. 1787 in the collection of the Fitzwilliam Museum, Cambridge, published in Gray 1975, p. 134.

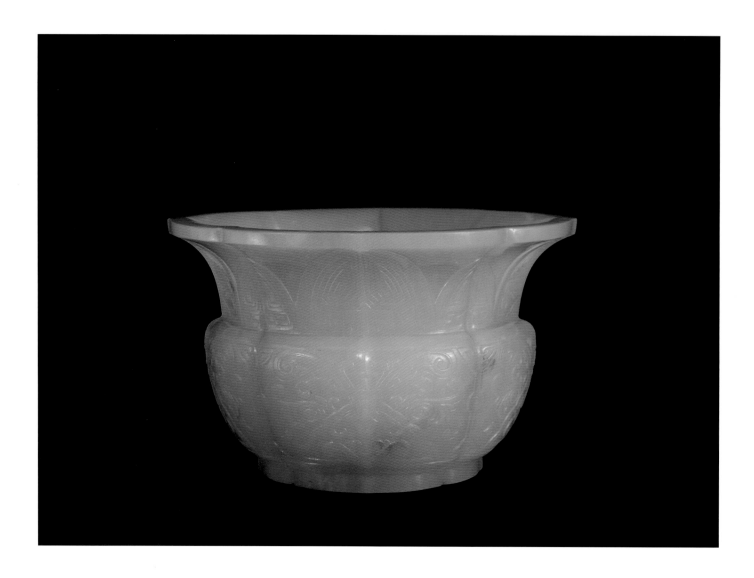

74. *Archaistic Jar, zhadou*; Qing dynasty, 18th century; Nephrite; H 2⅞ × W 4½ (7.3 × 11.4 CM);
A Private American Collection

Translucent white jade is carved to form the archaistic *zhadou* shape. The skin of the
jade contains a few small areas of russet markings. *Zhadou* were often used to hold
table scraps and frequently appear in ceramic form. This small jade *zhadou* likely
served a purely decorative function. The flaring ovoid rim is divided into eight
uniform lobes. Ribs extend horizontally from the lobes along the surface of the vessel,
terminating in a short unadorned footring that repeats the design of the rim. The
eight horizontal ribs alternate between raised and incised treatment. Eight leaf-form
medallions bearing carved archaistic patterns adorn the convex shoulder. Two large
stylized archaistic monster masks decorate the body of the vessel, with further
archaistic zoomorphic imagery appearing between the masks. —JJ

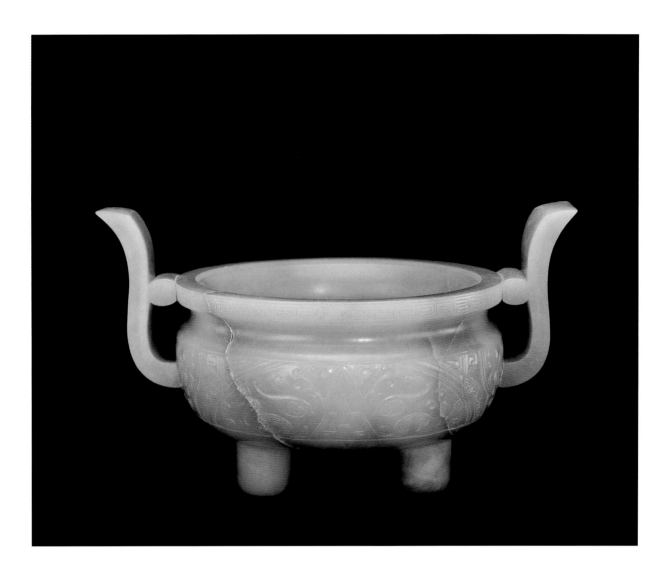

75. *Tripod Censer*; Qing dynasty (1644–1911); Nephrite; H 3⅞ × W 6⅞ × D 4¾ (9.8 × 17.5 × 12.1 CM); National Museum of History, Taiwan, 71-00743

An archaistic tripod is carved from a single piece of celadon jade and features large flaring upturned handles rising from the body of the vessel. Brown and tan areas follow natural cleavages in the stone. Archaistic zoomorphic creatures are the primary subject of the low relief carving on the surface of the tripod. Both sides of the vessel, framed by the upturned handles, feature a stylized monster mask. A similarly archaistic *leiwen* pattern encircles the lip. Three short round legs support the vessel. The fanciful shape of the vessel is a Qing dynasty reinterpretation of a *ding*, a bronze tripod of the Shang and Zhou dynasties which became one of the most enduring shapes appearing in Chinese vessels. —JJ

76. *Archer's Thumb Ring*; Qing dynasty (1644–1911); Jadeite; H 1 × W 1¼ INCHES (2.5 × 3.2 CM); National Museum of History, Taiwan, 37283

Jadeite of especially beautiful color and translucency is carved in the form of an archer's thumb ring.[1] Originally thumb rings were carved with a small hook extending from the ring to aid in pulling a bow string. Examples of early jade hooked archer's thumb rings include those excavated from Eastern Zhou dynasty tombs (770–221 BC).[2] Over time, the thumb ring became solely an adornment for men and the hook was eliminated in favor of a smooth, round ring. An archer's ring of similar size, design, and material was excavated at the tomb of Feng Guozhang (1857–1919) at Xicun in Hejian, Hebei province.[3]

— JJ

1. Previously published in *Jade: A Traditional Chinese Symbol of Nobility and Character* (*Yu: Zhongguo chuantong meide de xiangzheng*, Taipei: National Museum of History, Taiwan, 1990, p. 81); *Jade: Ch'ing Dynasty Treasures* (*Qing dai yu diao zhi mei*, Taipei: National Museum of History, Taiwan, 1998, p. 234).

2. Rawson 2002, pp. 286–288.

3. Gu 2005, vo. 1, p. 238.

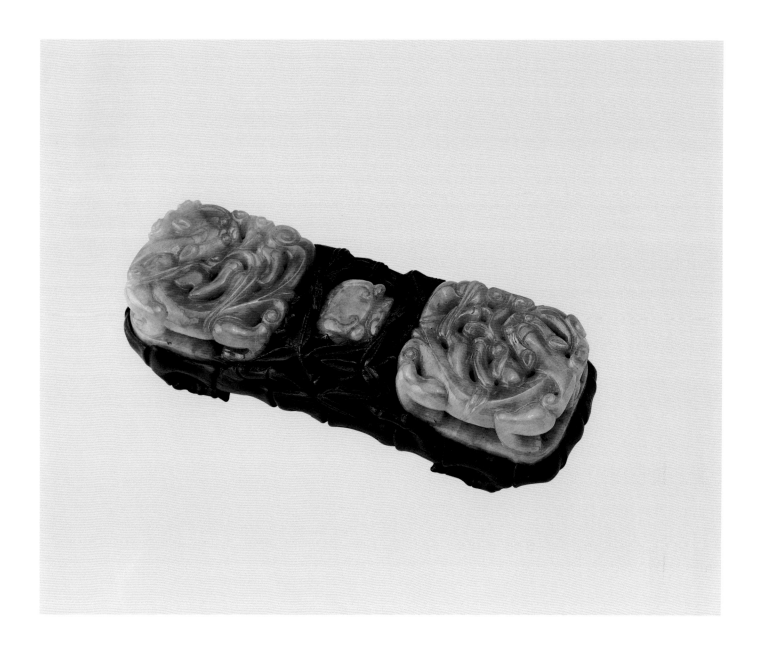

77. **Buckle**; Qing dynasty (1644–1911); Jadeite with wooden mount; Overall: H 1¹⁄₁₆ × W 4 × D 1⅜ INCHES (2.7 × 10.2 × 3.5 CM); National Museum of History, Taiwan, 37284

Composed of bright green jadeite, the buckle and hook are set into a carved wooden stand.[1] The two square plaques forming the top of the buckle and hook sections are openwork carved with recoiled dragons set amongst swirling clouds and *lingzhi* fungus. The head of a third and larger dragon forms the hook. Jade was used for functioning buckles by the Han dynasty (206 BC–220 AD). During the Qing dynasty buckle sets were created as purely decorative and archaistic objects rather than as functioning accessories.[2]

— JJ

1. Previously published in *Jade: A Traditional Chinese Symbol of Nobility and Character* (*Yu: Zhongguo chuantong meide de xiangzheng*, Taipei: National Museum of History, Taiwan, 1990, p. 80); *Jade: Ch'ing Dynasty Treasures* (*Qingdai yu diao zhi mei*, Taipei: National Museum of History, Taiwan, 1998, p. 226).

2. Knight, Li, and Bartholomew 2007, p. 51.

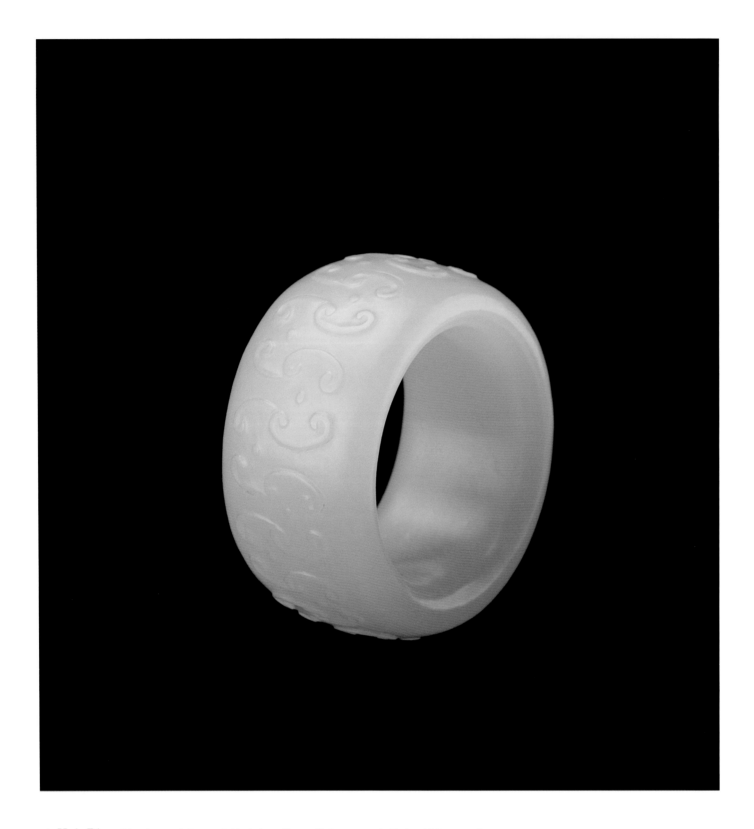

78. *Hair Ring*; Qing dynasty (1644–1911); Nephrite; H ⅞ × W 1⅝ (2.2 × 4.1 CM); National Museum of History, Taiwan, 71-00715

Creamy white jade of uniform tone is carved to form a ring used to hold hair. The outer surface of the ring is decorated with a continuous band of C-shaped curls confronting a small circle in low relief. A fine jade object of this type was an adornment limited to those of elite status. —JJ

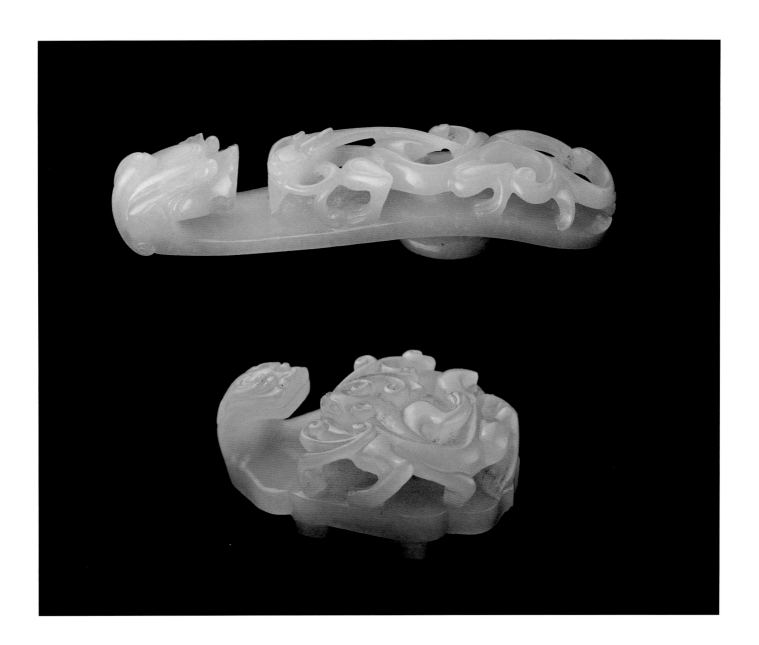

79. **Dragon-decorated Belt Hook**; Qing dynasty (1644–1911); Nephrite; H 5 × W 1 × D 1³⁄₁₆
INCHES (12.7 × 2.5 × 3.0 CM); National Museum of History, Taiwan, 71-00665

The use of jade for belt hooks dates back to the Eastern Zhou dynasty.[1] Hooks, such
as this example,[2] could have been used to close garments and thus can also be
described as garment hooks. This white jade hook is decorated with a large dragon
with bulging eyes and faces a smaller, open-work carved dragon. The dragon is the
most popular theme appearing on jade hooks.

1. Rawson 2002, p. 345

2. Previously published in *Jade: A Traditional
Chinese Symbol of Nobility and Character* (*Yu:
Zhongguo chuantong meide de xiangzheng*, Taipei:
National Museum of History, Taiwan, 1990,
p. 80); *Jade: Ch'ing Dynasty Treasures* (*Qingdai yu
diao zhi mei*, Taipei: National Museum of History,
Taiwan, 1998, p. 226).

80. **Belt Hook**; Qing dynasty (1644–1911); Nephrite; H 2⁵⁄₈ × W 1⁷⁄₈ × D 1 INCHES (6.7 × 4.8 × 2.5 CM);
National Museum of History, Taiwan, 76-00229

A single piece of white jade is carved to form a belt hook.[1] The upraised hook forms
the head of a dragon while a smaller open-work carved dragon is shown scampering
amongst clouds.

1. Previously published in *Jade: A Traditional
Chinese Symbol of Nobility and Character* (*Yu:
Zhongguo chuantong meide de xiangzheng*, Taipei:
National Museum of History, Taiwan, 1990,
p. 80); *Jade: Ch'ing Dynasty Treasures* (*Qingdai yu
diao zhi mei*, Taipei: National Museum of History,
Taiwan, 1998, p. 226).

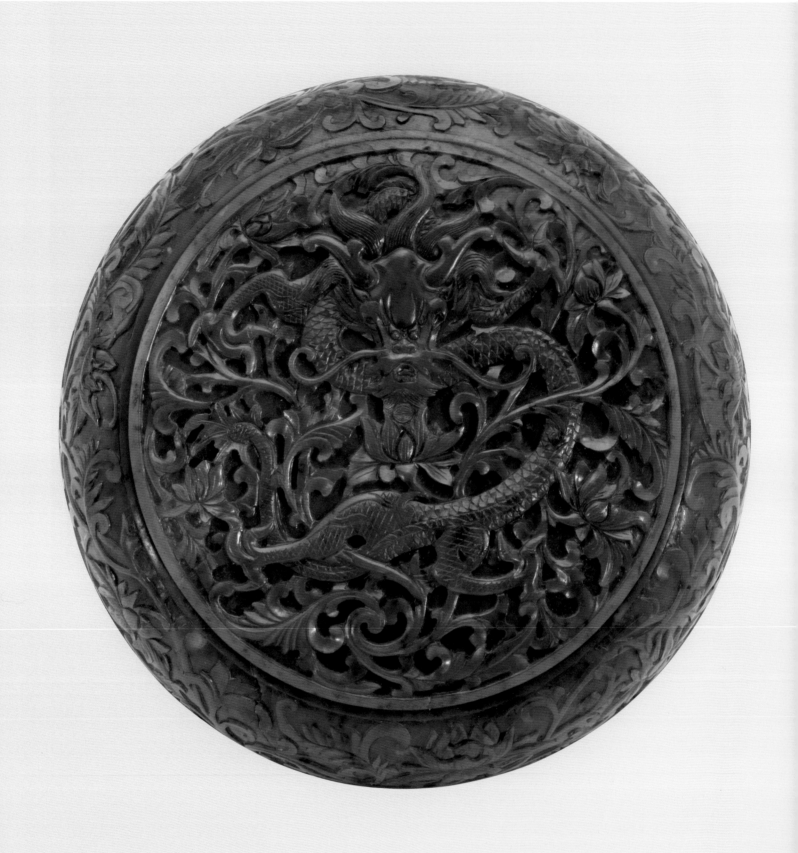

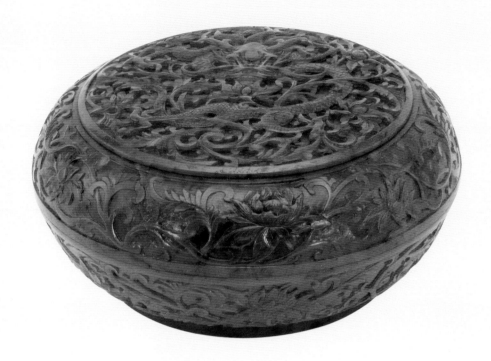

81. *Spinach-green Covered Bowl*; Qing dynasty, Qianlong period (1735–1796); Nephrite;
Overall: H 3½ × DIAM 7⅝ INCHES (8.9 × 19.4 CM); George Walter Vincent Smith Art Museum,
Springfield, Massachusetts, George Walter Vincent Smith Collection, GWVS-60.23.79

A wide circular covered bowl with flaring sides and short rim stands on a short ringed
foot. This beautifully carved object is composed of semi-translucent "spinach jade"
with numerous black inclusions. The bowl and cover are perfectly fitted. The cover
is carved with a powerfully coiled forward-facing dragon set amongst lotuses and
botanical scrolls. The dragon medallion is contained within a uniform circular
border. The scaled sinuous body of the three-clawed dragon forms an S-shape. The
expertly carved face of the dragon features bulging eyes, high forehead, a curling
beard and two horns. Strands of hair flow behind the dragon's head. The iconic
dragon motif can also be found on contemporaneous blue-and-white porcelains and
robes of the mid-17 to mid-18 century.[1] Just below the dragon's head a lotus supports
a small incised roundel. The sides of the cover and bowl are also well carved in
raised relief.

Qing emperors were fascinated by jade objects created in India and Central Asia.
Known as Mughal jades, these objects were imported into China beginning in the
mid-18th century and introduced new motifs and designs.[2] Emperor Qianlong
(1735–1796) coined the term "Hindustan jade" to describe jades objects from India
and the Islamic world and the Emperor encouraged the production of such jades
in China.[3]

A Mughal-inspired element present in this covered bowl is the distinctive scroll of
acanthus leaves. The artist cleverly combines the traditional Chinese lotus blossom
motif with the imported Mughal style of representing vines and leaves. The scrolls
of acanthus leaves were borrowed from the Mughal tradition and integrated with
indigenous Chinese visual elements. — CLP

1. For the chronological development of the dragon
head motif in the Qing dynasty, see Wang Zhimin
1999, pp. 64–5.

2. Bartholomew 2009, pp. 317–8.

3. Wuying dian copy of *Collected Poetry and Prose
of the Qing Qianlong Emperor* 1976; Yang and
Teng, 1983, p. 90.

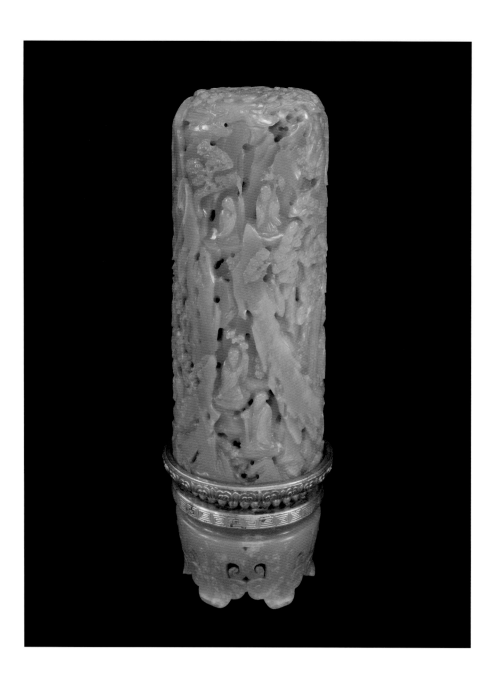

82. *Aromatics Container*; Qing dynasty, 18th century; Nephrite and gold; H 10¹³/₁₆ × W 3¹¹/₁₆ × D 3¹¹/₁₆ INCHES (27.4 × 9.7 × 9.7 CM); George Walter Vincent Smith Art Museum, Springfield, Massachusetts, George Walter Vincent Smith Collection, GWVS-60.23.79

The cylindrical aromatics container is deeply carved with a scene of sages in a mountainous landscape. The tall domed cover sets into a gold collar attached to a jade base. The gold collar is decorated with knob-like projections and a band of the archaistic *leiwen* pattern. Numerous holes created by drilling pierce the jade cover and are incorporated into the design of the rocky landscape. These holes allow air to flow through the cylinder so that the aromatic contents disperse. Such aromatics containers were primarily made of carved bamboo and became popular in the late Ming dynasty (late 16th–early 17th century).[1] These containers held aromatics, such as camphor to protect textiles from insects, and were also used to hold incense.[2] This deeply carved example is composed of pale celadon nephrite with small areas of cream and tan. A similarly carved jade aromatics container dated to the Qianlong period (1735–1796) is in the collection of the Victoria and Albert Museum.[3] — JJ

1. Li He, p. 218, in Knight, Li, and Bartholomew 2007.

2. Wilson 2004, p. 53.

3. V&A: 1652–1882, illustrated in Wilson, 2004, p. 54. See also a Qianlong period incense burner at the Seattle Art Museum illustrated in Watt 1989, p. 84.

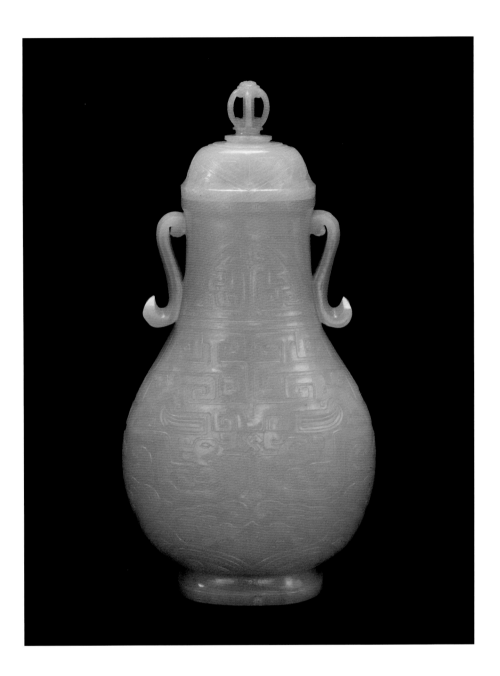

83. *Vase with Vajra-handled Cover*; Qing dynasty, Qianlong period (1735–1796); Nephrite; H 12¾ × W 6 × D 2½ INCHES (32.4 × 15.2 × 6.4 CM); George Walter Vincent Smith Art Museum, Springfield, Massachusetts, George Walter Vincent Smith Collection, GWVS-60.23.82

Numerous design motifs appear on this large and elegant covered vase composed of light-celadon *hetian* jade. The handle of the lid is in the form of one end of a vajra. The vajra originates in Indian symbolism but came to be associated with Esoteric Buddhism in the Himalayas and East Asia. The surface of the vase is finely carved, primarily with archaistic decor. On one side (pictured) two confronting dragons flank a swastika, here a Buddhist symbol, near the center of the vase. The lip of the vase and lid are incised with variations of the archaistic *leiwen* pattern, as are the scroll handles and short splayed foot. —JJ

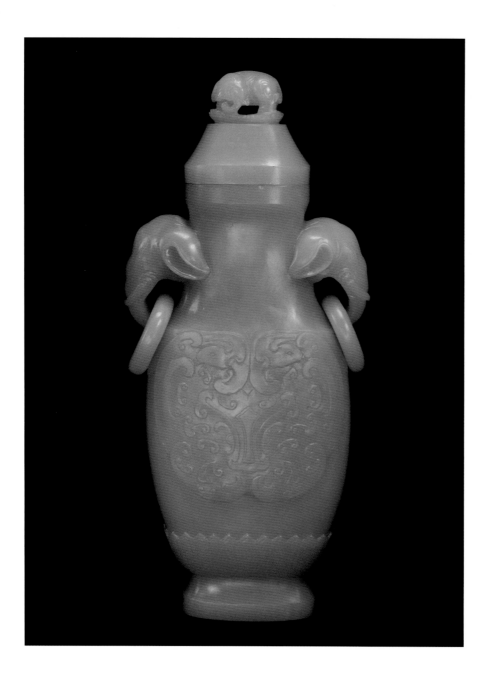

84. *Elephant Decorated Vase with Cover*; Qing dynasty, Qianlong period (1735–1796); Nephrite; H 10³⁄₁₆ × W 9 × D 2½ INCHES (29.9 × 22.9 × 6.4 CM); George Walter Vincent Smith Art Museum, Springfield, Massachusetts, George Walter Vincent Smith Collection, GWVS-60.23.82

This exquisite vase features two large elephant handles and is surmounted by an elephant calf forming the handle of the cover. The calf stands on a small plinth decorated with stylized clouds. The elephant head handles are well proportioned and deeply carved. Circular loose rings hang from the handles. The entire object was carved from a single piece of whitish-celadon jade of beautiful, even tone. The addition of loose jade rings and chains became popular in the early Qing dynasty and demonstrates the skill of the carver. Archaistic imagery of two birds encircling a stylized animal head appears on a raised medallion on both sides of the vase. A band of pointed petal-forms encircles the lower section of the vase above the undecorated, splayed foot. —JJ

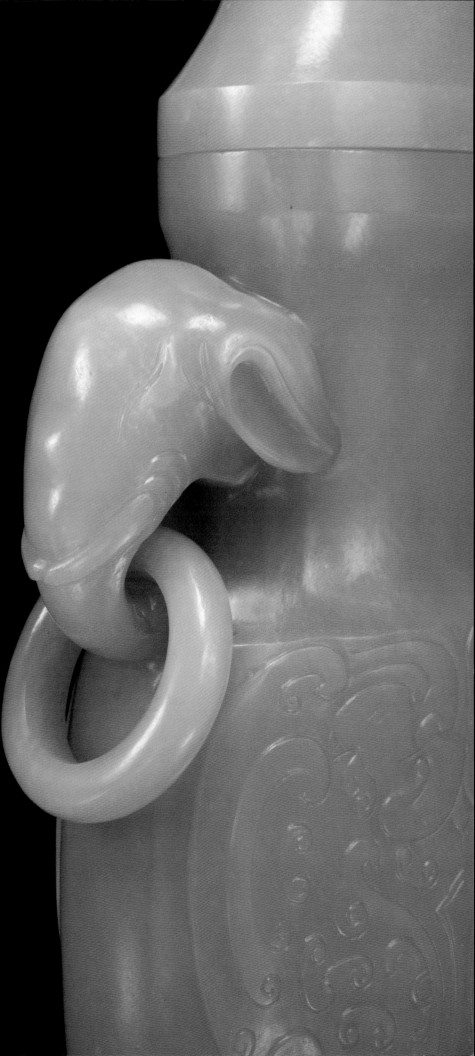

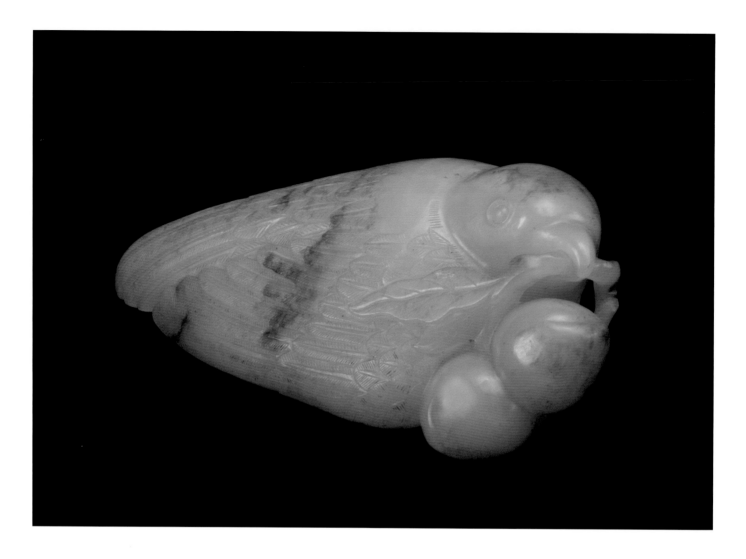

85. *Bird with Fruiting Branch*; Qing dynasty, Qianlong period (1735–1796); Nephrite; H 1½ × W 2⅜ × D 3¾ INCHES (3.8 × 6.0 × 9.5 CM); A Private American Collection

Off-white jade with areas of russet and tan is carved into a remarkably beautiful fig-ure of a seated bird. The natural "skin" of the jade is incorporated into the design of the carving, such as russet areas on the bird's head and the fruiting branch held in the bird's beak. The plummage is very finely incised and rendered with remarkable detail. The underside of the sculpture is also finely carved, particularly the wings, legs, and tail feathers. A small four character seal mark meaning "made during the reign of Emperor Qianlong" (*qianglong nianzhi*) can be seen between the bird's feet. The seal indicates that this sensitive figure of a bird was made for the Emperor. Qianlong, a keen collector of Chinese art and an artist himself, was particularly fond of jade.

—JJ

DETAIL: Qianlong reign mark.

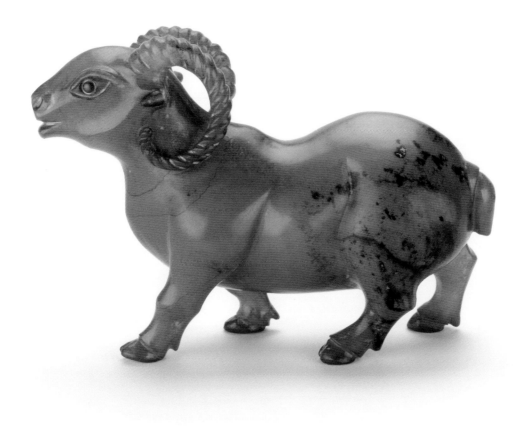

86. _Ram_; Late Qing dynasty, 19th century to 20th century; Nephrite; H 2¼ × W 3⁷⁄₁₆ × D 1⁹⁄₁₆ INCHES (5.7 × 8.7 × 3.9 CM); Arthur M. Sackler Gallery, Smithsonian Institution, Washington, D.C.: Gift of Arthur M. Sackler, s1987.815

A corpulent ram stands alertly on four short individually carved legs. The smooth and polished tan nephrite includes dark patches on the "skin." Features of the ram, such as the horns, hooves, and face, are carved in great detail. Jade animal carvings in China typically depict creatures sitting or reclining with folded legs. Legs carved in the round, such as with this standing figure, appear in the Qing dynasty. —JJ

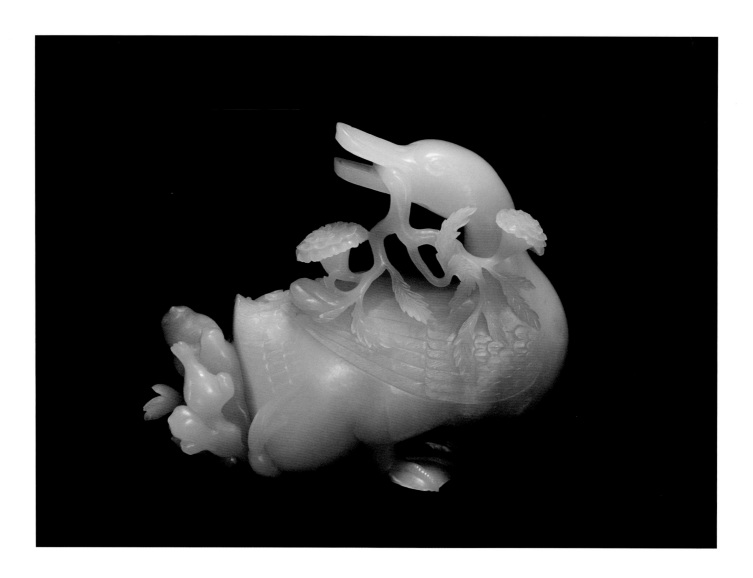

87. *Duck*; Qing dynasty (1644–1911); Nephrite; H 6 × W 2⅞ × D 4⅜ INCHES (15.2 × 7.3 × 11.1 CM);
National Museum of History, Taiwan, 76-00300

Pale celadon jade with tan and russet markings is carved into a realistic depiction
of a duck. The artist captures numerous fine details in this representation, such as
incised feathers on the wings and tail. The duck holds the stem of a plant bearing
flowers and leaves in its bill and looks backwards across his body. A group of aquatic
plants is shown against the duck's tail. The underside of the sculpture is also carved
with the webbed feet of the duck particularly well represented. The emphasis on
realistic representation is characteristic of Qing dynasty jade animal carving. —JJ

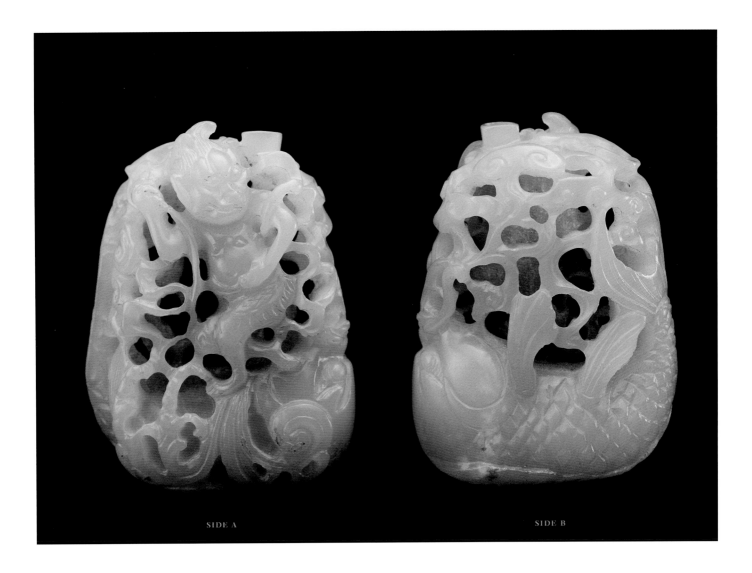

SIDE A · SIDE B

88. *Kui Xing*; Qing dynasty (1644–1911); Nephrite; H 2½ × W 1¾ × D 1 INCHES (6.4 × 4.4 × 2.5 CM);
National Museum of History, Taiwan, 71-00938

Semi-translucent pale celadon jade is carved in the form of an openwork pebble. The subject depicted on side A is the popular immortal Kui Xing.[1] He is shown with fierce eyes and flaring nostrils and holds an ink brush in his left hand. Kui Xing appears to be looking over his shoulder and stands amongst vines and tendrils.

A measuring vessel, known as a *dou*, can be seen just above the right of the immortal's large head. The combination of the character for ghost (*gui*) and measuring cup (*dou*) form the character *gui* which means achieving the first rank in the Imperial exams of the Ming and Qing dynasties. Thusly, the image conveyed a very auspicious meaning for success in the Imperial examinations.

Side B further reinforces the meaning implied in the aforementioned imagery. A large carp is shown in the lower section, likely referring to the popular phrase, "When a fish jumps over the Dragon Gate, it will turn into a dragon," a metaphor for success in Imperial exams, and forthcoming social status and wealth.[2] —CLP

1. Liu 2008, p. 71.

2. Ibid., p. 142.

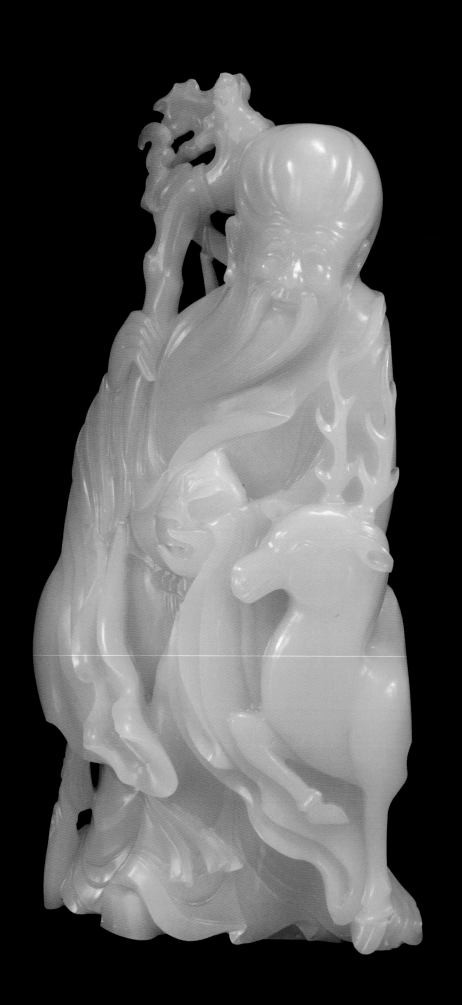

89. *Shoulao*; Qing dynasty, 18th century; Nephrite; H 10¹³⁄₁₆ × W 5⁵⁄₁₆ × D 2⁵⁄₁₆ INCHES
(27.4 × 13.5 × 5.8 CM); George Walter Vincent Smith Art Museum, Springfield, Massachusetts,
George Walter Vincent Smith Collection, GWVS-60.23.76

Shoulao, the popular God of Longevity, is carved from a single piece of creamy white
heitan jade of even tone. He is shown holding a staff of gnarled wood in his right
hand and his characteristic attribute, the Peach of Immortality, in his left hand.
A rolled scroll hangs from the back of the staff. Shoulao's high forehead and wispy
beard are delineated with finely incised lines. The dynamic folds of the cloak lend a
sense of movement to the large stone sculpture.

 Two animals are evident in the carving: a deer carved to the left of Shoulao
and a small bat clinging to the top of the gnarled staff. These figures represent the
Star Gods—Luxing, the God of Rank and Fuxing, the God of Blessing. Deer is
pronounced *lu* and bat is pronounced *fu* in Mandarin Chinese, thus forming
homonyms for the Gods.[1] Together with the figure of Shoulao, or Shouxing as he
is also known, all of the popular Three Star Gods (Fu, Lu, Shou) are represented in
this sculpture. —JJ

1. Knight, Li, and Bartholomew, 2007, p. 283.

BIBLIOGRAPHY

CHINESE SOURCES

Anhui wenwu gongzuodui, ed. "Anhui changfeng yanggong fajue jiuzuo zhanguo mu," *Kaoguxue jikan* 1982, vol. 2, pp. 47–59.

Baoji shi kaogu gongzuodui, ed. "Baoji shi yimencun er hao chunqiu mu fajue jianbao," Wenwu 1993: 10, pp. 1–14.

Beijing daxue kaogu xuexi shang zhou zu, shanxi sheng kaogu yanjiusuo, and zou heng. "Tianma qucun, 1980–1989," Beijing: Kexue chubanshe, 2000, vols. 1–4.

Beijing daxue zhendan gudai wenming yanjiu zhongxin, Beijing daxue zhongguo kaoguxue yanjiu zhongxin, Baoji qingtongqi bowuguan, and Taiwan zhendan yishu bowuguan. "Yuguo yuqi," *Wenwu chubanshe*, 2010.

Chan Lai Pik. *Xizhou xiangsheng dongwu yuqi yanjiu 1046–771 BCE (Animal-shaped jade carvings in the Western Zhou dynasty 1046–771 BCE).* PhD dissertation, Hong Kong: Chinese University of Hong Kong, 2009.

Chengdu shi wenwu kaogu yanjiusuo and pengzhou shi bowuguan. *Sichuan pengzhou songdai jinyinqi jiaozang,* Beijing: Kexue chubanshe, 2003.

Chu Ge. *Longshi,* Taipei: Self-published, 2009.

Gao Yuzhen. *Qingdai yudiao zhi mei,* Taipei: Guoli lishi bowuguan, 1997.

Gu Fang. *Zhonguo chutu yuqi quanji,* Beijing: Kexue chubanshe, 2005, vols. 1–15.

———. *Zhongguo chuanshi yuqi quanji,* Beijing: Kexue chubanshe, 2010, vols. 1–6.

Guangzhou shi wenwu guanli weiyuanhui, Zhongguo shehui kexueyuan kaogu yanjiusuo, and Guangdong sheng bowuguan. *Xihan Nanyue wang mu,* Beijing: Wenwu chubanshe, 1991.

Guoli lishi bowuguan (National Museum of History, Taiwan) and Henan bowuguan. *Guibao zhongxian: Hui xian liulige jia yi mu qiwu tuji (Re-exploring Treasures: Artifacts from the Jia and Yi Tombs of Huixian),* Taiwan: Guoli lishi bowuguan, 2005.

Guo Baojun and Zhongguo kexueyuan kaogu yanjiusuo. *Shanbiaozhen yu liulige,* Beijing: Kexue chubanshe, 1959.

Guo Xiang (d. 312). *Zhuangzi zhu,* Shanghai: Shanghai guji chubanshe, 1987 (reprinted).

Guoli gugong bowuyuan. *Gugong suocang hendusitan yuqi tezhan tulu,* Taipei: Guoli gugong bowuyuan, 1983.

———. *Gu se: shiliu zhi shiba shiji yishu de fanggufeng,* Taipei: Guoli gugong bowuyuan, 2003.

Han Jianwu and Ji Dongshan, eds. *Shenyun yu huihuang: shaanxi lishi bowuguan guobao jianshang (yuzaqi juan),* Xian: Sanqin chubanshe, 2006.

Hao Yixing (1757–1825). *Erya yishu,* Beijing: Shanhai guji chubanshe, 1983 (reprinted).

Heilongjiang sheng wenwu kaogu yanjiusuo, Li Chenqi, and Zhao Pingchun, eds. *Heilongjiang gudai yuqi,* Beijing: Wenwu chubanshe, 2008.

Henan sheng wenwu kaogu yanjiusuo and sanmenxia shi wenwu gongzuodui. *Sanmenxia guo guo mu,* Beijing: Wenwu chubanshe, 1999.

Henan sheng wenwu yanjiusuo, henan sheng dajiang kuqu kaogu fajue dui, and xichuan xian bowuguan, eds. *Xichuan xasi chunqiu chu mu,* Beijing: Wenwu chubanshe, 1991.

Henan sheng wenwu kaogu yanjiusuo, and pingdingshan shi wenwu kaogu yanjiusuo, eds. "Pingdingshan yingguo mu de fajue," Wenwu 1984, 2, pp. 1–5.

Henan sheng wenwu kaogu yanjiusuo, and henan sheng wenwu kaogu yanjiusuo, eds. *Xichuan heshangling yu xujialing chu mu,* Zhengzhou: Daxiang chubanshe, 2004.

Henan sheng wenwu kaogu yanjiusuo, pingdingshan shi wenwu kaogu yanjiusuo, eds. "Pingdingshan Yingguo mu 84 hao mu de fajue," Wenwu 1998, 9, pp. 4–17.

Henan Xinyang diqu wenguanhui, ed. "Chunqiu zaoqi huang junmeng fufu mu fafue baogao," Kaogu 1984, 4, pp. 302–32.

Hsu Tian-fu. *Qing dai yu diao zhi mei,* Taipei: Guoli lishi bowuguan, 1997.

Huang Nengfu and Qiao Qiaoling. *Yiguan tianxia: zhongguo fuzhuang tushi,* Beijing: Zhonghua shuju, 2009.

Hubei sheng bowuguan, and Zhongguo shehui kexue yuan kaogu yanjiusuo, eds. *Zenghou yi mu,* Beijing: Wenwu chubanshe, 1989, 2 vols.

Ji Naijun. "Yan'an shi faxian de gudai yuqi," Wenwu 1984, 2, pp. 84–87.

Jiang Tao, Wang Longzheng, and Qiao Binzhu, eds. *Sanmenxia guoguo nüguizu mu chutu yuqi jingcui,* Taipei: Zhongzhi meishu chubanshe, 2002.

Jiangxi sheng bowuguan, Jiangxi sheng wenwu kaogu yanjiusuo, and xingan xian bowuguan. *Xingan shangdai damu,* Beijing: Wenwu chubanshe, 1997.

Kwan, Simon. *Zhongguo gudai boli,* Hong Kong: Art Museum, The Chinese University of Hong Kong, 2001.

Li Ling. *Rushan yu chusai,* Beijing: Wenwu chubanshe, 2004.

Li Yanjun. *Yuqi cidian,* Ha'erbin: Heilongjiang renmin chubanshe, 2008.

Liaoning sheng wenwu kaogu yanjiusuo. "Liaoning niuheliang hongshan wenhua nushenmiao yu jishizhangqun fajue jianbao," Wenwu 1986, 8, pp. 1–17.

———. "Liaoling niuheliang di wu didian yihao zhang zhongxindamu," Wenwu 1997, 8, pp. 4–8.

Liu Xinyao. *Yu ji bu,* Taipei: Yiwen yinshuguan, 1964–1975.

Liu Yue. *Zhongguo diangu 80 meili,* Beijing: Shijie tushu chuban gongsi and beijing gongsi, 2011.

Liu Yunhui. *Shaanxi chutu dongzhou yuqi,* Beijing: Wenwu chubanshe and Taipei: Zhongzhi meishu chubanshe, 2006.

———. *Shaanxi chutu handai yuqi,* Beijing: Wenwu chubanshe and Taipei: Zhongzhi meishu chubanshe, 2009.

Lu Liancheng and Hu Zhisheng, eds. "Baoji yuguo mudi," Wenwu chubanshe, 1988, 2 vols.

Nanjing shi bowuguan. "Nanjing ming wang xingzu mu qingli jianbao," Kaogu, 1972, 4, pp. 23, 31–33.

Nanjing bowuyuan, ed. "1982 nian jiangsu changzhou wujin sidun yizhi de fajue," Kaogu 1984, 2, pp. 109–129.

Ren Shinan. "Zhongguo shiqian yuqi leixing chuxi," Zhongguo kaoguxue luncong, Beijing: Kexue chubanshe, 1993, pp. 106–30.

Shaanxi sheng kaogu yanjiuyuan, Zhendan yishu bowuguan, Sun Bingjun, Cai Qingliang, eds. *Ruiguo jinyu xuancui: shaanxi hancheng chunqiu baozang,* Xian: Sanqin chubanshe, 2007.

———. Weinan shi wenwu baohu kaogu yanjiusuo, Hancheng shi wenwu luyouju; Sun Bingjun, et. al., eds. "Shaanxi hancheng liangdaicun yizhi M26 fajue jianbao, Wenwu 2008, 1, pp. 4–21.

Shangdong sheng wenwu kaoguyanjiusuo, ed. *Qufu luguo gucheng,* Jinan: Qilu shushe, 1982.

Shanghai shi wenwu baoguan weiyuanhui, ed. "Shanghai shi qingpu xian fuquanshan liangzhu wenhua mudi," Wenwu 86, 10, pp. 1–25.

——. "Shanghai xiding fahuata yuan ming digong qingli jianbao," Wenwu, 1999, 2, pp. 4–15, 97.

——. "Shanghai shi fuquanshan liangzhu wenhua muzang," Wenwu 1984, 2, pp. 1–5.

Shanxi sheng kaogu yanjiusuo, and Beijing daxue kaogu xuexi, eds. "Tianma qucun yizhi: beizhao jinhou mudi di er ci fajue," Wenwu 1994, 1, pp. 4–28.

Sun Bingjun. "Shaanxi sheng hancheng shi liangdaicun 27 hao damu chutu yuqi yanjiu," Lishi wenwu, 2006, vol. 158, 9, pp. 54–63.

Sun Hua. "Xingan dayangzhou da mu niandai jianlun," Nanfang wenwu 1992, 2, pp. 35–40.

Sun Ji. Sun ji tan wenwu, Taipei: Dongda tushu gongsi, 2005.

Xu Wenbin, Chongqing shi wenhua ju, and Chongqing shi bowuguan. Sichuan handai shique, Beijing: Wenwu chubanshe, 1992.

Wang Fu (1079–1126). Chongxiu xuanhe bogutu, Shanghai: Shanghai guji chubanshe, 1987 (reprinted).

Wang Qijun. Zhongguo jianzhu tujie cidian, Beijing: Jixie gongye chubanshe, 2007.

Wang Zhimin. Longpao, Taipei: Yishu tushu gongsi, 1999.

Yang Boda. Zhongguo yuqi quanji, vols. 1–3, Shijiazhuang: Hebei meishu chubanshe, 2005.

Yang Mei-li. "Pu an cheng daojue, yabi qi xuanji: Xinshiqi shidai beifang xi huanxing yuqi zhi san-yabi xing qi," Gugong wenwu yuekan, no. 128, Nov. 1993, pp. 68–76.

Yang Yuan. "Lun handai de luoshen huangxiang ji qi fuhao gongneng," Zhongguo hanhua xuehui di shi er jie nianhui lunwenji, Zhongguo hanhua xuehui, Sichuan bowuguan, and Gu Sen. Hong Kong: Zhongguo guoji wenhua chubanshe, 2010.

Zhang Changshou. "Ji fengxi xin faxin di shoumian yushi," Kaogu, 1987, 5, pp. 470–3, 469.

Zhang, Minghua. Zhongguo guyu: faxian yu yanjiu 100 nian, Shanghai: Shanghai shudian chubanshe, 2004.

Zhao Dianzeng. "Tianmen kao," Sichuan wenwu, 1990, 6, pp. 3–11.

Zhao Fangzhi, ed. Caoyuan wenhua: youmu minzu de guangkuo wutai, Hong Kong: Shangwu yinshuguan, youxian gongsi, 1996.

Zhaoyang shi wenhua ju, Liaoning sheng wenwu kaogu yanjiusuo, eds. Niuheliang yizhi, Beijing: Xueyuan chubanshe, 2004.

Zhejiang sheng wenwu kaogu yanjiusuo. Fanshan, Beijing: Wenwu chubanshe, 2005.

——, Shanghai shi wenwu guanli weiyuanhui, and Nanjing bowuguan. Liangzhu wenhua yuqi, Beijing: Wenwu chubanshe and Hong Kong: Liangmu chubanshe, 1989.

Zheng Xuan (ca. 127–200) and Kong Yingda (ca. 574–648). "Zhouli zhushu," in Siku quanshu. Jingbu lilei, vol. 90, Shanghai: Shanghai guji chubanshe, 1987 (reprinted).

Zhongguo chuantong meide de xiangzheng (Jade: A Traditional Chinese Symbol of Nobility of Character), Taipei: Guoli lishi bowuguan, 1990.

Zhongguo kexueyuan kaogu yanjiusuo and Hebei sheng wenwu guanli chu. Mancheng hanmu fajue baogao, Beijing: Wenwu chubanshe, 1980.

Zhongguo shehui kexueyuan kaogu yanjiusuo neimenggu gongzuodui, ed. "Neimenggu aohanqi xinglongwa juluo yizhi 1992 nian gajue jianbao," Kaogu, 1997, 1, pp. 1–26.

——. "Changsha fajue baogao," Beijing: Kexue chubanshe, 1957.

——. Yinxu yuqi, Beijing: Wenwu chubanshe, 1980.

——. Yinxu de faxian yu yanjiu, Beijing: Kexue chubanshe, 1994.

——. "Dadianzi – xiajiadian xiaceng wenhua yizhi yu mudi fajue baogao," Beijing: Kexue chubanshe, 1996.

——. Yinxu fuhao mu, Beijing: Wenwu chubanshe, 1980.

Zhongguo shehui kexueyuan kaogu yanjiusuo erlitou dui. "1980 nian qiu henan yanshi erlitou yizhi fajue jianbao," Kaogu 1983, 3, pp. 199–205, 219.

Zhongguo shehui kexueyuan yuyan yanjiusuo cidian bianjishi, Lu shuxiang, and Ding Shengshu, eds. Xiandai hanyu cidian. Beijing: Shangwu yinshuguan, 2000.

Zhongguo wenwu bao, Beijing: Dec. 12, 1999.

Zhongguo yuqi quanqi bianji weiyuanhui, ed. Zhongguo yuqi quanqi, Shijiazhuang: Hebei chubanshe, 1991–1993, vol. 1–6.

Zibo shi bowuguan, and Qigu cheng bowuguan, eds. Linzi shangwang mudi, Jinan: Qilu chubanshe, 1997.

ENGLISH SOURCES

Bartholomew, Terese Tse. "Non-Chinese Jades: Islamic and Mughal Works" in Later Chinese Jades: Ming Dynasty to Early Twentieth Century from the Asian Art Museum of San Francisco. Knight, Michael, Li He, and Terese Tse Bartholomew. San Francisco: Asian Art Museum, 2007, pp. 315–319.

——. "Pictorial Puns and Symbols in Qing Dynasty Jades" in Later Chinese Jades: Ming Dynasty to Early Twentieth Century from the Asian Art Museum of San Francisco. Knight, Michael, He Li, and Terese Tse Bartholomew. San Francisco: Asian Art Museum, 2007, pp. 229–247.

Cahill, James. "The Yuan Dynasty (1271–1368)" in Three Thousand Years of Chinese Painting, Yang Xin, Nie Chongzheng, Lang Shaojun, Richard M. Barnhart, James Cahill, and Wu Hung. New Haven: Yale University Press and London: Foreign Language Press, 1997, pp. 138–195.

Canadian Foundation for the Preservation of Chinese Cultural and Historical Treasures. Jade, the Ultimate Treasure of Ancient China. Toronto: Canadian Foundation for the Preservation of Chinese Cultural and Historical Treasures, 2000.

Childs-Johnson, Elizabeth. "Jade as Material and Epoch" in China: 5,000 Years of Innovation and Transformation in the Arts, Sherman Lee, ed., New York: Guggenheim Museum Publications, 1998.

Chung Wah-pui, Carol Michaelson, and Jenny F. So. Chinese Jade Animals, Hong Kong: Urban Council of Hong Kong, 1996.

Fontein, Jan and Tung Wu. Unearthing China's Past. Boston: Museum of Fine Arts, 1973.

Garines, Alan M. and Julia L. Handy. "Mineralogical Alteration of Chinese Tomb Jades." Nature 253, Feb. 6, 1975, pp. 433–434.

Gu Fan. The Treasures of Chinese Private Jade Collections, Beijing: Science Press 2008.

Forsyth, Angus and Brian S. McElney. Jades from China, Bath: Museum of East Asian Art, 1994.

Li He. "Chinese Jade Art in the Ming and Qing Dynasties" in *Later Chinese Jades: Ming Dynasty to Early Twentieth Century from the Asian Art Museum of San Francisco*. Knight, Michael, He Li, and Terese Tse Bartholomew. San Francisco: Asian Art Museum, 2007, pp. 15–45.

Kerr, Alex. *Immortal Images: The Jade Collection of Margaret and Trammell Crow*, Dallas: Crow Family Interests, 1989.

Kerr, Rose. *Song through 21st Century Eyes – Yaozhou and Qingbai Ceramics*, Dreumel: Meijering Art Books, 2009.

Knight, Michael, He Li, and Terese Tse Bartholomew. *Later Chinese Jades: Ming Dynasty to Early Twentieth Century from the Asian Art Museum of San Francisco*, San Francisco: Asian Art Museum, 2007.

——. "Archaism in Chinese Jade from the 960–1911" in *Later Chinese Jades: Ming Dynasty to Early Twentieth Century from the Asian Art Museum of San Francisco*. Knight, Michael, Li He, and Terese Tse Bartholomew. San Francisco: Asian Art Museum, 2007, pp. 141–153.

Lawton, Thomas, et. al., *Asian Art in the Arthur M. Sackler Gallery*, Washington D.C.: Smithsonian Books, 1987.

Legge, James, trans. *Li ji (Book of Rites)*, New York: New Hyde Park, 1967.

Lu, Peter J. "Early Precision Compound Machine from Ancient China," *Science*, New Series, vol. 304, no. 5677 (Jun. 11, 2004), p. 1638.

Masterworks of Chinese Jade in the National Palace Museum, Taipei: National Palace Museum, Taiwan, 1970.

Middleton, Andrew and Ian Freestone. "The Mineralogy and Occurrence of Jade," in *Chinese Jade: From the Neolithic to the Qing*, Jessica Rawson, Chicago: Art Media Resources, 2002, p. 417.

Nott, Stanley Charles. *Chinese Jade throughout the Ages: A Review of Its Characteristics, Decoration, Folklore, and Symbolism*, Rutland, VT: C.E. Tuttle, 1962.

Pinder-Wilson, Ralph. "The Islamic World" in *The World of Jade*, Stephen Markel, ed., Maharashtra: Marg Publications, 1992.

Rawson, Jessica. *Western Zhou Ritual Bronzes from the Arthur M. Sackler Collections*. 2 vols., Washington D. C. and Cambridge, MA: The Arthur M. Sackler Foundation and the Arthur M. Sackler Museum, 1990.

——. *Chinese Jade: From the Neolithic to the Qing*, Chicago: Art Media Resources, 2002.

—— and John Ayers. *Chinese Jade throughout the Ages*, London: Oriental Ceramic Society, 1975.

——. "The Reuse of Ancient Jades," in *Chinese Jades: Colloquies on Art and Archaeology in Asia*, No. 18, Rosemary Scott, ed., London: University of London, Percival David Foundation of Chinese Art, School of Oriental and African Studies, 1997.

Salmony, Alfred. *Chinese Jade through the Wei Dynasty*, New York: Ronald Press, 1963.

Scott, Rosemary E., ed. *Chinese Jades: Colloquies on Art & Archaeology in Asia*, No. 18, London: University of London, Percival David Foundation of Chinese Art, School of Oriental and African Studies, 1997.

So, Jenny F. "Impressions of Times Past: Chinese Jades of the 12th to 17th Centuries," *Transactions of The Oriental Ceramic Society*, vol. 74, 2011, forthcoming.

——. "The Functions of Jade Animal Sculpture in Ancient China" in *Chinese Jade Animals*. Chung, Wah-pui, Carol Michaelson, and Jenny F. So, Hong Kong: Hong Kong Museum of Art, 1996, pp. 27–32.

——. "Jade and Stone," *Ancient Sichuan: Treasures from a Lost Civilization*. Robert Bagley ed., Seattle Art Museum, Princeton: Princeton University Press, 2001.

—— and Emma C. Bunker. *Traders and Raiders on China's Northern Frontier*, Arthur M. Sackler Gallery, Smithsonian Institution, Seattle: University of Washington Press, 1995.

Steinhardt, Nancy. "The Architecture of Living and Dying" in *The World of Khubilai Khan: Chinese Art in Yuan Dynasty*. James Watt C. Y. ed., Metropolitan Museum of Art, New Haven, London: Yale University Press, 2010, pp. 65–83.

Watt, James C. Y. *Chinese Jades from Han to Ching*, New York: Asia Society, John Weatherhill, Inc., 1980.

——. *The World of Khubilai Khan: Chinese Art in Yuan Dynasty*, New York: Metropolitan Museum of Art; New Haven, London: Yale University Press, 2010.

—— and Michael Knight. *Chinese Jades from the Collection of the Seattle Art Museum*, Seattle: Seattle Art Museum, 1989.

Whitlock, Herbert Percy and Martin L. Ehrmann. *The Story of Jade*, New York: Sheridan House, 1949.

Wilson, Ming. *Chinese Jades*, London: V & A Publications, 2004.

Wu Hung. "The Origins of Chinese Painting: Paleolithic Period to Tang Dynasty," in *Three Thousand Years of Chinese painting*. Yang Xin, Nie Chongzheng, Lang Shaojun, Richard M. Barnhart, James Cahill, and Wu Hung. New Naven and London: Yale University Press; Beijing: Foreign Language Press, 1997.

Yang Mei-li. "The Development of Archaic Circular Jades ." In *A Catalogue of the National Palace Museum's Special Exhibition of Circular Jade*. Taipei: National Palace Museum, 1995, pp. 1–12 (Chinese); pp. 13–32 (English translation).

Yang Xiaoneng. *The Golden Age of Chinese Archaeology: Celebrated Discoveries from the People's Republic of China*, Washington, D.C.: National Gallery of Art, 1999.

Zhang Minghua. *Chinese Jade: Power and Delicacy in a Majestic Art*, San Francisco: Long River, 2004.